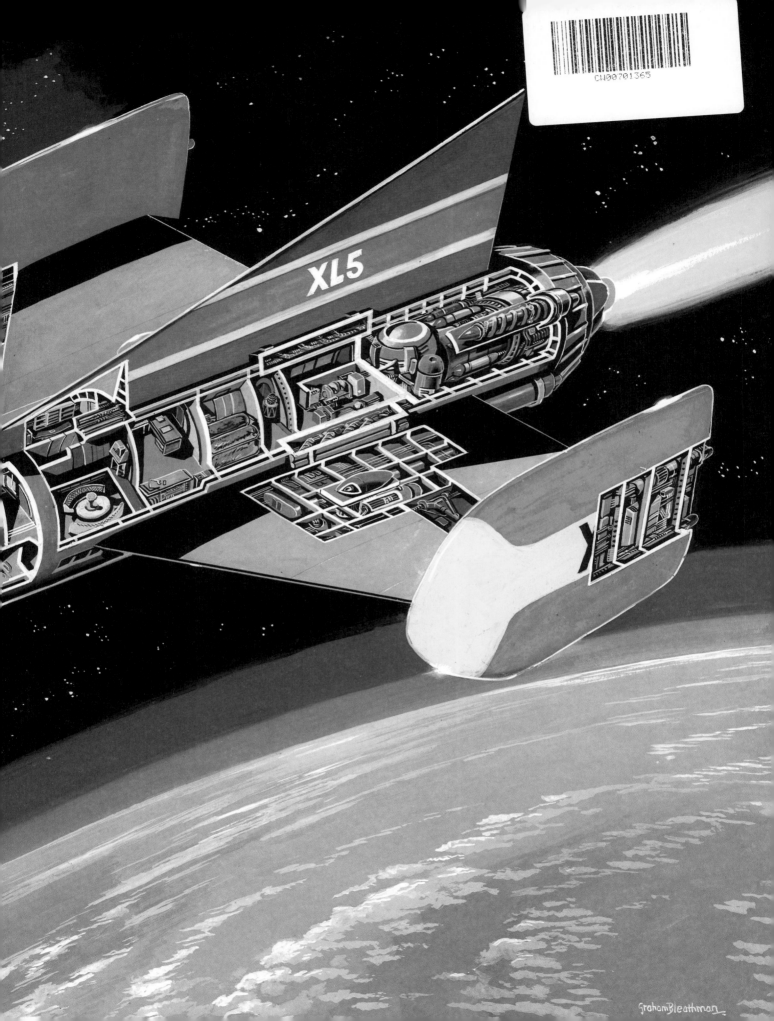

XL5

Graham Bleathman

£6
aer

INSIDE THE WORLDS OF GERRY ANDERSON

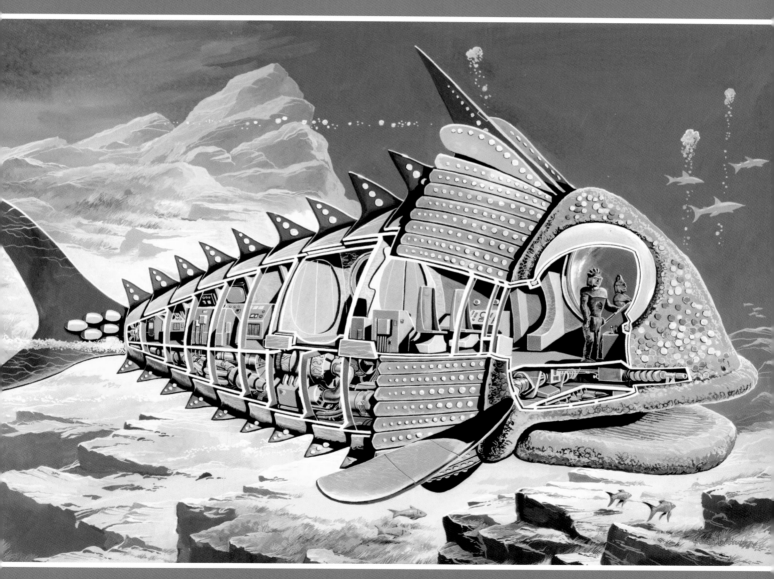

CLASSIC COMICS

EGMONT

FEATURING CROSS-SECTION ARTWORKS BY GRAHAM BLEATHMAN

It all started with a visit to Exeter cathedral. As part of an art college assignment in 1980, I was given the job of drawing the cathedral's interior for a project to design a guidebook. The result was my first cutaway.

I wasn't unfamiliar with this type of illustration, of course. As a child, I had grown up watching **Thunderbirds**, **Stingray** and other programmes created by Gerry Anderson, and read the comics and annuals of the 1960s and 70s which were tied in to these series. Many of these publications featured cutaways of the major craft and locations, and I was also an admirer of Leslie Ashwell Wood's cutaways for the **Eagle** comic of the 1950s and 60s.

So here was an opportunity to try my hand at creating one of my own. The result was liked by my tutor, and I was subsequently encouraged to produce similar illustrations for newspapers and magazines when I left college. While most of these cutaways were of historic buildings, some were of more diverse subjects, illustrating features about the **SS Great Britain**, mechanical dinosaur exhibitions and a cutaway of the set for the TV show **Casualty**, to name but a few.

In 1991, the **BBC** began screening **Thunderbirds**; its first network broadcast on **BBC2** was almost an overnight success. One of the more unusual cutaways that I had been commissioned to draw in 1990 was Thunderbird 2 for the TV pullout section of the **Bristol Evening Post**. In the summer of 1991, this was shown to Alan Fennell, editor of a new **Thunderbirds** comic to be published by Fleetway. The comic's contents were mostly reprints from **TV Century 21**, but Fennell wanted new material too; this

was to include comic strip adaptations of TV episodes and pull out 'technical data' posters, which is where my cutaways came in. Fennell liked the **Evening Post** cutaway and commissioned full painted versions of Thunderbirds 1 and 2, followed by the rest of the Thunderbird craft for the new publication. The comic was a runaway success, and the first six issues had to be reprinted in two special editions for those who missed out on the first fortnightly editions.

Looking back now, I realise what a privilege it was to be working for Alan. He was the editor and principal comic writer for **TV Century 21** (later referred to simply as **TV21**), and he also oversaw the production of those annuals I had so admired as a child. He was also the screenwriter for many of the episodes of **Fireball XL5**, **Stingray** and **Thunderbirds** that I had grown up with.

The actual working process was fairly straightforward. Each cutaway was produced on a fortnightly basis, covering the well known vehicles from each series before going on to tackle the more unusual craft and locations. The artwork was fully painted in gouache, each approximately 55cm x 37cm in size. I also painted a number of covers for the comic during its four year run, often illustrating a scene from one of the reprinted **TV21** comic strips.

In the days before the internet, DVD or Bluray, I used the original 1960s cutaways as a starting point for reference, with additional detail either supplied from VHS recordings of the shows or simply made up where no previous reference was available. VHS video recordings weren't always reliable, however, and a

number of errors are easy to spot throughout this book; notably the Aircraft carrier 'Atlantic' on pages 105-6. On video it looked to me like a normal single-hulled warship; on DVD it is quite clearly shown as a twin-hulled vessel.

Following the success of **Thunderbirds**, the **BBC** broadcast **Stingray**, **Captain Scarlet** and later **Joe 90** from 1992 to 1994. As Fleetway launched a tie-in comic for each of these, I transferred from one comic to the next producing cutaways and a number of cover paintings. By 1994, however, these short-lived publications had merged with the original Thunderbirds comic, and some of the cutaways intended for **Captain Scarlet** and **Joe 90** ended up in a comic that echoed **TV21**; it was now an anthology title featuring many of Anderson's shows.

Once the principal vehicles had been drawn for each series, Fennell was keen to feature cutaways based on less well known craft and locations, especially those seen in the comic strips and not

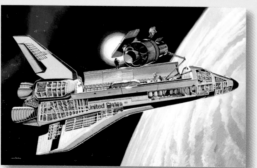

in the television episodes. Readers of this book will therefore not find the WASP Rescue Launches, Submarine fleet, Manufacturing plant, Submarine Aircraft Carrier, Sea Leopard or the Atlantic Tunnel on TV; these were created by **TV21** to broaden the series' universe beyond the confines of their TV episodes. Nor were the world capital Unity City, and its political rival Katannia – capital of an 'Eastern block' country called Bereznik - seen in any TV episode. These were also the creations of **TV21** writers who were living through the cold war of the 1960s, and were reflecting the popularity of espionage stories on TV and film in a number of comic strip stories.

As an additional nod to **TV21**, each cutaway had a 'Dateline' logo printed somewhere on it. For **Thunderbirds**, Fennell chose the 2026 on-screen date that has proved controversial with fans of the series over the years! The original date for **Thunderbirds** in **TV21** was 2066, tieing it in with the 2060s adventures of **Stingray** and **Fireball XL5**, plus the dates on the comics' famous newspaper style front pages. This was further compounded by 'Thunderbirds; the complete story', a strip detailing the history of International Rescue in the early years of the 21st century. It ran for 45 issues, and was written by Alan Fennell and illustrated by Andrew Skilleter, Steve Kyte and **TV21** veteran Mike Noble, along with my single contribution of a Space Shuttle cutaway.

After absorbing its sister titles, **Thunderbirds the Comic** was finally closed in March 1995, after 89 issues. I went on to produce cutaways for the short–lived **Space Precinct** comic, and continued to provide artwork for a diverse range of publications and subject matter. However, **Thunderbirds** doesn't seem to go away for very long, and consequently, I have been called upon to draw new cutaways for different publishers on three separate occasions over the years. Yet it is the fully painted illustrations reproduced in this book that I am particularly fond of, which probably means that I am glad I made that visit to Exeter cathedral nearly 35 years ago!

Graham Bleathman, 2014

TRACY ISLAND

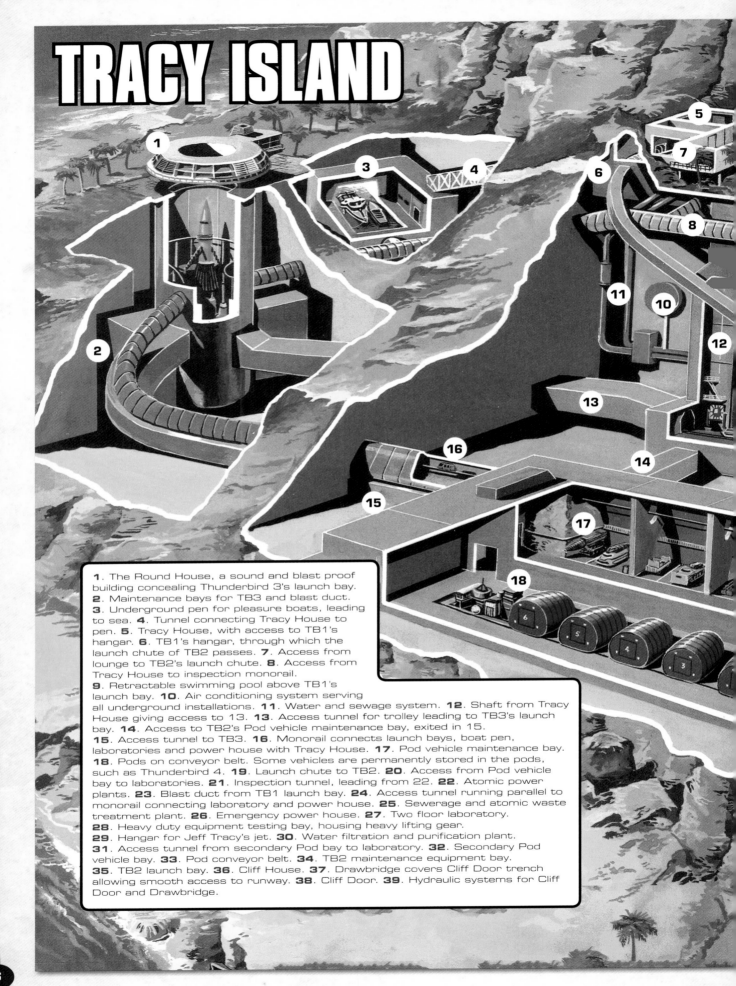

1. The Round House, a sound and blast proof building concealing Thunderbird 3's launch bay. **2.** Maintenance bays for TB3 and blast duct. **3.** Underground pen for pleasure boats, leading to sea. **4.** Tunnel connecting Tracy House to pen. **5.** Tracy House, with access to TB1's hangar. **6.** TB1's hangar, through which the launch chute of TB2 passes. **7.** Access from lounge to TB2's launch chute. **8.** Access from Tracy House to inspection monorail. **9.** Retractable swimming pool above TB1's launch bay. **10.** Air conditioning system serving all underground installations. **11.** Water and sewage system. **12.** Shaft from Tracy House giving access to 13. **13.** Access tunnel for trolley leading to TB3's launch bay. **14.** Access to TB2's Pod vehicle maintenance bay, exited in 15. **15.** Access tunnel to TB3. **16.** Monorail connects launch bays, boat pen, laboratories and power house with Tracy House. **17.** Pod vehicle maintenance bay. **18.** Pods on conveyor belt. Some vehicles are permanently stored in the pods, such as Thunderbird 4. **19.** Launch chute to TB2. **20.** Access from Pod vehicle bay to laboratories. **21.** Inspection tunnel, leading from 22. **22.** Atomic power plants. **23.** Blast duct from TB1 launch bay. **24.** Access tunnel running parallel to monorail connecting laboratory and power house. **25.** Sewerage and atomic waste treatment plant. **26.** Emergency power house. **27.** Two floor laboratory. **28.** Heavy duty equipment testing bay, housing heavy lifting gear. **29.** Hangar for Jeff Tracy's jet. **30.** Water filtration and purification plant. **31.** Access tunnel from secondary Pod bay to laboratory. **32.** Secondary Pod vehicle bay. **33.** Pod conveyor belt. **34.** TB2 maintenance equipment bay. **35.** TB2 launch bay. **36.** Cliff House. **37.** Drawbridge covers Cliff Door trench allowing smooth access to runway. **38.** Cliff Door. **39.** Hydraulic systems for Cliff Door and Drawbridge.

DATELINE 2026

Tracy Island is, to the outside world, the luxury home of ex-astronaut and multi-millionaire Jeff Tracy, his mother and sons Scott, Virgil, John, Gordon and Alan, housekeeper Kyrano and his daughter Tin Tin. Also resident is the scientific genius known as Brains, designer of the Thunderbirds vehicles and Tracy Island's installations. But behind this domestic facade is the secret headquarters of the International Rescue organisation.

Graham Bleathman 91

THUNDERBIRD 1

International Rescue's Thunderbird 1 is the ultra-sonic craft which has an undisclosed top speed. Sources close to I-R suggest a cruising speed of 15,000 miles per hour. Powered by varying conventional and nuclear fuel-fed drive units, TB1 has specialised armaments, but is essentially used for survey and reconnaissance work. With the ability to arrive at the danger zone in rapid time, TB1 houses a mobile control unit which helps the pilot to assess situations prior to the employment of other Thunderbird machines and hardware.

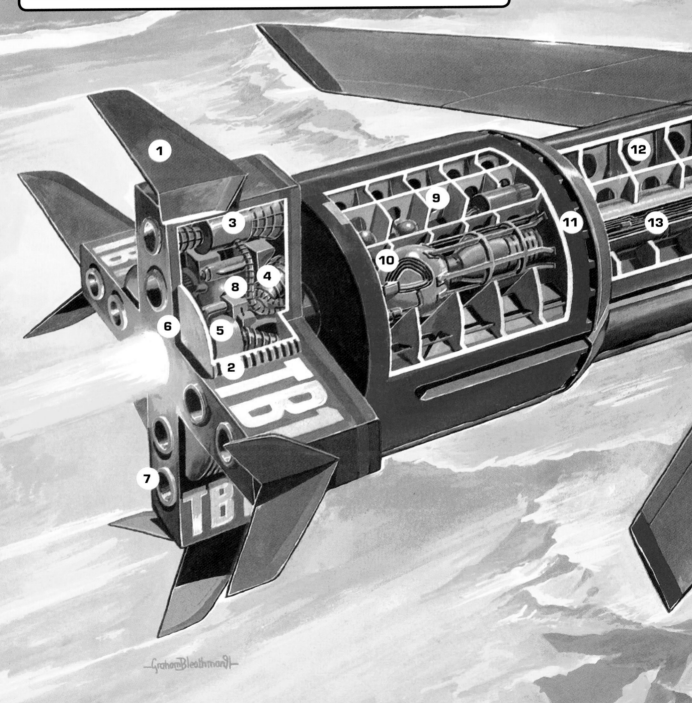

GrahamBleathman91

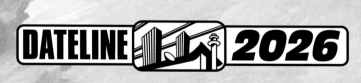

DATELINE 2026

1. Stabilisers. 2. Cooling fins. 3. Ramjet intake and heat exchanger.
4. One of four inner front air intakes. 5. Turbo-jet turbine. 6. High
performance sustainer rocket. 7. Booster rocket exhaust port.
8. Fuel lines. 9. Rocket propellant and pumps. 10. Atomic pile in
lightweight sandwich shielding. 11. Rear pitch and yaw jets within air
intakes. 12. Turbo-jet fuel tanks. 13. Central service duct. 14. Folding
wing slot giving added strength to fuselage. 15. Centrally placed vertical
take-off rocket and fuel tank. 16. Folding wing, containing landing leg.
17. Auxiliary motors and batteries. 18. Braced wing hinge and hydraulic
ram controlling wing angle during flight. 19. Pressure bulkhead.
20. Life support systems. 21. Air recycling duct. 22. Bulkhead
supporting pilot's seat. 23. Entry hatch with folding ladder used when
landed horizontally. 24. Fuselage refrigeration unit. 25. Control panel.
26. Computerised instrumentation system allowing simplified control of
aircraft at high speed. 27. Forward pitch and yaw jets. 28. Forward
radar, probe and detection systems within heat-resistant nose cone.

THUNDERBIRD 2

Fantastic in its power and strength, Thunderbird 2 is constructed of an alloy developed by Hiram Hackenbacker, fondly known to the International Rescue team as "Brains". With interchangeable Pods, Thunderbird 2 carries vital heavy engineering and life-saving equipment at speed to the danger zone. An estimated cruising speed of 2000 m.p.h. has been recorded and optimum altitude for TB2 is 60,000 feet, but as with other International Rescue craft and systems, much of the technical data is secret.

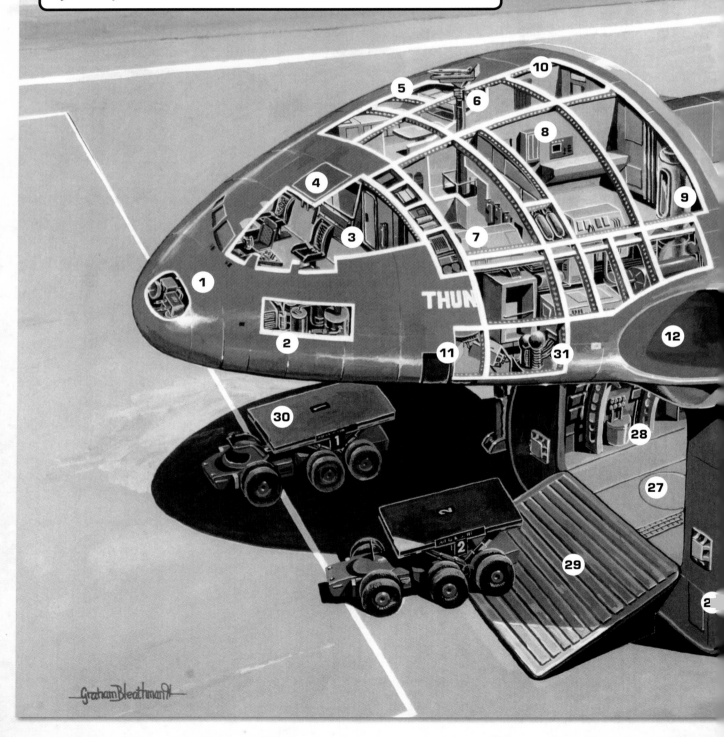

Graham Bleathman

1. Forward radar and detection unit.
2. Fuselage refrigeration and air recycling unit.
3. Pilot's cabin. 4. Chute entry hatch. 5. Living accommodation. 6. Missile launcher. 7. Hand-held rescue equipment store. 8. Laboratory. 9. Lift to floor level Pod door. 10. Entry hatch to Pod overhead gallery. 11. Observation window with TV scanners. 12. Ramjet air intake. 13. Hydraulic landing gear in airflow fairing. 14. Primary heat exchanger. 15. Split duct around aft landing leg hydraulics. 16. Re-heat secondary heat exchanger. 17. Magnetic bolts to secure Pod in flight. 18. Starboard vertical take-off rocket. 19. Rocket fuel tanks and pumps. 20. Atomic pile in lightweight shielding supplies heat to jet exchangers and turbo electrical generators. 21. Cruising speed turbo jets. 22. Ram-air turbine providing emergency electrical power. 23. Booster rocket for ramp launch. 24. Remote-controlled elevator car in Pod. 25. Inner stressed wall providing strength to Pod's lightweight fuselage. 26. Door giving access to lift when in flight. 27. Equipment turntable. 28. Pod vehicle maintenance equipment. 29. Ramp doubles as Pod door, 30. Master elevator car. 31. Forward vertical take-off rocket, next to lift.

DATELINE 2026

THUNDERBIRD 3

A staggering 200 feet in length, Thunderbird 3 is piloted by Alan Tracy. Scott and sometimes Brains and Tin-Tin, usually accompanies Alan on space missions. Apart from space rescue work, the orange spaceship is also used for the regular servicing of Thunderbird 5 and as a shuttle for the transfer of personnel as Alan and his brother John take it in turns to man the International Rescue Earth-orbit satellite.

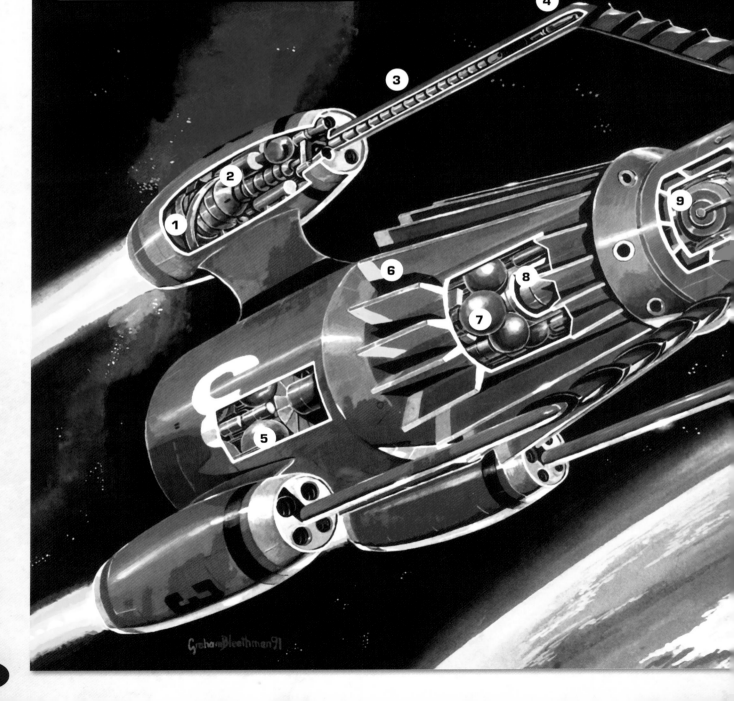

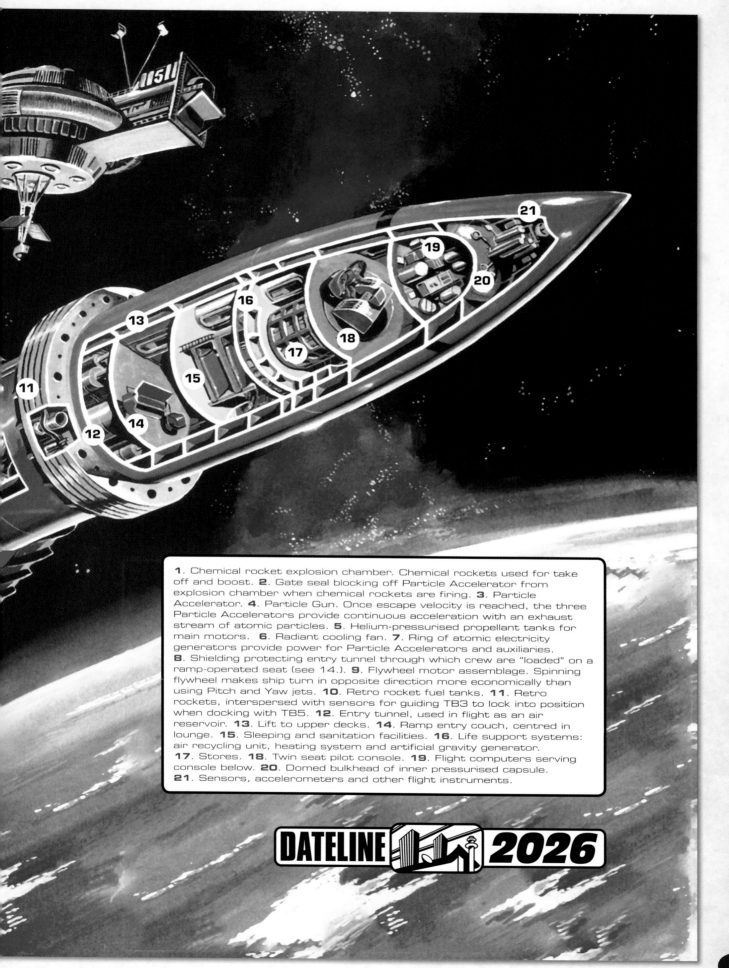

1. Chemical rocket explosion chamber. Chemical rockets used for take off and boost. 2. Gate seal blocking off Particle Accelerator from explosion chamber when chemical rockets are firing. 3. Particle Accelerator. 4. Particle Gun. Once escape velocity is reached, the three Particle Accelerators provide continuous acceleration with an exhaust stream of atomic particles. 5. Helium-pressurised propellant tanks for main motors. 6. Radiant cooling fan. 7. Ring of atomic electricity generators provide power for Particle Accelerators and auxiliaries. 8. Shielding protecting entry tunnel through which crew are "loaded" on a ramp-operated seat (see 14.). 9. Flywheel motor assemblage. Spinning flywheel makes ship turn in opposite direction more economically than using Pitch and Yaw jets. 10. Retro rocket fuel tanks. 11. Retro rockets, interspersed with sensors for guiding TB3 to lock into position when docking with TB5. 12. Entry tunnel, used in flight as an air reservoir. 13. Lift to upper decks. 14. Ramp entry couch, centred in lounge. 15. Sleeping and sanitation facilities. 16. Life support systems: air recycling unit, heating system and artificial gravity generator. 17. Stores. 18. Twin seat pilot console. 19. Flight computers serving console below. 20. Domed bulkhead of inner pressurised capsule. 21. Sensors, accelerometers and other flight instruments.

DATELINE 2026

THUNDERBIRD 4

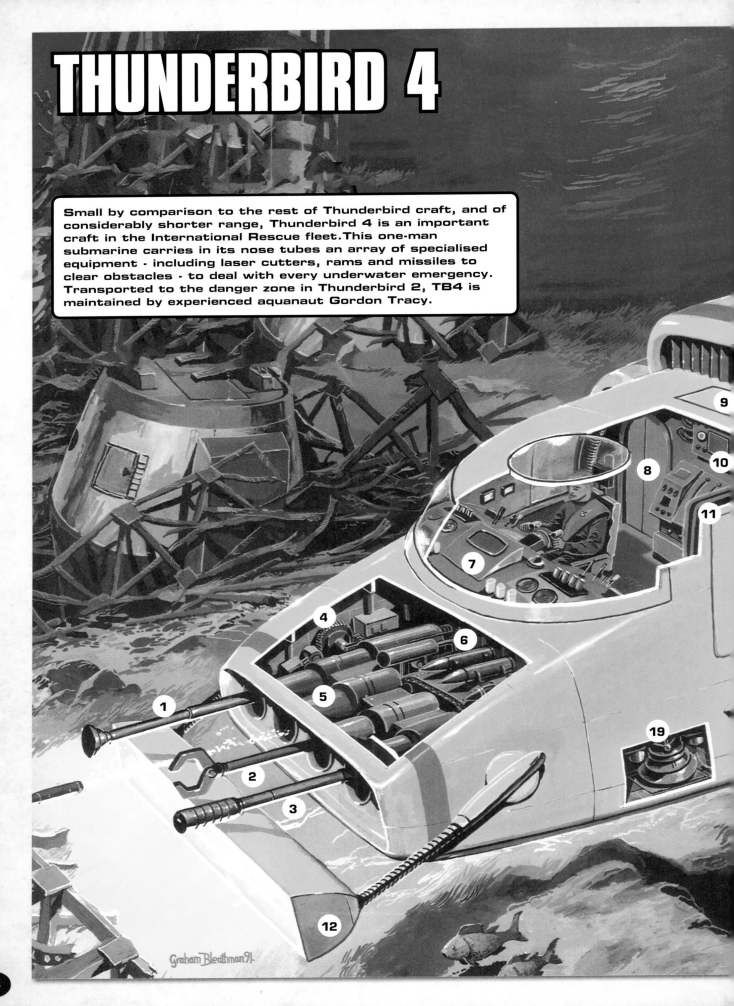

Small by comparison to the rest of Thunderbird craft, and of considerably shorter range, Thunderbird 4 is an important craft in the International Rescue fleet. This one-man submarine carries in its nose tubes an array of specialised equipment - including laser cutters, rams and missiles to clear obstacles - to deal with every underwater emergency. Transported to the danger zone in Thunderbird 2, TB4 is maintained by experienced aquanaut Gordon Tracy.

Graham Bleathman 91

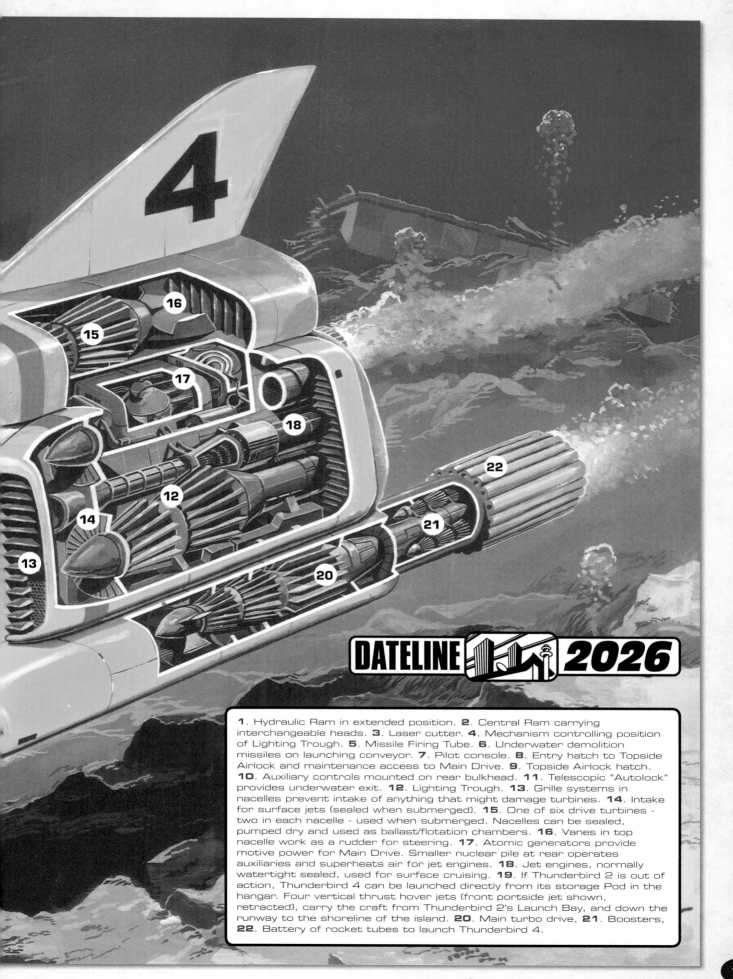

DATELINE 2026

1. Hydraulic Ram in extended position. 2. Central Ram carrying interchangeable heads. 3. Laser cutter. 4. Mechanism controlling position of Lighting Trough. 5. Missile Firing Tube. 6. Underwater demolition missiles on launching conveyor. 7. Pilot console. 8. Entry hatch to Topside Airlock and maintenance access to Main Drive. 9. Topside Airlock hatch. 10. Auxiliary controls mounted on rear bulkhead. 11. Telescopic "Autolock" provides underwater exit. 12. Lighting Trough. 13. Grille systems in nacelles prevent intake of anything that might damage turbines. 14. Intake for surface jets (sealed when submerged). 15. One of six drive turbines - two in each nacelle - used when submerged. Nacelles can be sealed, pumped dry and used as ballast/flotation chambers. 16. Vanes in top nacelle work as a rudder for steering. 17. Atomic generators provide motive power for Main Drive. Smaller nuclear pile at rear operates auxiliaries and superheats air for jet engines. 18. Jet engines, normally watertight sealed, used for surface cruising. 19. If Thunderbird 2 is out of action, Thunderbird 4 can be launched directly from its storage Pod in the hangar. Four vertical thrust hover jets (front portside jet shown, retracted), carry the craft from Thunderbird 2's Launch Bay, and down the runway to the shoreline of the island. 20. Main turbo drive, 21. Boosters, 22. Battery of rocket tubes to launch Thunderbird 4.

THUNDERBIRD 5

8

In a secret orbit around the Earth hangs Thunderbird 5, vital communications satellite for International Rescue. TB5 is constantly manned by either John or Alan Tracy, and monitors communications worldwide to give instant warning of potentially dangerous events.

I-R's "ear in space" also picks up radio transmissions on all wavebands and frequencies selecting special reference to rescue and emergency situations. Supplies for the satellite are provided by Thunderbird 3 which docks with TB5 at regular intervals to facilitate maintenance and shift changeovers.

10

1

3

5

6

7

4

2

Graham Bleathman 91.

DATELINE 2026

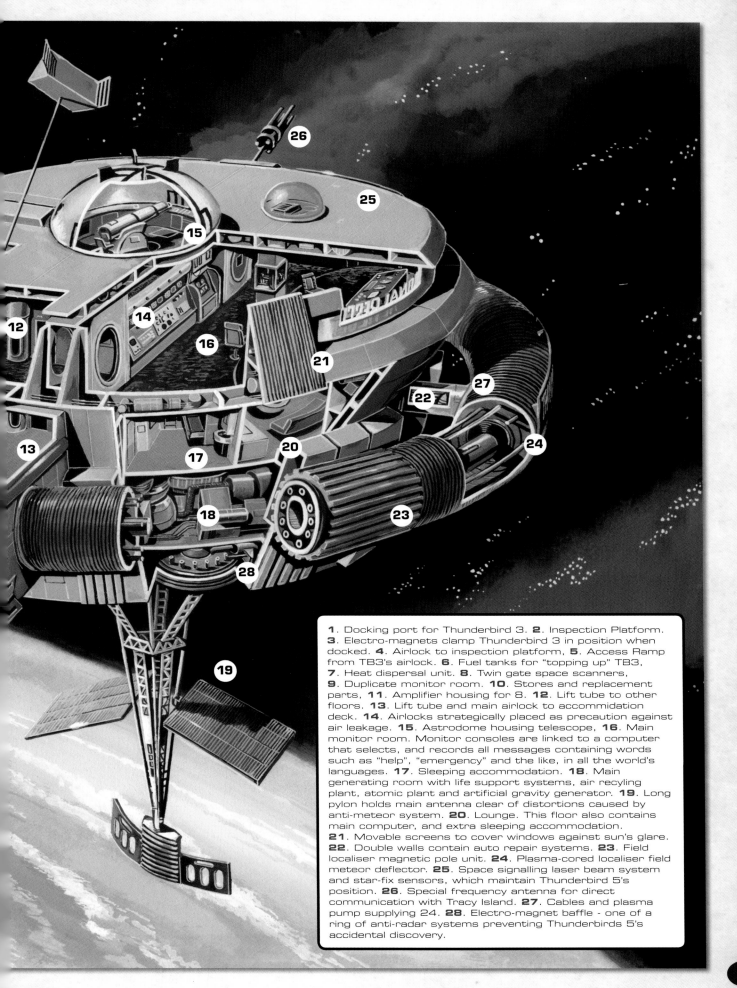

1. Docking port for Thunderbird 3. **2**. Inspection Platform. **3**. Electro-magnets clamp Thunderbird 3 in position when docked. **4**. Airlock to inspection platform, **5**. Access Ramp from TB3's airlock. **6**. Fuel tanks for "topping up" TB3, **7**. Heat dispersal unit. **8**. Twin gate space scanners, **9**. Duplicate monitor room. **10**. Stores and replacement parts, **11**. Amplifier housing for 8. **12**. Lift tube to other floors. **13**. Lift tube and main airlock to accommodation deck. **14**. Airlocks strategically placed as precaution against air leakage. **15**. Astrodome housing telescope, **16**. Main monitor room. Monitor consoles are linked to a computer that selects, and records all messages containing words such as "help", "emergency" and the like, in all the world's languages. **17**. Sleeping accommodation. **18**. Main generating room with life support systems, air recyling plant, atomic plant and artificial gravity generator. **19**. Long pylon holds main antenna clear of distortions caused by anti-meteor system. **20**. Lounge. This floor also contains main computer, and extra sleeping accommodation.
21. Movable screens to cover windows against sun's glare. **22**. Double walls contain auto repair systems. **23**. Field localiser magnetic pole unit. **24**. Plasma-cored localiser field meteor deflector. **25**. Space signalling laser beam system and star-fix sensors, which maintain Thunderbird 5's position. **26**. Special frequency antenna for direct communication with Tracy Island. **27**. Cables and plasma pump supplying 24. **28**. Electro-magnet baffle - one of a ring of anti-radar systems preventing Thunderbirds 5's accidental discovery.

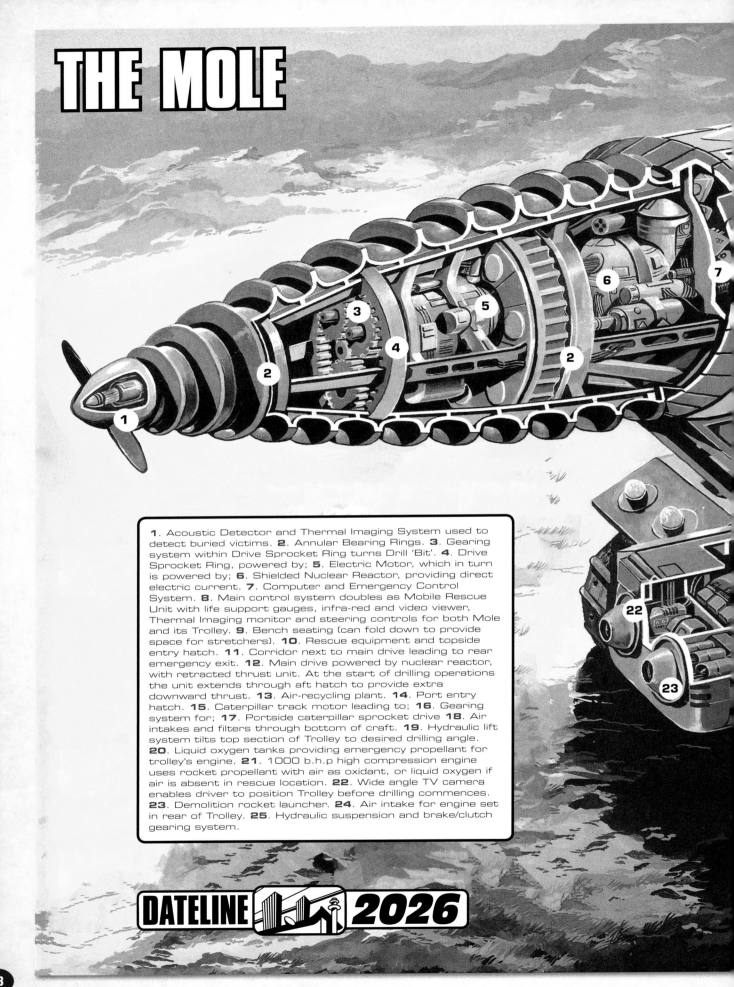

THE MOLE

1. Acoustic Detector and Thermal Imaging System used to detect buried victims. 2. Annular Bearing Rings. 3. Gearing system within Drive Sprocket Ring turns Drill 'Bit'. 4. Drive Sprocket Ring, powered by; 5. Electric Motor, which in turn is powered by; 6. Shielded Nuclear Reactor, providing direct electric current. 7. Computer and Emergency Control System. 8. Main control system doubles as Mobile Rescue Unit with life support gauges, infra-red and video viewer, Thermal Imaging monitor and steering controls for both Mole and its Trolley. 9. Bench seating (can fold down to provide space for stretchers). 10. Rescue equipment and topside entry hatch. 11. Corridor next to main drive leading to rear emergency exit. 12. Main drive powered by nuclear reactor, with retracted thrust unit. At the start of drilling operations the unit extends through aft hatch to provide extra downward thrust. 13. Air-recycling plant. 14. Port entry hatch. 15. Caterpillar track motor leading to; 16. Gearing system for; 17. Portside caterpillar sprocket drive 18. Air intakes and filters through bottom of craft. 19. Hydraulic lift system tilts top section of Trolley to desired drilling angle. 20. Liquid oxygen tanks providing emergency propellant for trolley's engine. 21. 1000 b.h.p high compression engine uses rocket propellant with air as oxidant, or liquid oxygen if air is absent in rescue location. 22. Wide angle TV camera enables driver to position Trolley before drilling commences. 23. Demolition rocket launcher. 24. Air intake for engine set in rear of Trolley. 25. Hydraulic suspension and brake/clutch gearing system.

DATELINE 2026

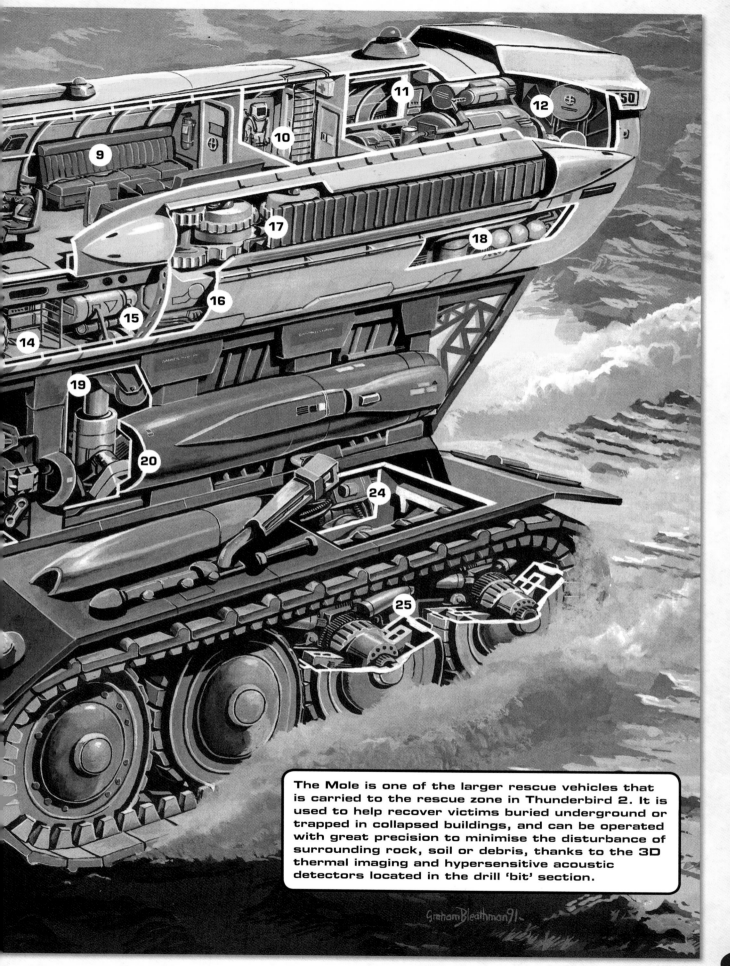

The Mole is one of the larger rescue vehicles that is carried to the rescue zone in Thunderbird 2. It is used to help recover victims buried underground or trapped in collapsed buildings, and can be operated with great precision to minimise the disturbance of surrounding rock, soil or debris, thanks to the 3D thermal imaging and hypersensitive acoustic detectors located in the drill 'bit' section.

Graham Bleathman 91

THE FIREFLY

Brains has designed many firefighting machines for International Rescue. The most successful is the Firefly, which uses Cahelium Extract X in its construction, one of the toughest metals known. The Firefly can travel to the heart of a blaze and snuff out a fire at its source. This is achieved by firing Nitro-glycerine shells through the forward gun mounted behind the Protective Shield.

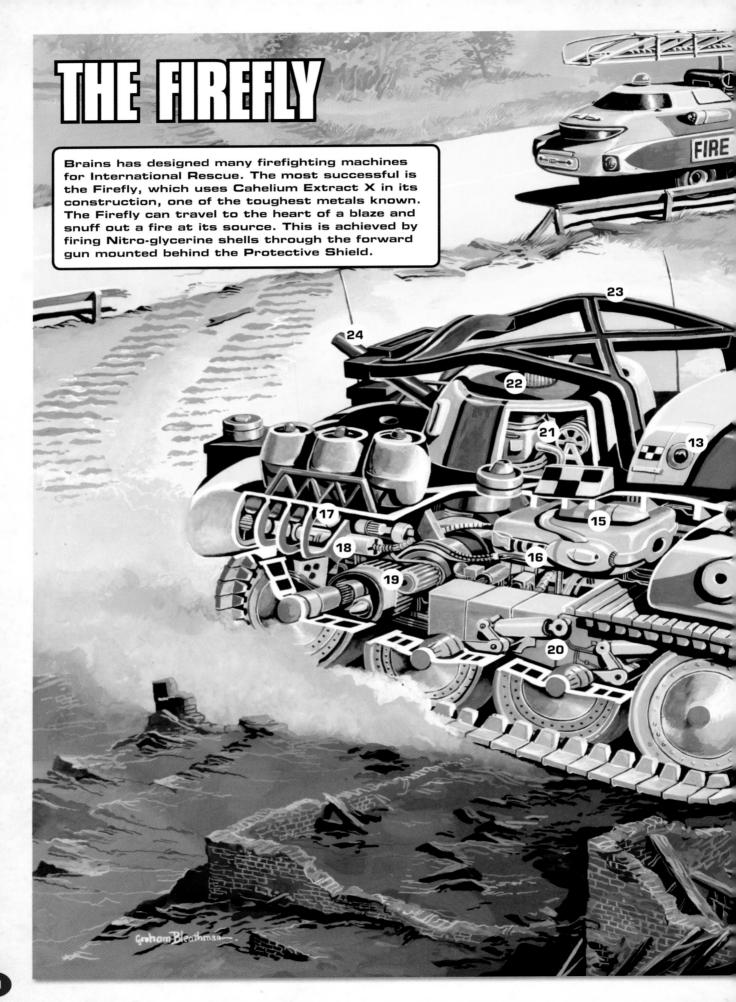

Graham Bleathman

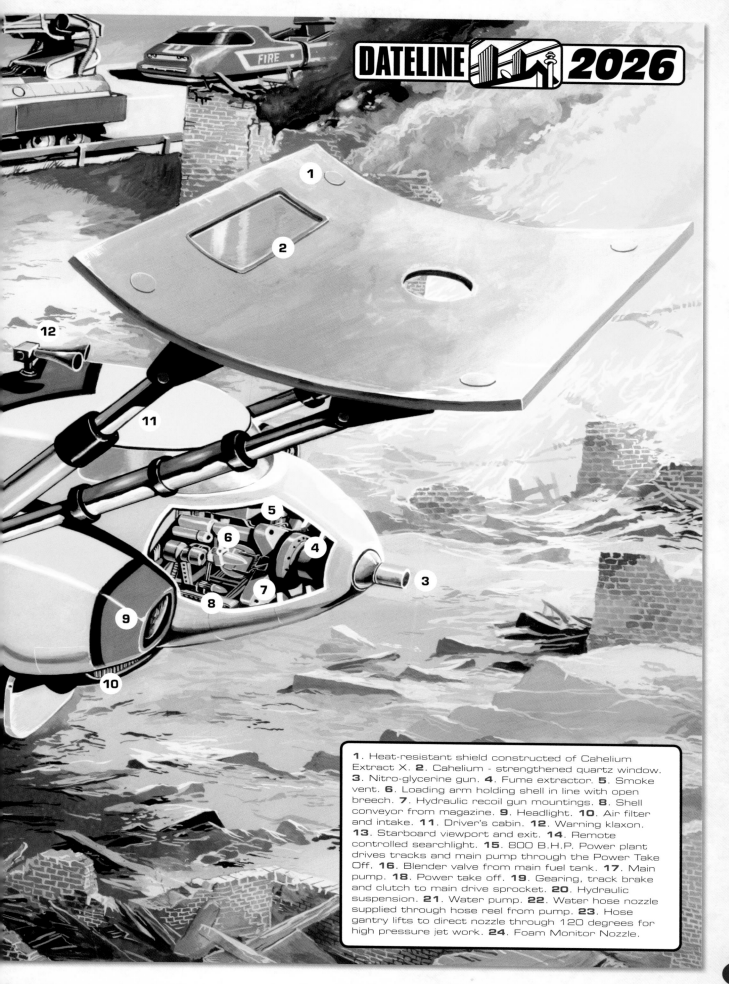

1. Heat-resistant shield constructed of Cahelium Extract X. **2**. Cahelium - strengthened quartz window. **3**. Nitro-glycerine gun. **4**. Fume extractor. **5**. Smoke vent. **6**. Loading arm holding shell in line with open breech. **7**. Hydraulic recoil gun mountings. **8**. Shell conveyor from magazine. **9**. Headlight. **10**. Air filter and intake. **11**. Driver's cabin. **12**. Warning klaxon. **13**. Starboard viewport and exit. **14**. Remote controlled searchlight. **15**. 800 B.H.P. Power plant drives tracks and main pump through the Power Take Off. **16**. Blender valve from main fuel tank. **17**. Main pump. **18**. Power take off. **19**. Gearing, track brake and clutch to main drive sprocket. **20**. Hydraulic suspension. **21**. Water pump. **22**. Water hose nozzle supplied through hose reel from pump. **23**. Hose gantry lifts to direct nozzle through 120 degrees for high pressure jet work. **24**. Foam Monitor Nozzle.

INSIDE THE
CREIGHTON-WARD
STATELY HOME

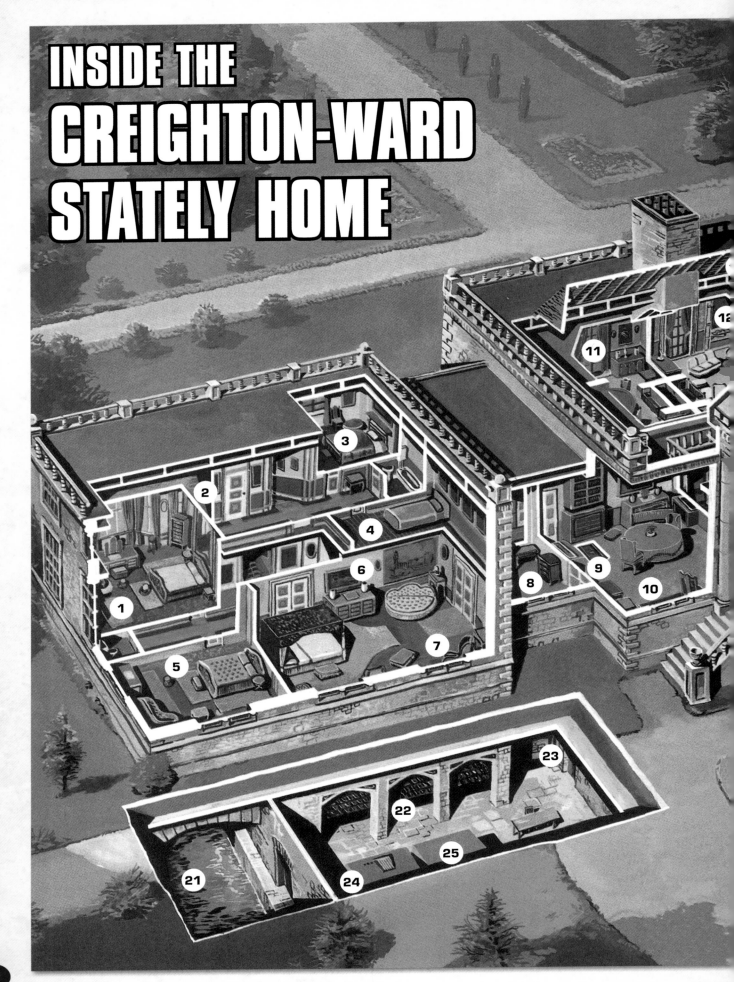

DATELINE 2026

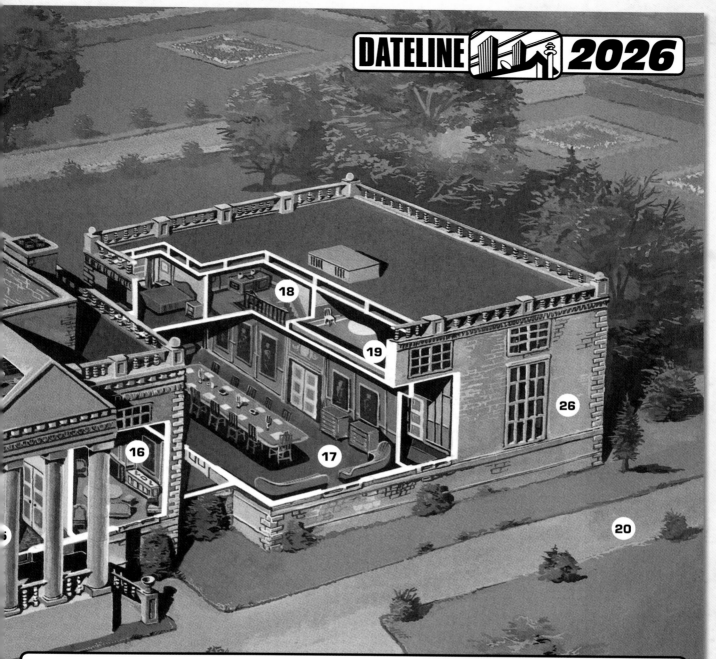

Built in the mid-eighteenth century, the Creighton-Ward Mansion stands on the site of a Norman castle in rural Kent. Designated by World Heritage as a grade one listed building, Creighton-Ward Mansion has nonetheless been extensively, yet subtly modernised to include infra-red burglar alarms, inter-room video communications, and a forensics laboratory has been built in what were the servants' basement quarters "below stairs". Running costs are kept to a minimum: only Parker and Lil the cook live permanently on site with her ladyship.

1. Master bedroom. 2. First floor guest rooms. 3. Parker's bedroom. 4. Guest bedroom. 5. King Charles bedchamber. 6. LCD flatscreen two-way TV monitor: all rooms are linked via disguised video screens behind paintings. Hidden anti-intruder cameras linked to the infra-red burglar alarm system also transmit pictures to any designated monitor. 7. Lady Penelope's bedroom. 8. Anteroom to library. 9. Under-floor safe hidden under carpet, designed by Parker and Brains. 10. Library. 11. Games room. 12. The grand drawing room. 13. Attic containing emergency power system. 14. Satellite communications system links mansion video monitor system with Thunderbird 5. Audio messages to hidden radio receivers (such as her ladyship's teapot) are also boosted through here, along with TV transmissions from around the world. 15. Hall and entrance behind portico, containing staircase to first floor bedrooms. 16. Reception hall. 17. Banqueting hall. 18. Stairs to first floor rooms. Below these are stairs to the basement and old servants' quarters, including Lil's kitchen.
19. Recreation room, including art studio, book and video library. 20. Driveway leading to FAB 1's garage and visitors' centre for tourists, both adjacent to the east wing. 21. Underground stream and path leads from ornamental lake via basement to sluice gates at the river in Creighton Village. 22. Wine cellar. 23. Access to servants' quarters (now a forensic laboratory), heating and self-contained power system, and Lil's kitchen beyond. 24. Computer. 25. Weapons store. 26. Ballroom.

THE SECRETS OF FAB 1

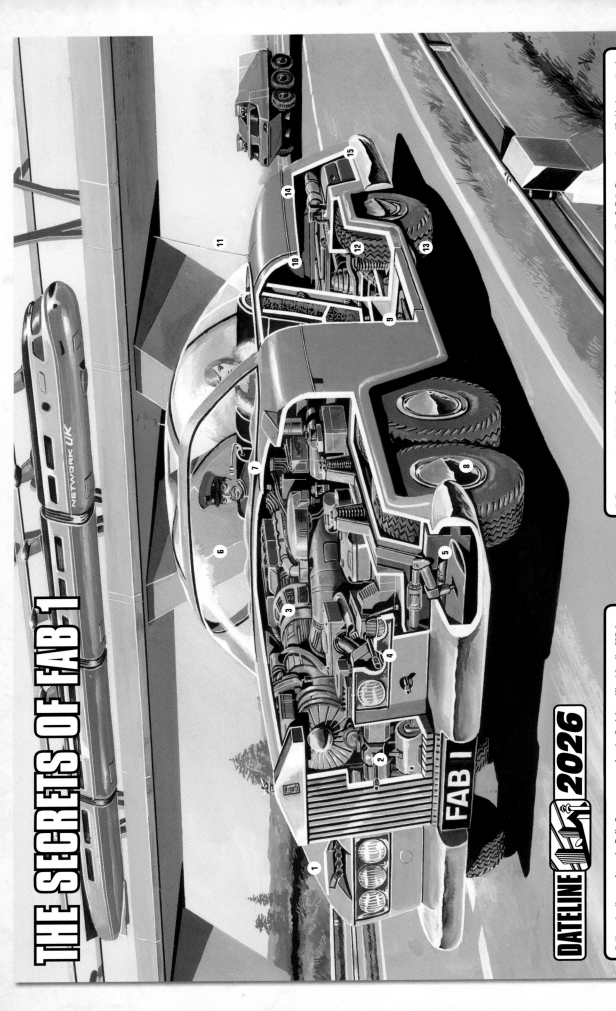

DATELINE 2026

Built under licence from the Rolls-Royce company for the Creighton-Ward family, FAB 1 underwent several modifications when Lady Penelope took possession. These included the incorporation of hydrofoils for travel on water, machine and laser guns, and engine improvements giving a top speed well in excess of 200 mph. Alterations also carried out by International Rescue include a satellite communications system which allows her ladyship to contact Tracy Island via Thunderbird 5 space station at all times.

1. Emergency retro air brakes. 2. Primary forward machine gun operated through grille. 3. Rolls Royce engine modified by International Rescue. 4. Secondary machine guns and laser cannons. 5. Adjustable forward hydrofoils extend below wheel level lifting car clear of water. 6. Laminated bullet-proof glass/steel canopy incorporates gull wing split doors. 7. Central driving position includes communications console and controls for machine, laser and harpoon guns. 8. All six wheels incorporate retractable tyre-slashers and studs for snow conditions. 9. Underfloor space for down-and-under doors. 10. Boot space, above hydraulic platform with fold-down safety rails. 11. Satellite, UHF TV and neutronic radio antenna. 12. Rear machine gun and harpoon system. 13. Rear hydrofoil incorporates a vortex aquajet power unit for water propulsion. 14. Smoke and oil dispenser used if FAB 1 is pursued. 15. Fuel tanks.

FAB 2

FAB 2 is one of several ocean-going pleasure cruisers owned by Lady Penelope. Docked at a secret location on England's south coast, the ship was specially built for her ladyship by International Engineering, a company owned by Jeff Tracy. FAB 2 is capable of attaining a top speed of 100 knots, and can stay at sea without maintenance for three years. It can be operated by one person, or completely automatically using a computerised Auto-bosun.

DATELINE 2026

1. Satellite communications room, linking FAB 2 with International Rescue, the Creighton-Ward mansion and monitoring World TV and radio broadcasts. 2. One of five lifeboats. A guest bedroom is located behind the two aft port and starboard lifeboats. 3. Starboard air vent for upper decks. 4. Radar system. 5. Captain's cabin and ship's main computer. 6. Searchlight. 7. Control room, featuring Automatic Bosun. 8. Foghorn. 9. Forward lounge. 10. Lady Penelope's suite. 11. Bathroom. 12. Dining area. 13. Bomb-proof garage containing FAB1, with exit hatches on both sides of the ship. 14. Workshop, with access to garage. 15. Toilets. 16. Parker's bedroom (Lil's bedroom is on the portside, on the other side of the ship's central corridor). 17. Crews' quarters: although the ship can be operated by one person, on-board social functions often require the hire of extra staff. A wardrobe is located opposite the crews' quarters on the portside of the ship. 18. Galley, with access to the central corridor linking all rooms on this deck. 19. Food hatch for dining area above. 20. Lift to dining room. 21. Starboard winch system leading to main anchor winch located immediately below the forward sun deck. 22. One of several air vents. 23. Laundry room. 24. Stair access to sun deck. 25. Water filtration, purification and sanitation plant. 26. Starboard aquajet. 27. Main turbine. 28. Atomic plant supplying power to turbine and aquajets. 29. Maintenance access to engine room. 30. Engine monitoring room. 31. Armament store and torpedo loading system. 32. Starboard torpedo tubes. 33. Sonar system. 34. Waste filter from sanitation plant.

25

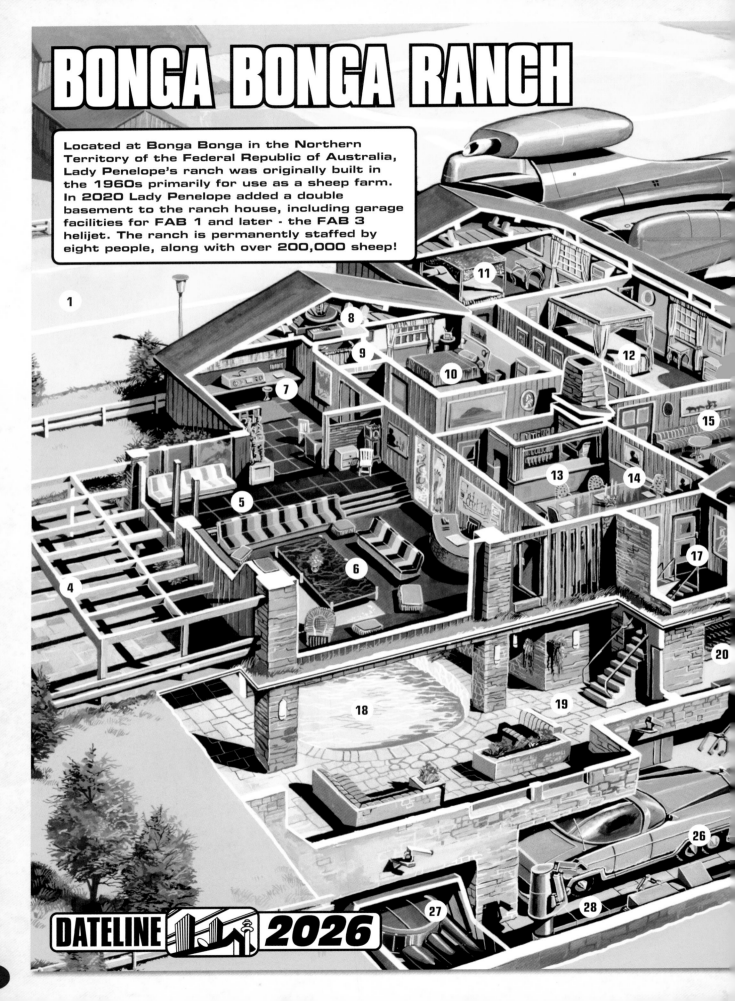

BONGA BONGA RANCH

Located at Bonga Bonga in the Northern Territory of the Federal Republic of Australia, Lady Penelope's ranch was originally built in the 1960s primarily for use as a sheep farm. In 2020 Lady Penelope added a double basement to the ranch house, including garage facilities for FAB 1 and later - the FAB 3 helijet. The ranch is permanently staffed by eight people, along with over 200,000 sheep!

DATELINE 2026

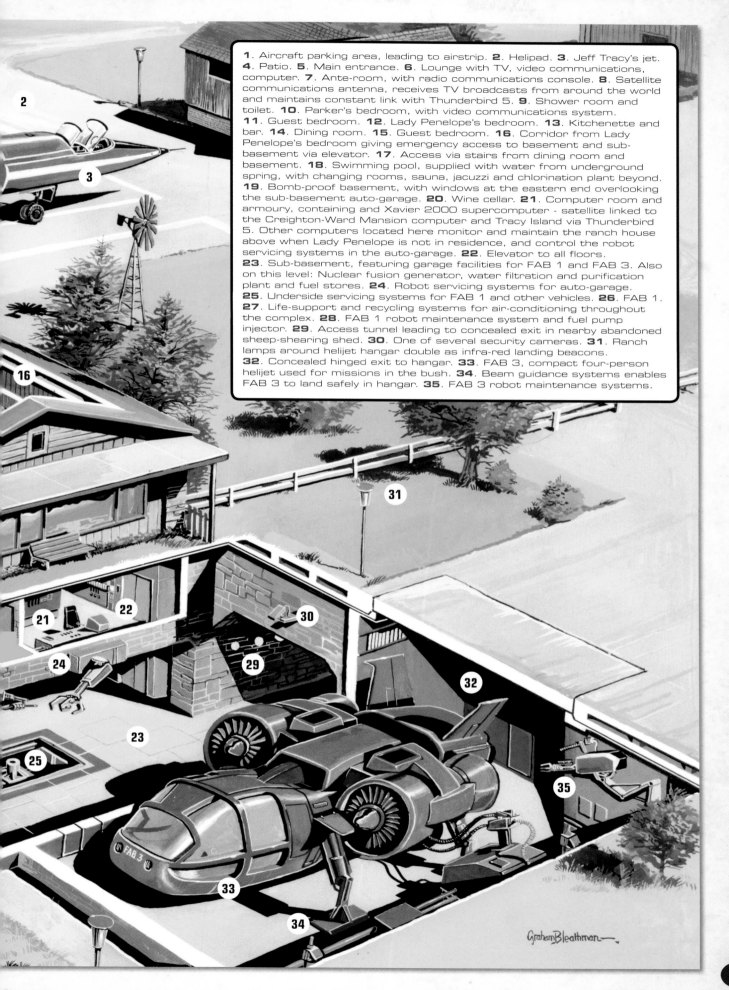

1. Aircraft parking area, leading to airstrip. 2. Helipad. 3. Jeff Tracy's jet. 4. Patio. 5. Main entrance. 6. Lounge with TV, video communications, computer. 7. Ante-room, with radio communications console. 8. Satellite communications antenna, receives TV broadcasts from around the world and maintains constant link with Thunderbird 5. 9. Shower room and toilet. 10. Parker's bedroom, with video communications system. 11. Guest bedroom. 12. Lady Penelope's bedroom. 13. Kitchenette and bar. 14. Dining room. 15. Guest bedroom. 16. Corridor from Lady Penelope's bedroom giving emergency access to basement and sub-basement via elevator. 17. Access via stairs from dining room and basement. 18. Swimming pool, supplied with water from underground spring, with changing rooms, sauna, jacuzzi and chlorination plant beyond. 19. Bomb-proof basement, with windows at the eastern end overlooking the sub-basement auto-garage. 20. Wine cellar. 21. Computer room and armoury, containing and Xavier 2000 supercomputer - satellite linked to the Creighton-Ward Mansion computer and Tracy Island via Thunderbird 5. Other computers located here monitor and maintain the ranch house above when Lady Penelope is not in residence, and control the robot servicing systems in the auto-garage. 22. Elevator to all floors. 23. Sub-basement, featuring garage facilities for FAB 1 and FAB 3. Also on this level: Nuclear fusion generator, water filtration and purification plant and fuel stores. 24. Robot servicing systems for auto-garage. 25. Underside servicing systems for FAB 1 and other vehicles. 26. FAB 1. 27. Life-support and recycling systems for air-conditioning throughout the complex. 28. FAB 1 robot maintenance system and fuel pump injector. 29. Access tunnel leading to concealed exit in nearby abandoned sheep-shearing shed. 30. One of several security cameras. 31. Ranch lamps around helijet hangar double as infra-red landing beacons. 32. Concealed hinged exit to hangar. 33. FAB 3, compact four-person helijet used for missions in the bush. 34. Beam guidance systems enables FAB 3 to land safely in hangar. 35. FAB 3 robot maintenance systems.

Graham Bleathman

MATEO ISLAND

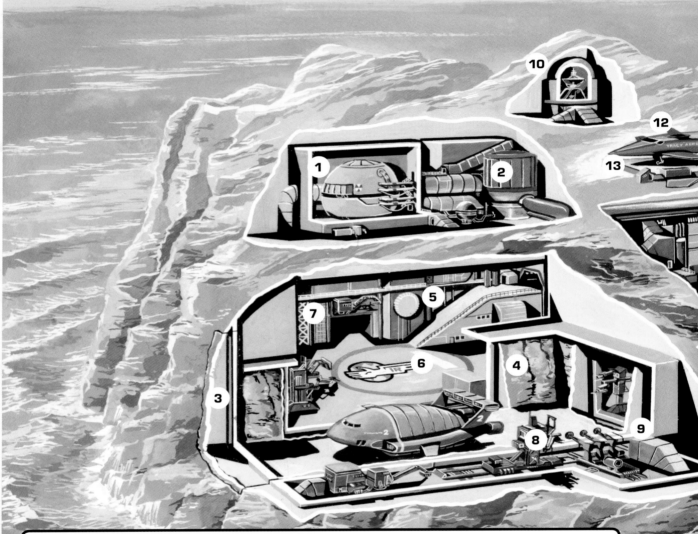

1. Atomic fusion reactor, encased within cahelium-graphite silo. 2. Water, purification and sanitation system. 3. Disguised cliff door, slides down to reveal entrance to main hangar. 4. Main hangar, disguised as the interior of a cavern, with room for Thunderbirds 1 and 2 to land for servicing if required. 5. Ramp leading to Topside Fuel Terminal and landing tower. 6. Aircraft turning area, accessed from disguised door in main hangar. 7. Access to further storage facilities and disguised emergency exit. 8. Auto repair systems, normally concealed behind interior rock face doors of main hangar. 9. Access passage to fuel storage bays and Thunderbird 4 docking bay at water level. 10. Satellite communication system, continually monitoring the island's status through its central computer to Tracy Island via Thunderbird 5. 11. Emergency docking bay for Thunderbird 3, with concealed exit doors disguised as topside rock formations. 12. VTOL fuel tanker owned by Tracy Aerospace, docked on Topside Landing Tower. 13. Beam guidance beacon ensures safe take off and landing of fuel tankers to and from the Landing Tower. 14. Blast shield for horizontal take off if required. 15. Telescopic support column of Landing Tower, incorporating fuel lines leading to main pumps. 16. Topside Fuel Terminal, accessed via disguised roof doors through which Landing Tower projects. 17. Part of the raised disguised roof doors of the Topside Fuel Terminal. 18. Topside Terminal pumps. 19. Central computer monitors and regulates fuel flow from Topside and Cliffside Fuel Terminals, and maintains Mateo Island's life support and technical systems. 20. Main fuel pump serving Cliff Fuel Terminal. 21. Cahelium-strengthened fuel tanks, encased within blast shield. 22. Water inlet valves: in case of fire, air can be pumped out of the fuel storage silo or alternatively, the area can be flooded within 120 seconds. 23. Forward electro-magnetic clamp anchors fuel tanker to Cliffside Fuel Terminal, ensuring no movement of the ship during loading operations. Each clamp also incorporates navigation fuel lights and beam guidance system ensuring safe docking in most weather conditions. 24. Automated Fuel Retrieval System, can be operated by the crew of the tanker without the need of the Tracy Family to be present during fuel collection operations. 25. Ocean Pioneer VIII, part of a successful shipping line bought recently by one of Jeff Tracy's companies. 26. Emergency Docking Bay for Thunderbird 4.

INTERNATIONAL RESCUE'S SUPPLY AND REPAIR BASE

Mateo Island is one of a cluster of atolls and islands in the Pacific Ocean owned by multi-millionaire Jeff Tracy. Situated approximately 60 miles south west of Tracy Island, Mateo conceals a series of workshops and hangars plus a massive fuel store, all of which were built with the aid of the Mole during the early trials before International Rescue was inaugurated.

DATELINE 2026

THE HOOD'S TEMPLE

In every nation, across every ocean, the Hood is known as World Enemy No. 1. The whereabouts of his base was unknown until its recent discovery by operatives of the Universal Secret Service and World Police. The Temple, located deep in Malaysian jungle is believed to be several hundred years old, though it is evident that the Hood has had part of it extended to include a control centre and living accommodation, whilst below ground vast laboratories and hangars have been built to accommodate the Hood's vast array of vehicles. It is believed that these were constructed by a variety of companies owned or run by some of the many criminal organisations under the Hood's control.

DATELINE 2026

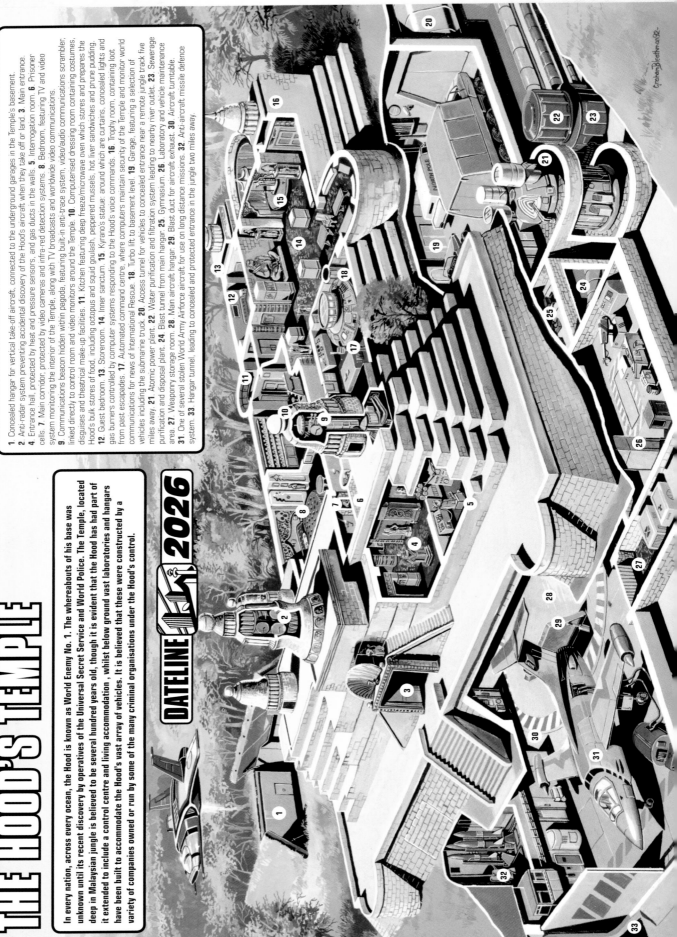

1. Concealed hangar for vertical take-off aircraft, connected to the underground garages in the Temple's basement.
2. Anti-radar system preventing accidental discovery of the Hood's aircraft when they take off or land. 3. Main entrance.
4. Entrance hall, protected by heat and pressure sensors, and gas ducts in the walls. 5. Interrogation room 6. Prisoner cells. 7. Main corridor, protected by video cameras and infra-red detection systems. 8. Bedroom, featuring TV and video system monitoring the interior of the Temple, along with TV broadcasts and worldwide video communications.
9. Communications beacon hidden within pagoda, featuring built-in anti-trace system, video/audio communications scrambler; linked directly to control room and video monitors around the Temple. 10. Computerised dressing room containing costumes, disguises and theatrical make-up facilities. 11. Kitchen featuring deep freeze/microwave oven which stores and prepares the Hood's bulk stores of food, including octopus and squid goulash, peppered mussels, hot liver sandwiches and prune pudding.
12. Guest bedroom. 13. Storeroom. 14. Inner sanctum. 15. Kyrano's statue: around which are curtains, concealed lights and gas burners controlled by computer systems responding to the Hood's voice commands. 16. Trophy room, containing loot from past escapades. 17. Automated command centre, where computers maintain security of the Temple and monitor world communications for news of International Rescue. 18. Turbo lift to basement level. 19. Garage, featuring a selection of vehicles including the submarine truck. 20. Access tunnel for vehicles to concealed entrance near a remote jungle track five miles away. 21. Atomic power plant. 22. Water purification and filtration system leading to nearby river outlet. 23. Sewerage purification and disposal plant. 24. Blast tunnel from main hangar. 25. Gymnasium. 26. Laboratory and vehicle maintenance area. 27. Weaponry storage room. 28. Main aircraft hangar. 29. Blast duct for aircraft exhaust. 30. Aircraft turntable.
31. One of several stolen World Army Airforce aircraft for use on long distance missions. 32. Anti-aircraft missile defence system. 33. Hangar tunnel, leading to concealed and protected entrance in the jungle two miles away.

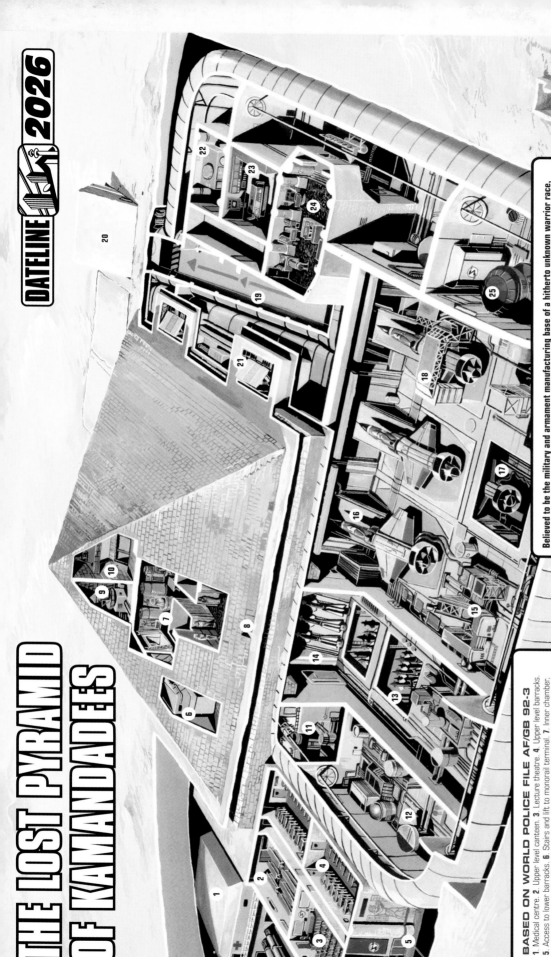

DATELINE 2026

THE LOST PYRAMID OF KAMANDADEES

BASED ON WORLD POLICE FILE AF/GB 92-3

1. Medical centre. **2.** Upper level canteen. **3.** Lecture theatre. **4.** Upper level barracks. **5.** Access to lower barracks. **6.** Stairs and lift to monorail terminal. **7.** Inner chamber, featuring water fountain, fake treasure, guarded and monitored by hidden intruder alarms. **8.** Electronically controlled entrance. **9.** Anti-satellite detection system cloaks pyramid from high altitude or orbital photography. **10.** Outer missile launch hatch. **11.** Monorail terminal. **12.** Aircraft fuel manufacturing plant. **13.** Missile storage area. **14.** Missile launcher. **15.** Aircraft manufacturing plant. **16.** Fighter aircraft in launch position. **17.** Lower level aircraft hangar. **18.** Aircraft maintenance area. **19.** Aircraft launch tunnel. **20.** Launch tunnel concealed entrance. **21.** Anti-radar system prevents location of pyramid being revealed by returning aircraft. **22.** Main life support monitoring complex. **23.** Base monitoring room. **24.** Control room. **25.** Nuclear power plant. **26.** Water purification and filtration system leading to underground reservoirs. **27.** Air recycling and pumping station. **28.** Emergency air intake and filter hidden in nearby low-lying ruins. **29.** Bomb-proof personnel shelter. **30.** Access to concealed entrance in desert 5 miles away.

Believed to be the military and armament manufacturing base of a hitherto unknown warrior race, the lost Pyramid of Kamamdadees was discovered in 2026 and was subsequently largely destroyed in an incident involving the rescue of two archaeologists by International Rescue. This reconstruction is based on later investigations carried out by the Universal Secret Service and the World Police, based on information supplied by International Rescue's agents based in the region.

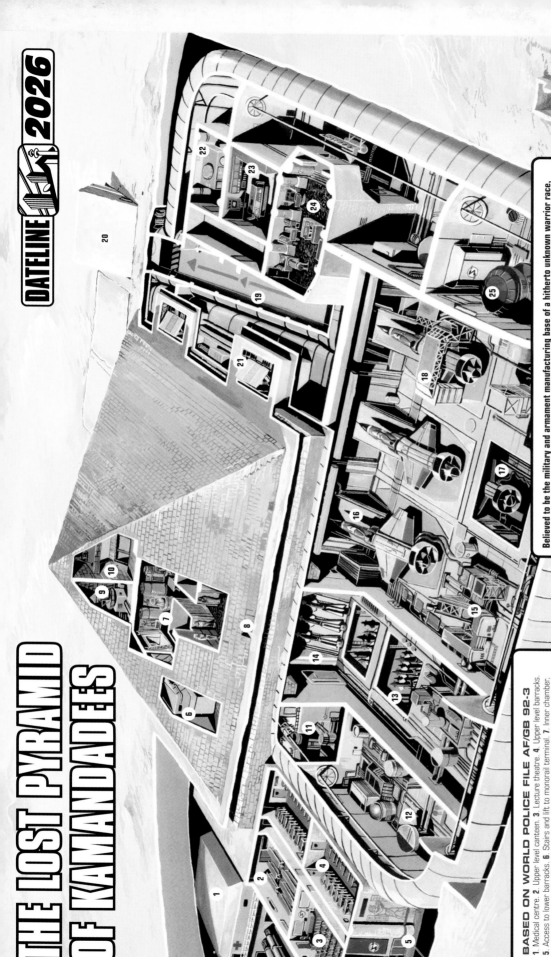

FIREBALL XL5

One of thirty XL patrol ships built at Space City between 2050 and 2062, Fireball XL5 has become the most well-known craft currently serving with World Space Patrol. Like its sister ships, Fireball XL5 incorporates the latest in space drive technology, including the Nutomic Hyperdrive System. In gradual development since 2003, various upgrades of the Hyperdrive have found their way into many spacecraft. Thanks to the pioneering research of Professor Matthew Matic, the system was gradually improved and installed in the present XL fleet, including Fireball XL5 in 2057.

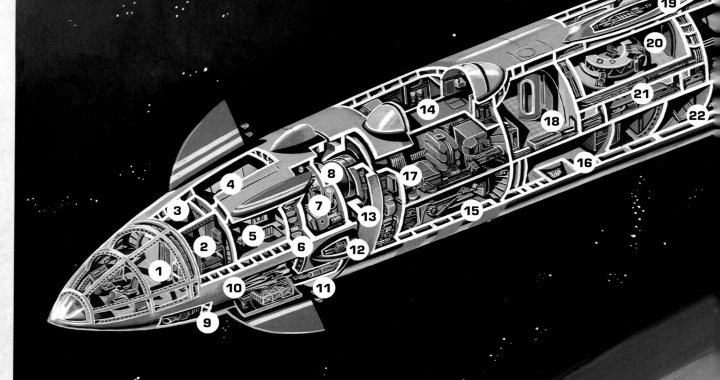

DATELINE 2067

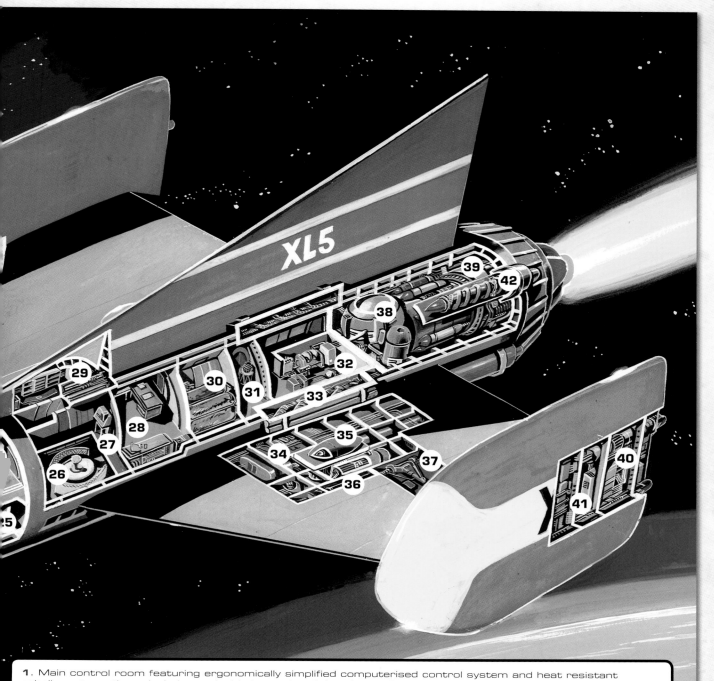

1. Main control room featuring ergonomically simplified computerised control system and heat resistant cahelium-strengthened windows, double layered and tinted to reduce solar glare. **2**. Port rest room. Starboard side features personal hygiene station and waste disposal plant. **3**. Airlock to rest room, hygiene station, corridor and Jetmobile bay. Located above this is a small missile topside battery. **4**. Topside Jetmobile bay hatch. **5**. Service area for food preparation and first aid, accessed via corridor alongside Jetmobile bay. **6**. Oxygen storage tanks. **7**. Atomic power plant. **8**. Retractable heat-resistant airlock tunnel to central top deck in Main Body. **9**. One of four retro rockets used for planetary landings. **10**. Interceptor missile launcher. **11**. One of three landing legs. Forward landing leg is located under the nose and the other to starboard. **12**. Heat dispersal unit. **13**. Electro-magnetic docking system, built into the main body's forward bulkhead. **14**. Astrodome. **15**. Main body forward landing leg with integrated access ramp leading to adjacent cargo hold. **16**. Cargo hold. **17**. Life support and computer systems bay. **18**. Ejection room and topside loading hatch. **19**. Sensor dome, with integrated Neutroni sub space communications antennae. **20**. Navigation bay, featuring Astrascope, Spacemascope, radar telescope, language decoders and internal monitoring systems. **21**. Monitoring systems linked to Sensordome and life support bay. **22**. Space Jail high security cell. **23**. Artificial gravity, gyroscope and auxiliary life support generator. **24**. Access corridor leading to lower deck, and upper deck corridor leading to workshops and atomic bays. **25**. Bedrooms, accessed from starboard corridor on lower deck. **26**. Lounge. **27**. Auxiliary control room. **28**. Workshop. **29**. Laboratory and sick bay. **30**. Hydroponics plant, used in conjunction with life support systems to purify the air. **31**. Space gyroscope monitor. **32**. Nutomic power plant maintenance bay. **33**. Power plant heat dispersal unit. **34**. Port wing chemical fuel tank. **35**. Fuel tank injector pump. **36**. Port wing retro rocket. **37**. Port wing landing leg (retracted). **38**. Shielded Nutomic power plant. **39**. Nutomic Hyperdrive. **40**. Port twin manoeuvring chemical rockets. **41**. Computerised fuel tank pump and manoeuvring rocket control assembly. **42**. Extra booster rockets. **43**. Starboard long-range sensors, and extra chemical rocket fuel tanks.

GrahamBleathman

STINGRAY

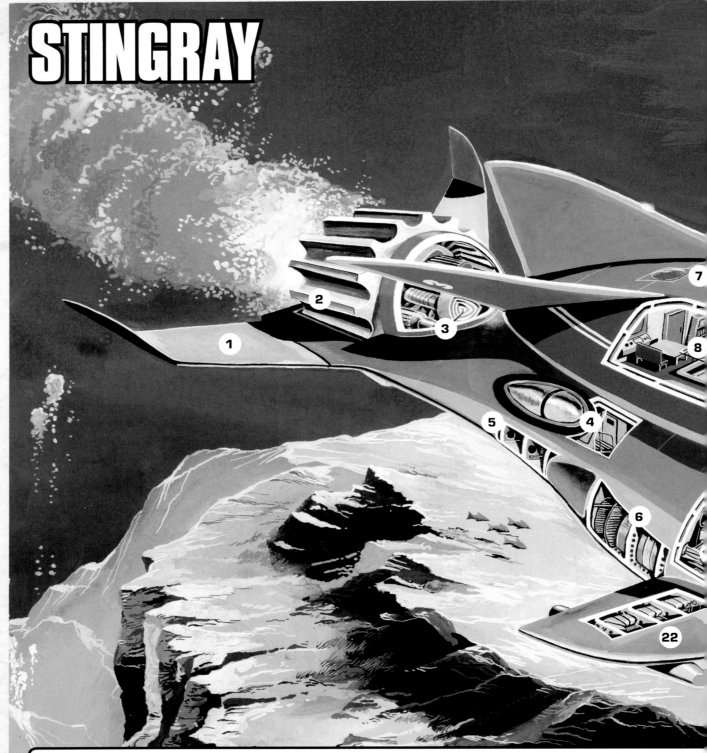

1. Starboard hydroplane. 2. Ratemaster assembly: featuring a contra-rotating anti-torque eddy damper.
3. Atomic generator, feeding twin motors driving the Drumman-WASP hydrojet. 4. Airlock access to starboard
Aquasprite, a two man mini-submarine. 5. Aft trim tanks. 6. Starboard heat dissipation unit and midships trim
tanks. 7. Topside emergency exit hatch. 8. Standby lounge with navigation computer and library. 9. Periscope,
featuring zoom lens video-scan recording system. 10. Conning tower hatch, through which Ejector Launch Tubes
from Stingray Pen passes. 11. Periscope arm swings clear when hatch is in use. 12. Lower deck wardroom, with
galley, sleeping quarters and maintenance areas to the rear (for main engine) and forward (to equipment bays and
auxiliary engine). 13. Main control cabin, with Cahelium-strengthened all-round window for maximum visibility.
14. Main computer monitors ship's life support systems, including cabin and temperature and pressurization.
15. Sting missile bay. 16. Auxiliary engine room. 17. Air compression and recycling unit. 18. Pressurised
diaphragm air-from-water extractors. 19. Electronics and general maintenance bay. 20. Monocopter exit hatch.
21. Three monocopters – each is a personal anti-gravity transport system for crew members travelling between
the surfaced Stingray and nearest shoreline. 22. Starboard stabilizing fin with integrated booster unit.
23. Starboard navigation light (retracts when missile is fired). 24. Forward trim tanks. 25. Forward sonar dome.
Electro-magnet baffle - one of a ring of anti-radar systems preventing TB's accidental discovery.

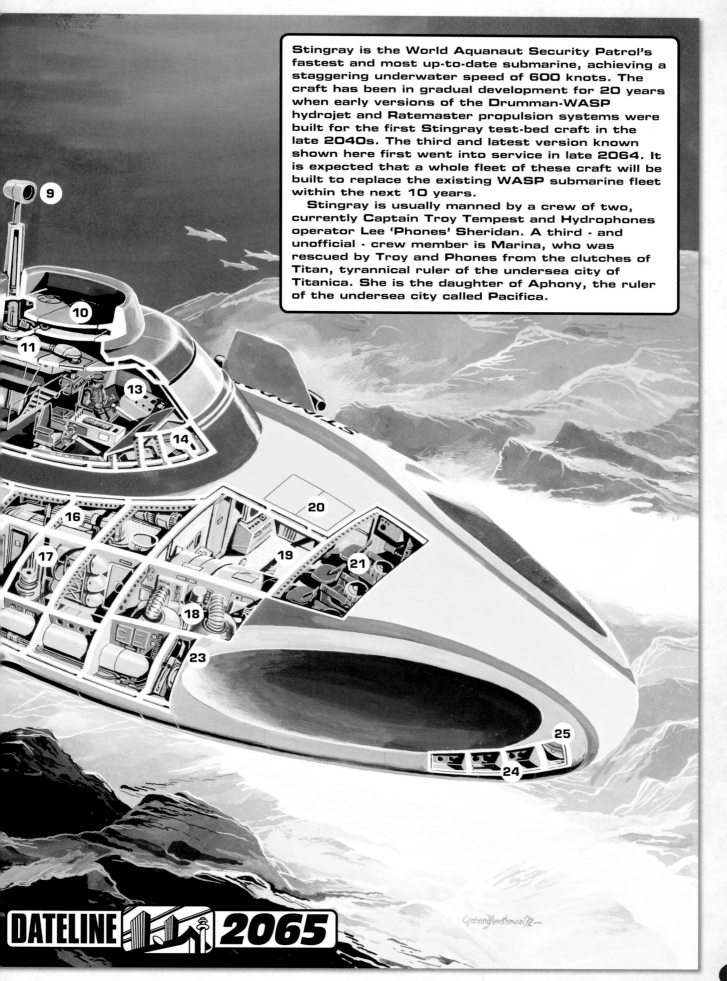

Stingray is the World Aquanaut Security Patrol's fastest and most up-to-date submarine, achieving a staggering underwater speed of 600 knots. The craft has been in gradual development for 20 years when early versions of the Drumman-WASP hydrojet and Ratemaster propulsion systems were built for the first Stingray test-bed craft in the late 2040s. The third and latest version known shown here first went into service in late 2064. It is expected that a whole fleet of these craft will be built to replace the existing WASP submarine fleet within the next 10 years.

Stingray is usually manned by a crew of two, currently Captain Troy Tempest and Hydrophones operator Lee 'Phones' Sheridan. A third - and unofficial - crew member is Marina, who was rescued by Troy and Phones from the clutches of Titan, tyrannical ruler of the undersea city of Titanica. She is the daughter of Aphony, the ruler of the undersea city called Pacifica.

DATELINE 2065

GrahamBleathman92

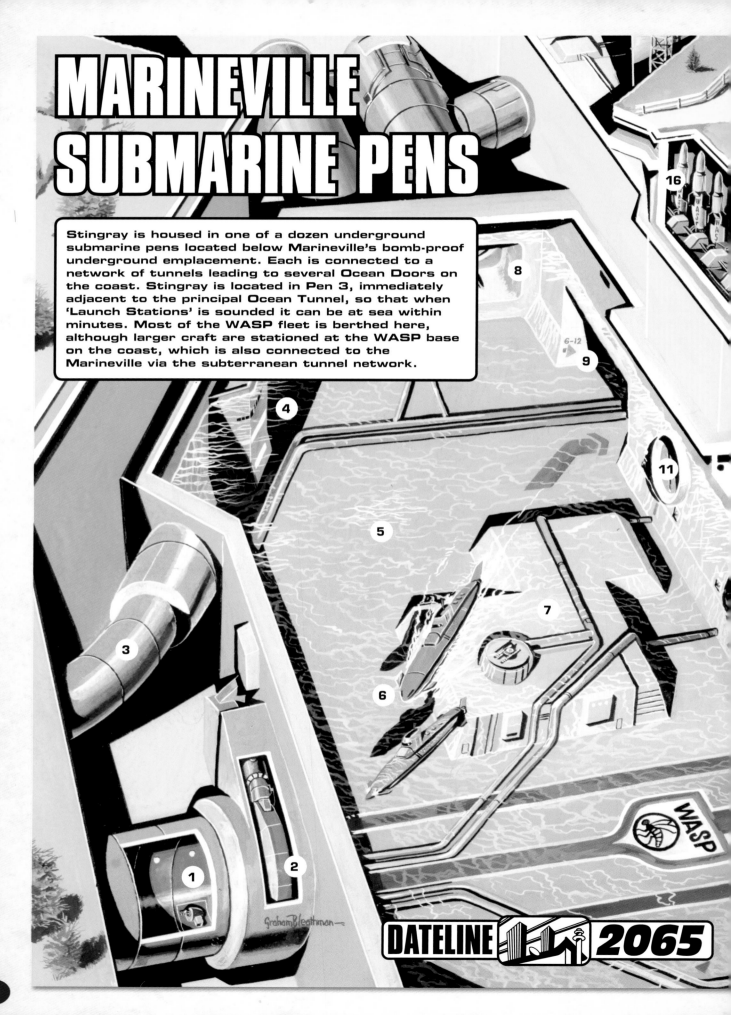

MARINEVILLE SUBMARINE PENS

Stingray is housed in one of a dozen underground submarine pens located below Marineville's bomb-proof underground emplacement. Each is connected to a network of tunnels leading to several Ocean Doors on the coast. Stingray is located in Pen 3, immediately adjacent to the principal Ocean Tunnel, so that when 'Launch Stations' is sounded it can be at sea within minutes. Most of the WASP fleet is berthed here, although larger craft are stationed at the WASP base on the coast, which is also connected to the Marineville via the subterranean tunnel network.

DATELINE 2065

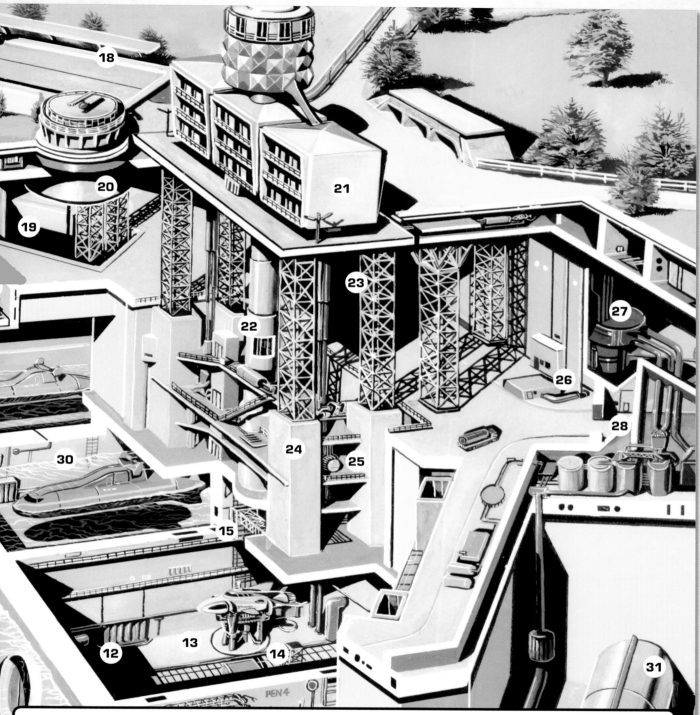

1. One of several tunnels connecting the pens to the Ocean Doors, each incorporating laser defence systems. 2. Cahelium reinforced Steelite inner door. 3. Emergency Escape Tunnel. 4. Observation Point and Harbour Master's office. 5. Underground harbour, giving access to all pens from principal launch tunnel. 6. WASP submarines preparing to leave harbour. 7. Underground harbour computer controlled auto-guidance, signalling and defence system controls traffic in the tunnel system to avoid submarine collisions. 8. Access to secondary ocean door tunnels. 9. Access to Pens 6 to 12. 10. Auto navigation beacons guide submarines into Pens. 11. Cahelium-reinforced Steelite Pen doors. 12. Drainage system in some Pens allows water to be pumped out for submarine maintenance. 13. Stingray Pen, with water pumped out. 14. Hydraulic clamp raises Stingray above normal water level when on Standby. 15. Stingray maintenance gantry. 16. Hydromic missiles storage bay. 17. Missile gantries swing into upright position as missiles on integrated conveyor rise into launch position when 'Battle Stations' is sounded. 18. Living quarters blast doors. 19. Living quarters emplacement silo. 20. Marineville tracking station silo built into roof of underground emplacement. 21. Control Tower Building. 22. Central telescopic support with integrated Injector Tubes connecting Control Tower to Stingray Pens. 23. Control Tower support gantries. 24. Support gantry silo ensures smooth hydraulically controlled movement of surface buildings during 'Battle Stations' procedure. 25. Control Tower emplacement silo incorporating multi-floored maintenance and life support systems. 26. Emplacement site office. 27. Water filtration, sanitation and purification plant. 28. Access tunnel to hospital. 29 and 30. Pens 1 and 2. Pens 4 and 5 are located on the other side of Pen 3. These pens can be accessed via large doors at the rear to allow bigger submarines to be maintained. 31. Emergency escape tunnel from underground emplacement.

MARINEVILLE CONTROL TOWER

Inaugurated in the early years of the 21st century, the World Aquanaut Security Patrol shared its headquarters with the World Naval Academy in San Diego until November 15, 2036 when World President Nikita Bandranaik opened Marineville.

The Control Tower is the hub of all WASP activities, and like other installations at Marineville, can descend into an underground emplacement in times of attack.

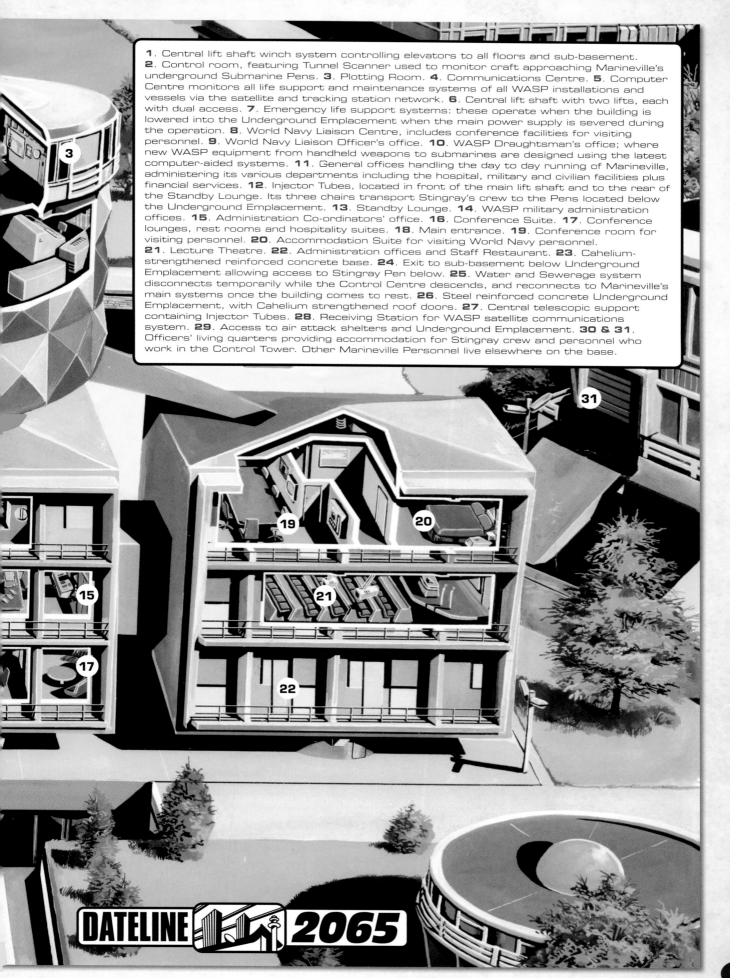

1. Central lift shaft winch system controlling elevators to all floors and sub-basement. 2. Control room, featuring Tunnel Scanner used to monitor craft approaching Marineville's underground Submarine Pens. 3. Plotting Room. 4. Communications Centre. 5. Computer Centre monitors all life support and maintenance systems of all WASP installations and vessels via the satellite and tracking station network. 6. Central lift shaft with two lifts, each with dual access. 7. Emergency life support systems: these operate when the building is lowered into the Underground Emplacement when the main power supply is severed during the operation. 8. World Navy Liaison Centre, includes conference facilities for visiting personnel. 9. World Navy Liaison Officer's office. 10. WASP Draughtsman's office; where new WASP equipment from handheld weapons to submarines are designed using the latest computer-aided systems. 11. General offices handling the day to day running of Marineville, administering its various departments including the hospital, military and civilian facilities plus financial services. 12. Injector Tubes, located in front of the main lift shaft and to the rear of the Standby Lounge. Its three chairs transport Stingray's crew to the Pens located below the Underground Emplacement. 13. Standby Lounge. 14. WASP military administration offices. 15. Administration Co-ordinators' office. 16. Conference Suite. 17. Conference lounges, rest rooms and hospitality suites. 18. Main entrance. 19. Conference room for visiting personnel. 20. Accommodation Suite for visiting World Navy personnel. 21. Lecture Theatre. 22. Administration offices and Staff Restaurant. 23. Cahelium-strengthened reinforced concrete base. 24. Exit to sub-basement below Underground Emplacement allowing access to Stingray Pen below. 25. Water and Sewerage system disconnects temporarily while the Control Centre descends, and reconnects to Marineville's main systems once the building comes to rest. 26. Steel reinforced concrete Underground Emplacement, with Cahelium strengthened roof doors. 27. Central telescopic support containing Injector Tubes. 28. Receiving Station for WASP satellite communications system. 29. Access to air attack shelters and Underground Emplacement. 30 & 31. Officers' living quarters providing accommodation for Stingray crew and personnel who work in the Control Tower. Other Marineville Personnel live elsewhere on the base.

DATELINE 2065

WASP MANUFACTURING PLANT

Located not far from Marineville on the Pacific coast, the newly constructed WASP Manufacturing Plant was specially created for the production of Stingray class submarines. Whilst much of the manufacturing process is automated, the WASPs pride themselves that many aspects of construction are carried out by hand. The entire process is carried out on one site, from design, research and development, the assembly of components and full construction, to fitting out, finishing and testing prior to full sea trials. Names selected for the first batch of completed submarines are Barracuda, Moray, Spearfish and Thornback.

1. Ratemaster assembly plant. 2 Observation and visitors' gallery, leading to security entrance at surface level. 3 Factory floor control centre and computer room: the entire production line would be controlled from here. 4 Lifts from factory floor to control room, rest rooms and gallery. 5 Laser-guided spray paint system: although newly completed vessels would be painted in the Paint Shop elsewhere, insignia and identification markings would be added here. 6 Complete Ratemaster on conveyor. 7 One of several construction auto-drones. 8 Nearly complete vessel awaiting several components and requiring painting. 9 Main assembly line conveyor. 10 Unoccupied assembly bed. 11 Vessel in early stages of construction.

12. Electro-magnetic clamp positioning upper section of a vessel's hull ready for assembly. 13 Main production line parts conveyor. 14 Nearly complete Stingray class vessel, with insignia about to be added. 15 Part of the underwater tunnel system leading to submarine test areas, harbour and ocean doors. 16 Vessel on its way to Paint Shop and Internal Environment unit, where the ship's computer and electronics systems would be completed, and interior cabin fittings installed. 17 Administration offices. 18 Filtered air conditioning ducts.

DATELINE 2065

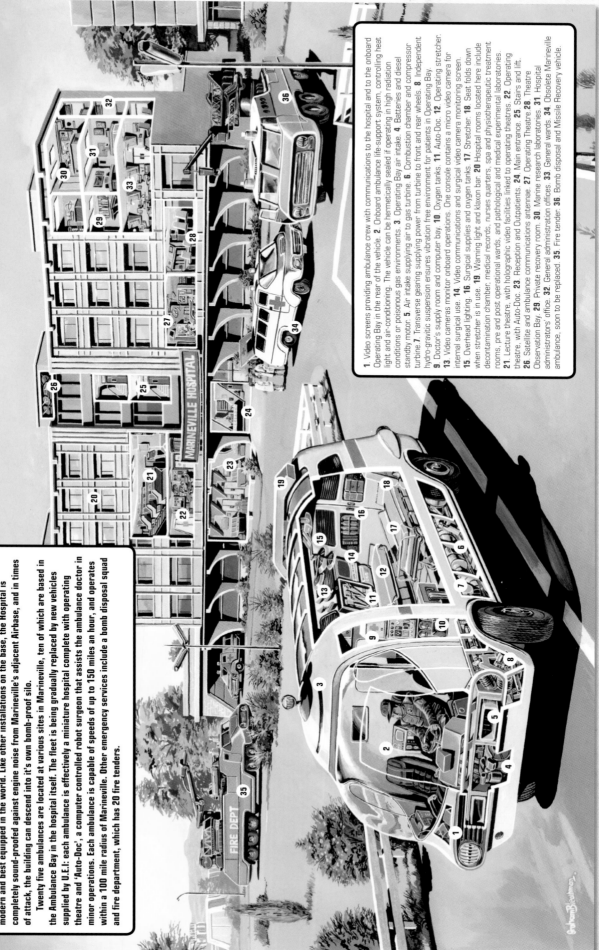

DATELINE 2065

MARINEVILLE HOSPITAL

Located not far from the Control Tower is Marineville Hospital, recognised as one of the most modern and best equipped in the world. Like other installations on the base, the Hospital is completely sound-proofed against engine noise from Marineville's adjacent Airbase, and in times of attack, the building can descend into it's own bomb-proof silo.

Twenty five ambulances are located at various sites in Marineville, ten of which are based in the Ambulance Bay in the hospital itself. The fleet is being gradually replaced by new vehicles supplied by U.E.I: each ambulance is effectively a miniature hospital complete with operating theatre and 'Auto-Doc', a computer controlled robot surgeon that assists the ambulance doctor in minor operations. Each ambulance is capable of speeds of up to 150 miles an hour, and operates within a 100 mile radius of Marineville. Other emergency services include a bomb disposal squad and fire department, which has 20 fire tenders.

1. Video screens providing ambulance crew with communications to the hospital and to the onboard Operating Bay in the rear of the vehicle. 2. Onboard ambulance life-support system, controlling heat light and air-conditioning. The vehicle can be hermetically sealed if operating in high radiation conditions or poisonous gas environments. 3. Operating Bay air intake. 4. Batteries and diesel standby motor. 5. Air intake supplying air to gas turbine. 6. Combustion chamber and compressor turbine. 7. Transverse gearing supplying power from turbine to front and rear wheels. 8. Independent hydro-gravitic suspension ensures vibration free environment for patients in Operating Bay. 9. Doctor's supply room and computer bay. 10. Oxygen tanks. 11. Auto-Doc. 12. Operating stretcher. 13. Video cameras monitor onboard operations. One console contains a micro video camera for internal surgical use. 14. Video communications and surgical video camera monitoring screen. 15. Overhead lighting. 16. Surgical supplies and oxygen tanks. 17. Stretcher. 18. Seat folds down when stretcher is in use. 19. Warning light and klaxon bar. 20. Hospital rooms located here include decontamination chamber, medical records, nurses quarters, spa and physiotherapeutic treatment rooms, pre and post operational wards, and pathological and medical experimental laboratories. 21. Lecture theatre, with holographic video facilities linked to operating theatres. 22. Operating theatre, with Auto-Doc. 23. Reception and Outpatients. 24. Main entrance. 25. Stairs and lift. 26. Satellite and ambulance communications antennae. 27. Operating Theatre. 28. Theatre Observation Bay. 29. Private recovery room. 30. Marine research laboratories. 31. Hospital administrators' office. 32. General administration offices. 33. General wards. 34. Obsolete Marineville ambulance, soon to be replaced. 35. Fire tender. 36. Bomb disposal and Missile Recovery vehicle.

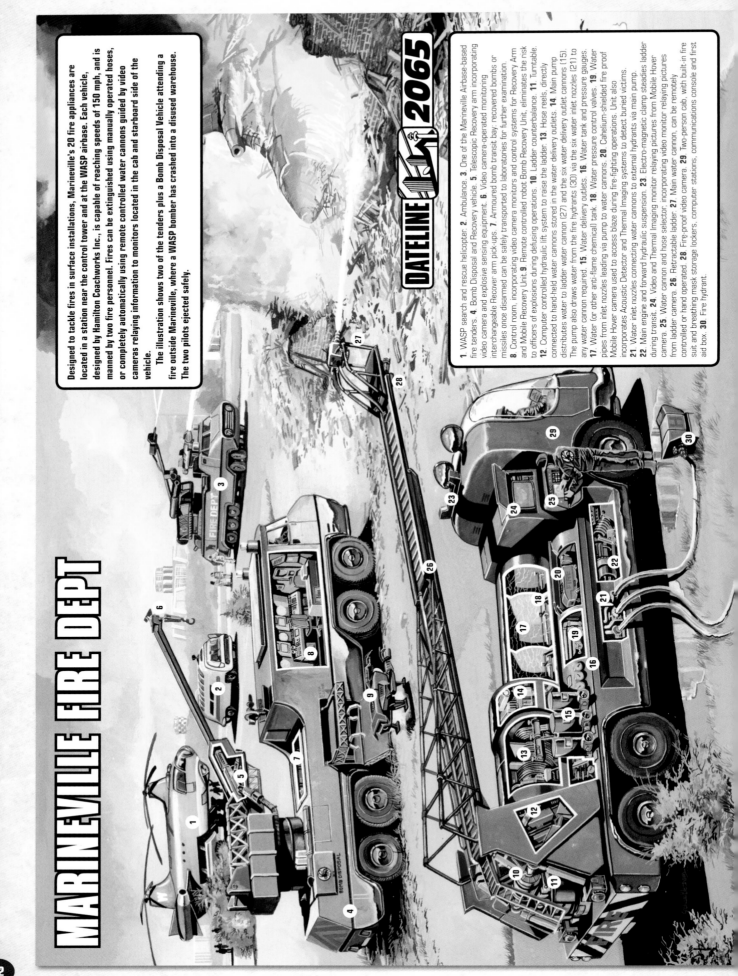

MARINEVILLE FIRE DEPT

Designed to tackle fires in surface installations, Marineville's 20 fire appliances are located in a station near the control tower and at the WASP airbase. Each vehicle, designed by Hamilton Coachworks Inc., is capable of reaching speeds of 150 mph, and is manned by two fire personnel. Fires can be extinguished using manually operated hoses, or completely automatically using remote controlled water cannons guided by video cameras relaying information to monitors located in the cab and starboard side of the vehicle.

The illustration shows two of the tenders plus a Bomb Disposal Vehicle attending a fire outside Marineville, where a WASP bomber has crashed into a disused warehouse. The two pilots ejected safely.

DATELINE 2065

1. WASP search and rescue helicopter. 2. Ambulance. 3. One of the Marineville Airbase-based fire tenders. 4. Bomb Disposal and Recovery vehicle. 5. Telescopic Recovery arm incorporating video camera and explosive sensing equipment. 6. Video camera-operated monitoring interchangeable Recover arm pick-ups. 7. Armoured bomb transit bay: recovered bombs or missiles once disarmed can be safely transported to laboratories for further examination. 8. Control room, incorporating video camera monitors and control systems for Recovery Arm and Mobile Recovery Unit. 9. Remote controlled robot Bomb Recovery Unit, eliminates the risk to officers of explosions during defusing operations. 10. Ladder counterbalance. 11. Turntable. 12. Computer controlled hydraulic lift system to raise the ladder. 13. Hose reels, directly connected to hand-held water cannons stored in the water delivery outlets. 14. Main pump distributes water to ladder water cannon (27) and the six water delivery outlet cannons (15). The pump also draws water from the fire hydrants (30) via the six water inlet nozzles (21) to any water cannon required. 15. Water delivery outlets. 16. Water tank and pressure gauges. 17. Water (or other anti-flame chemical tank. 18. Water pressure control valves. 19. Water pipes from inlet nozzles leading via pump to water cannons. 20. Cahelium-shielded fire proof Mobile Hover camera used to access blaze during fire-fighting operations. Unit also incorporates Acoustic Detector and Thermal Imaging systems to detect buried victims. 21. Water inlet nozzles connecting water cannons to external hydrants via main pump. 22. Main engine and forward hydraulic suspension. 23. Electro-magnetic clamp steadies ladder during transit. 24. Video and Thermal Imaging monitor relaying pictures from Mobile Hover camera. 25. Water cannon and hose selector, incorporating video monitor relaying pictures from ladder camera. 26. Retractable ladder. 27. Main water cannon, can be remotely controlled or hand operated. 28. Fire-proof video camera. 29. Two-person cab, with built-in fire suit and breathing mask storage lockers, computer stations, communications console and first aid box. 30. Fire hydrant.

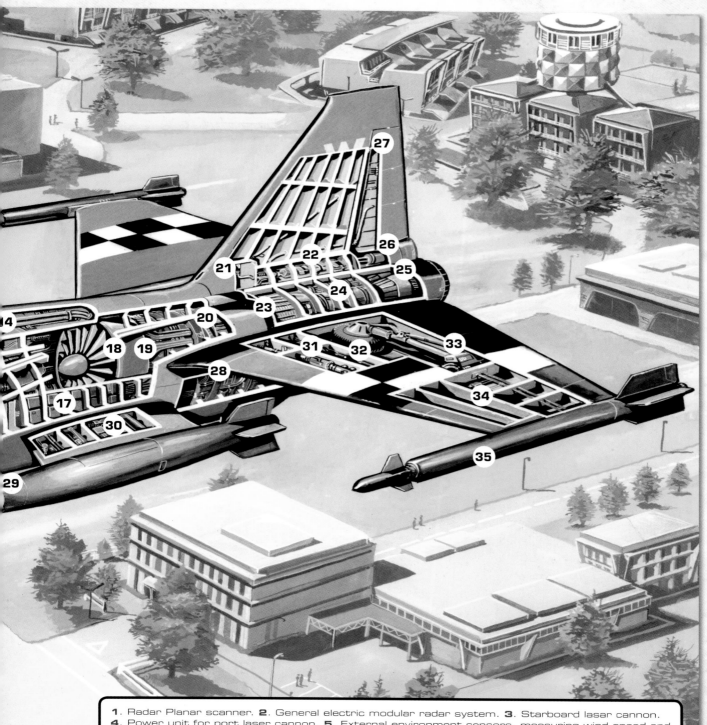

1. Radar Planar scanner. **2**. General electric modular radar system. **3**. Starboard lasar cannon. **4**. Power unit for port laser cannon. **5**. External environment sensors, measuring wind speed and skin temperature. **6**. Central computer. **7**. Weaponry computer monitoring system. **8**. Ejector seat. **9**. Cabin pressurisation control system. **10**. Cabin pressurisation nitrogen tank. **11**. Retracted shock absorber leg strut. **12**. Nose wheel (retracted). **13**. Fuel feed piping and bleed air duct to air conditioning plant. **14**. Fuel injector duct. **15**. Forward fuel tank. **16**. Port intake tank. **17**. Port fuselage fuel cells. **18**. Engine compressor intake. **19**. Zeus afterburning Turbofan rocket engine. **20**. Engine bleed air ducting. **21**. Air intake. **22**. Air conditioning system. **23**. Multi-stage compressors. **24**. Combustion chamber. **25**. Afterburner. **26**. Emergency braking parachute canister. **27**. Trailing edge communications aerials. **28**. Secondary engine electronic control system. **29**. Port Thor missile. **30**. Missile firing control system. **31**. Leading edge manoeuvre flap control system. **32**. Port wing landing wheel (retracted). **33**. Shock absorber landing leg hydraulic control motor. **34**. Wing-tip missile firing control system. **35**. Wing-tip F91 Seeker air-to-air missile. **36**. WASP Spearhead delta wing bomber. **37**. Marineville's newly built airbase control building.

Graham Bleathman

47

WASP SPEARHEAD BOMBER

Delivered to Marineville at the same time as the Arrowhead Interceptors, 50 Spearhead Bombers have recently gone into service with the WASP Airforce. Built by U.E.I., the Spearhead is powered by three 'Apollo' rocket engines and can attain a speed of 300 mph.

An integral part of the Spearhead craft is the aerohydromic missile. As its name suggests, it is developed from the silo-based hydromic missiles stored in front of Marineville's control tower. This version, held beneath a fuselage by electromagnetic clamps, is more controllable once fired by the Spearheads weaponry officer, and can be used as a torpedo if an aerial strike of a seaborne target is required. The warhead can be interchangeable: anything from high explosive, chemical or atomic can be installed.

The Spearhead is also armed with twelve standard high explosive bombs, and a forward laser cannon. The craft have also recently been used for search and reconnaissance missions.

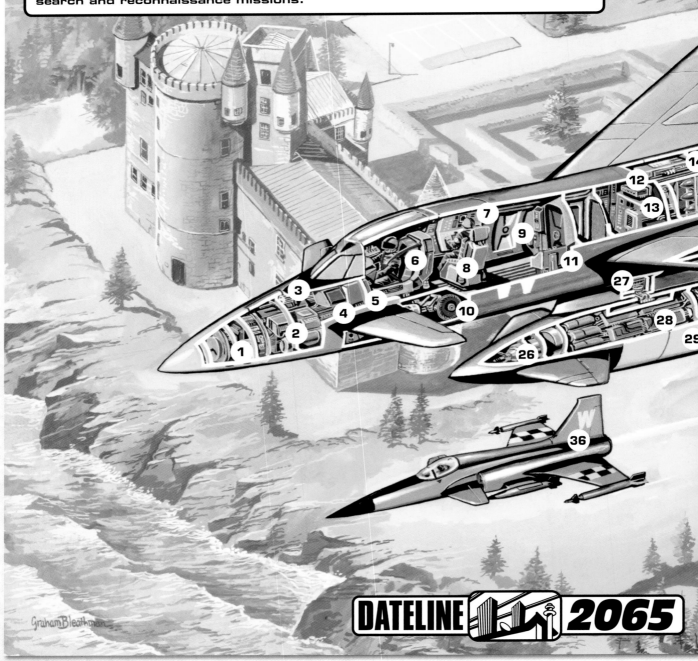

DATELINE 2065

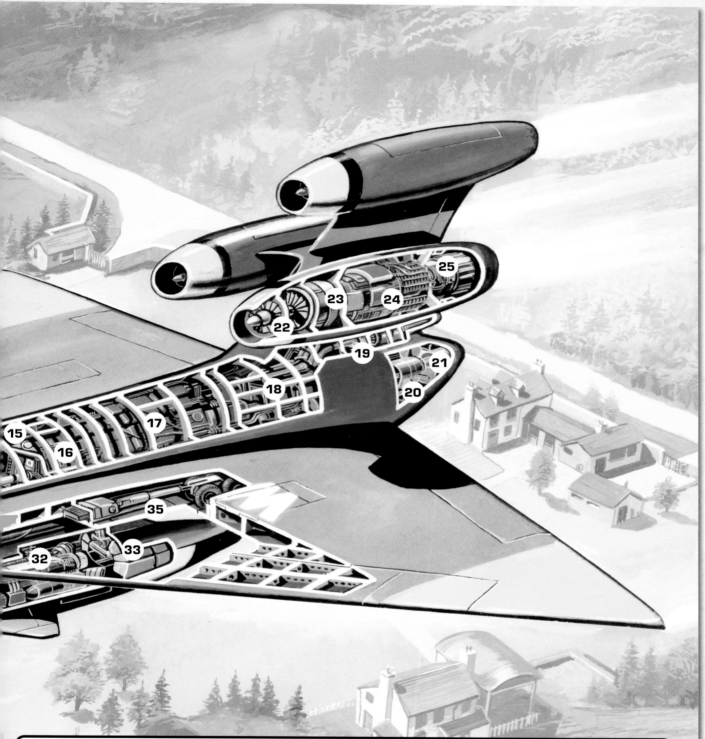

1. Radar planar scanner and anti-detection radar scrambler, **2**. External environment sensors, measuring skin temperature, wind speed and atmospheric pressure, **3**. Laser cannon, centrally placed (retracted), **4**. Power unit for laser cannon, **5**. Central computer, **6**. Pilot's ejector seat, **7**. Emergency exit hatch for weaponry officer's ejector seat, **8**. Weaponry officer, controlling main aerohydromic bomb guidance system, plus smaller bombs, **9**. Main exit hatch, **10**. Retracted telescopic nosewheel undercarriage, **11**. Internal environment control console, **12**. Corridor leading to avionics bay with integrated personal hygiene station on starboard side, **13**. Avionics bay and auxiliary bomb bay monitoring station, **14**. Bomb bay air conditioning plant and computerised monitoring station, linked to weaponry officer's console. **15**. Fuel injector duct, **16**. Computerised fuel injection distribution valve, **17**. Fuel tanks, **18**. Fuel distribution and emergency by-pass valves, **19**. Aft fuel injection duct, **20**. Rear radar planar scanner, **21**. Emergency braking parachute canister, **22**. Engine compressor intake, **23**. 'Apollo' afterburning turbo-fan rocket engine, **24**. Combustion chamber, **25**. Afterburner, **26**. Anti-detection radar scrambler, **27**. Forward electromagnetic clamp. **28**. Aerohydromic variable warhead chamber. **29**. Warhead inspection hatch, **30**. Computerised warhead detonation system. **31**. Aerohydromic missile guidance control system. **32**. Central fuel tank for twin rocket motors on each side, **33**. Flotation tanks for use in missiles 'torpedo' mode. **34**. Port bomb bay doors. **35**. Port wing telescopic landing wheels retracted. **36**. WASP Arrowhead Interceptor.

HYDROMIC MISSILE

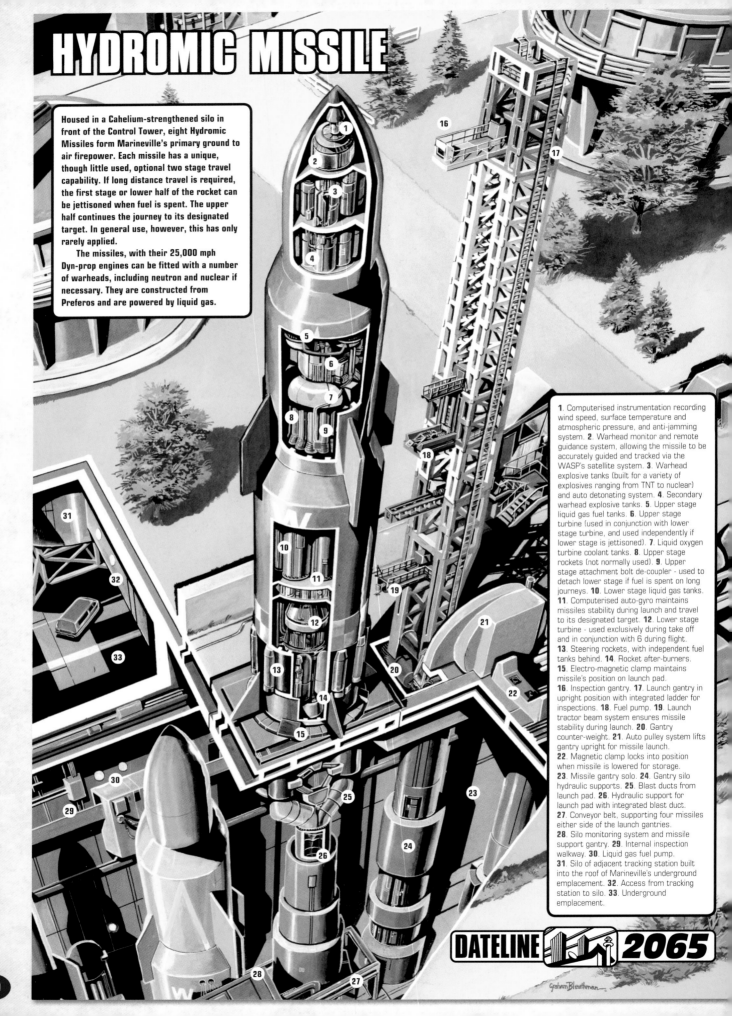

Housed in a Cahelium-strengthened silo in front of the Control Tower, eight Hydromic Missiles form Marineville's primary ground to air firepower. Each missile has a unique, though little used, optional two stage travel capability. If long distance travel is required, the first stage or lower half of the rocket can be jettisoned when fuel is spent. The upper half continues the journey to its designated target. In general use, however, this has only rarely applied.

The missiles, with their 25,000 mph Dyn-prop engines can be fitted with a number of warheads, including neutron and nuclear if necessary. They are constructed from Preferos and are powered by liquid gas.

1. Computerised instrumentation recording wind speed, surface temperature and atmospheric pressure, and anti-jamming system. 2. Warhead monitor and remote guidance system, allowing the missile to be accurately guided and tracked via the WASP's satellite system. 3. Warhead explosive tanks (built for a variety of explosives ranging from TNT to nuclear) and auto detonating system. 4. Secondary warhead explosive tanks. 5. Upper stage liquid gas fuel tanks. 6. Upper stage turbine (used in conjunction with lower stage turbine, and used independently if lower stage is jettisoned). 7. Liquid oxygen turbine coolant tanks. 8. Upper stage rockets (not normally used). 9. Upper stage attachment bolt de-coupler - used to detach lower stage if fuel is spent on long journeys. 10. Lower stage liquid gas tanks. 11. Computerised auto-gyro maintains missiles stability during launch and travel to its designated target. 12. Lower stage turbine - used exclusively during take off and in conjunction with 6 during flight. 13. Steering rockets, with independent fuel tanks behind. 14. Rocket after-burners. 15. Electro-magnetic clamp maintains missile's position on launch pad. 16. Inspection gantry. 17. Launch gantry in upright position with integrated ladder for inspections. 18. Fuel pump. 19. Launch tractor beam system ensures missile stability during launch. 20. Gantry counter-weight. 21. Auto pulley system lifts gantry upright for missile launch. 22. Magnetic clamp locks into position when missile is lowered for storage. 23. Missile gantry silo. 24. Gantry silo hydraulic supports. 25. Blast ducts from launch pad. 26. Hydraulic support for launch pad with integrated blast duct. 27. Conveyor belt, supporting four missiles either side of the launch gantries. 28. Silo monitoring system and missile support gantry. 29. Internal inspection walkway. 30. Liquid gas fuel pump. 31. Silo of adjacent tracking station built into the roof of Marineville's underground emplacement. 32. Access from tracking station to silo. 33. Underground emplacement.

DATELINE 2065

AGENT X20'S HOUSE

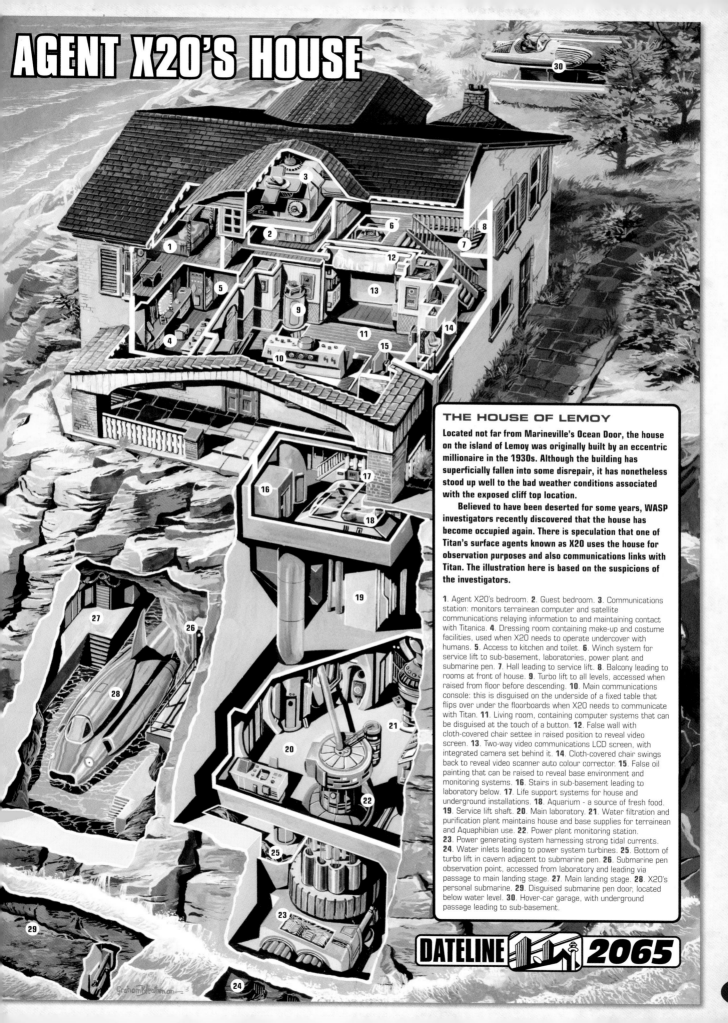

THE HOUSE OF LEMOY

Located not far from Marineville's Ocean Door, the house on the island of Lemoy was originally built by an eccentric millionaire in the 1930s. Although the building has superficially fallen into some disrepair, it has nonetheless stood up well to the bad weather conditions associated with the exposed cliff top location.

Believed to have been deserted for some years, WASP investigators recently discovered that the house has become occupied again. There is speculation that one of Titan's surface agents known as X20 uses the house for observation purposes and also communications links with Titan. The illustration here is based on the suspicions of the investigators.

1. Agent X20's bedroom. **2.** Guest bedroom. **3.** Communications station: monitors terrainean computer and satellite communications relaying information to and maintaining contact with Titanica. **4.** Dressing room containing make-up and costume facilities, used when X20 needs to operate undercover with humans. **5.** Access to kitchen and toilet. **6.** Winch system for service lift to sub-basement, laboratories, power plant and submarine pen. **7.** Hall leading to service lift. **8.** Balcony leading to rooms at front of house. **9.** Turbo lift to all levels, accessed when raised from floor before descending. **10.** Main communications console: this is disguised on the underside of a fixed table that flips over under the floorboards when X20 needs to communicate with Titan. **11.** Living room, containing computer systems that can be disguised at the touch of a button. **12.** False wall with cloth-covered chair settee in raised position to reveal video screen. **13.** Two-way video communications LCD screen, with integrated camera set behind it. **14.** Cloth-covered chair swings back to reveal video scanner auto colour corrector. **15.** False oil painting that can be raised to reveal base environment and monitoring systems. **16.** Stairs in sub-basement leading to laboratory below. **17.** Life support systems for house and underground installations. **18.** Aquarium - a source of fresh food. **19.** Service lift shaft. **20.** Main laboratory. **21.** Water filtration and purification plant maintains house and base supplies for terrainean and Aquaphibian use. **22.** Power plant monitoring station. **23.** Power generating system harnessing strong tidal currents. **24.** Water inlets leading to power system turbines. **25.** Bottom of turbo lift in cavern adjacent to submarine pen. **26.** Submarine pen observation point, accessed from laboratory and leading via passage to main landing stage. **27.** Main landing stage. **28.** X20's personal submarine. **29.** Disguised submarine pen door, located below water level. **30.** Hover-car garage, with underground passage leading to sub-basement.

DATELINE 2065

X20'S SUBMARINE

Docked in an underground pen below the Island of Lemoy, this submarine was discovered by WASP agents during their investigation of the sole house on the island, suspected of being the base of Surface Agent X20. Essentially built for one man, passengers can travel in the vessel, although internal space is very limited. Like the Terror Fish, X20's craft is constructed from fused Coral Titanium and is capable of reaching similar speeds to Titan's deadly war machines. Several other craft of similar design have also been sighted: a version encountered by Stingray recently sported an additional fin on the underside, whilst others have featured different coloured liveries.

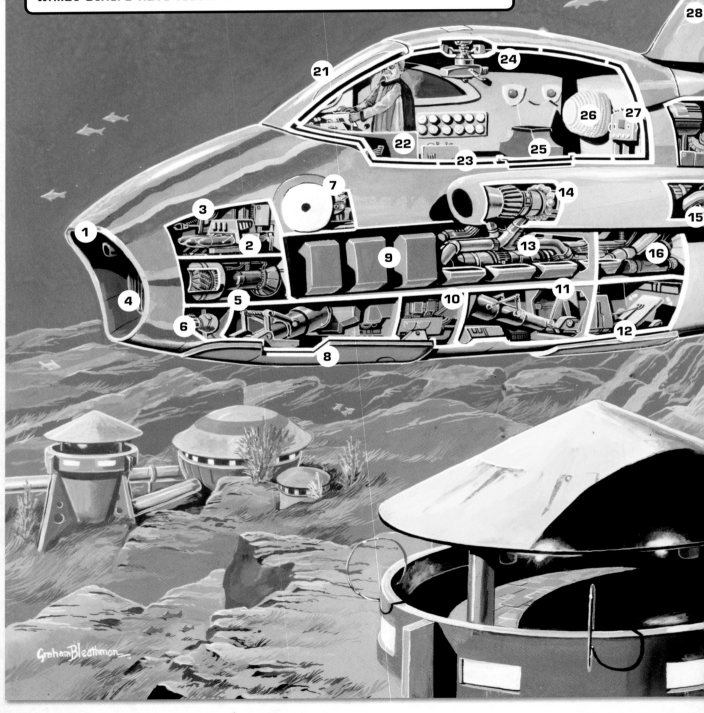

GrahamBleathman

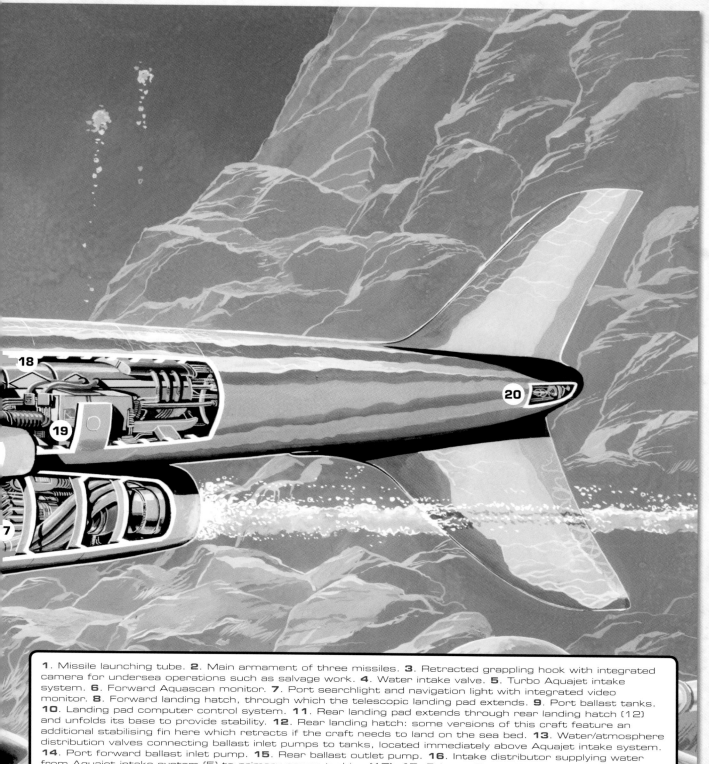

1. Missile launching tube. **2.** Main armament of three missiles. **3.** Retracted grappling hook with integrated camera for undersea operations such as salvage work. **4.** Water intake valve. **5.** Turbo Aquajet intake system. **6.** Forward Aquascan monitor. **7.** Port searchlight and navigation light with integrated video monitor. **8.** Forward landing hatch, through which the telescopic landing pad extends. **9.** Port ballast tanks. **10.** Landing pad computer control system. **11.** Rear landing pad extends through rear landing hatch (12) and unfolds its base to provide stability. **12.** Rear landing hatch: some versions of this craft feature an additional stabilising fin here which retracts if the craft needs to land on the sea bed. **13.** Water/atmosphere distribution valves connecting ballast inlet pumps to tanks, located immediately above Aquajet intake system. **14.** Port forward ballast inlet pump. **15.** Rear ballast outlet pump. **16.** Intake distributor supplying water from Aquajet intake system (5) to primary power turbine (17). **17.** Primary Power Turbine. **18.** Grenanol fuel tanks. **19.** Fuel injection pump and distributor valve. **20.** Rear Aquascan monitor. **21.** Quartz-strengthened viewing ports. **22.** Main control panel, computer controlled and ergonomically simplified to enable the craft to be operated easily by one pilot. **23.** Optional computer/communication console. **24.** Periscope, with integrated video monitor. **25.** Entry hatch: an interior integrated telescopic airlock system operates if access by air breathing individuals is required to and from the control cabin. **26.** Power system monitor. **27.** Life support monitoring system. **28.** Stabilising fin.

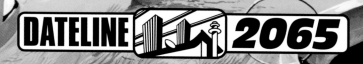

DATELINE 2065

TITANICA

Released from the World Security Council is this view of Titanica, home of Titan and the Aquaphibian race. The image was supplied by the Marineville Press Office and is based on reports from WASP undercover agents operating in Titan's capital.

Very little is known about the city or its inhabitants. It appears to be several kilometres wide in an undisclosed location beneath the Pacific Ocean, some 5000 or so fathoms below the surface. Much of the city is built beneath the sea-bed, with only selected structures such as power plants, early warning towers and some living accommodation for civil and military chiefs appearing at sea-bed level. Travel tubes connect these buildings with each other and the subterranean installations, some of which lead to Terror Fish launchers on the city boundaries.

DATELINE 2065

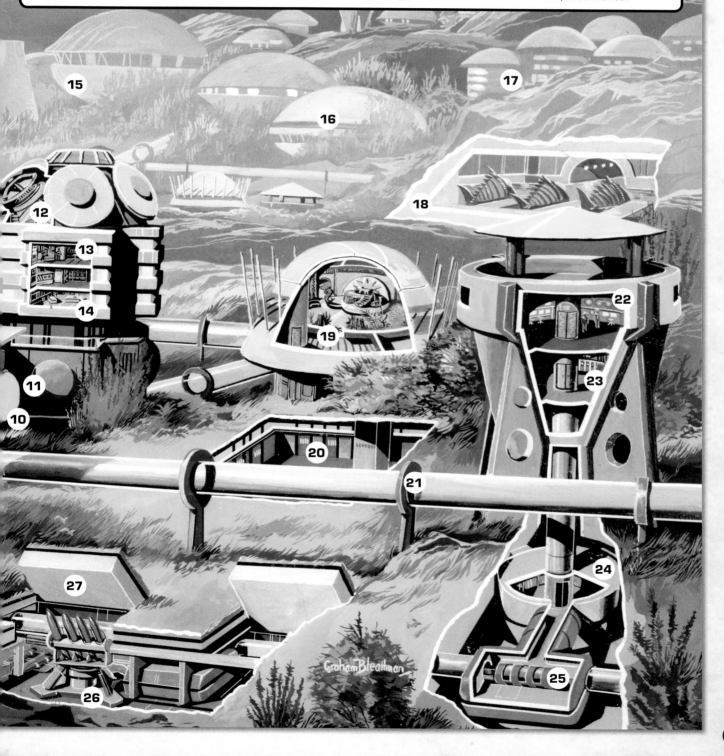

1. Terror Fish on standby for immediate launch. 2. Hydraulic Terror Fish launch system. 3. Telescopic airlock from travel tube terminus to Terror Fish port entry hatch. 4. Terminus for underground travel tube system. 5. Terror Fish manufacturing plant, incorporating a mining facility for metal ores used in Terror Fish construction. 6. Factory airlock incorporating telescopic Terror Fish support rail, enabling the completed vessel to transfer directly from the manufacturing plant to the adjacent hydraulic launcher for sea trials. 7. Geo-thermal power plant converts volcanic energy deep below the earth's crust into electrical power. Eight of these plants around the city supply power for heat, light, life support and food production systems. 8. Power plant monitoring room. 9. Terminus for underground travel tube. 10. Military administration headquarters. 11. Weapons research laboratories. 12. Sonar scan early warning tower, one of ten in and around Titanica. 13. Sonar scan monitoring room. 14. Computer centre and civil administration block. 15. Public conference facility. 16. Ruling council chamber, delegates from which report directly to Titan. 17. Living accommodation for military command personnel. 18. Terror Fish pens, one of four in Titanica, with another four located throughout the undersea kingdom. 19. The Throne Room of one of Titan's several palaces. 20. Prison and interrogation cells. 21. Fused coral Titanium-strengthened travel tube. 22. Secret police monitoring room. 23. Secret police offices, equipment stores and secondary monitoring room. 24. One of many terminuses for travel tubes and underground passages linking underground installations with surface buildings. 25. High speed travel tube car. 26. Part of Titanica's defence ring: underwater interceptor missiles placed around the city boundaries, linked by travel tubes. 27. Hydraulic doors disguising the positions of missile emplacements.

TERROR FISH

Just released from the Marineville Press office, this drawing of one of Titan's Mechanical Fish has been prepared from the reports of marine engineers who have examined a "Tin Terror" captured recently by Captain Troy Tempest. The craft is built from fused coral Titanium, an undersea material similar to Cahelium Extract X that is used in Stingray's construction. An average speed of 550 knots has been recorded. The Terror Fish are only a part of Titan's fleet: other craft include large cargo vessels and smaller single seat mini-submarines, all built to resemble fish or other ocean creatures.

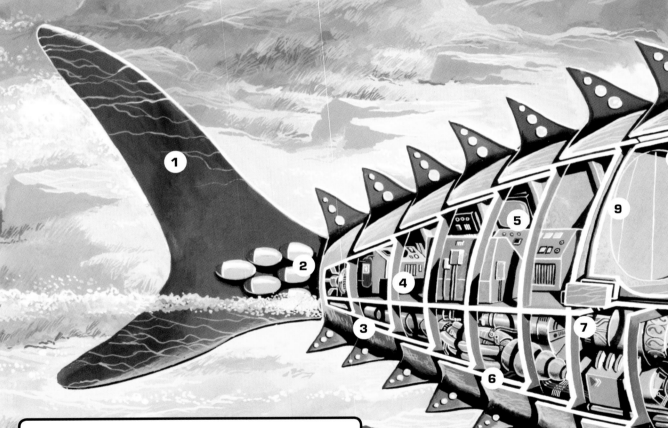

1. Rudder, with full horizontal and rotating movement for fast manoeuvres. 2. Rudder servos behind rear bulkhead. 3. Starboard Aquajet. 4. Lift support systems monitor internal atmosphere and cabin pressure. 5. Radio, sonar and Aquascan console (information from here duplicated on main control console) and engine monitor system. 6. Starboard turboflow Aquajet propulsion system, powered by Grenanol fuel. 7. Generators supplying power to auxiliary propulsion unit. 8. Grenanol fuel and ballast tanks. 9. Access hatch from aft cabin to airlocks. 10. Airlock, with entry hatches on both sides of craft. 11. Access hatch to passenger or cargo bay and control cabin beyond. 12. Optional passenger seating: this area can be used to carry small cargos if seating is removed. 13. Stabilising fin with integrated periscope (retracted). 14. Armour plated hull, constructed of fused coral Titanium with integrated navigation lights. 15. Quartz-strengthened viewing port "eyes". 16. Viewing port rim features lighting units which can be focused through the thickness of the quartz eyes to form a single searchlight beam. 17. Servo systems operating port and starboard stabilising fins. 18. Main control and central computer, which receives information from life support and Aquascan systems if the craft is operated by one pilot only. 19. Main armament of six missiles. 20. Hinged lower jaw in dropped position in readiness for instant missile release. 21. Forward Aquascan sensor, which also incorporates laser beam gun for removing obstacles. 22. Atmosphere recycling control and monitoring console.

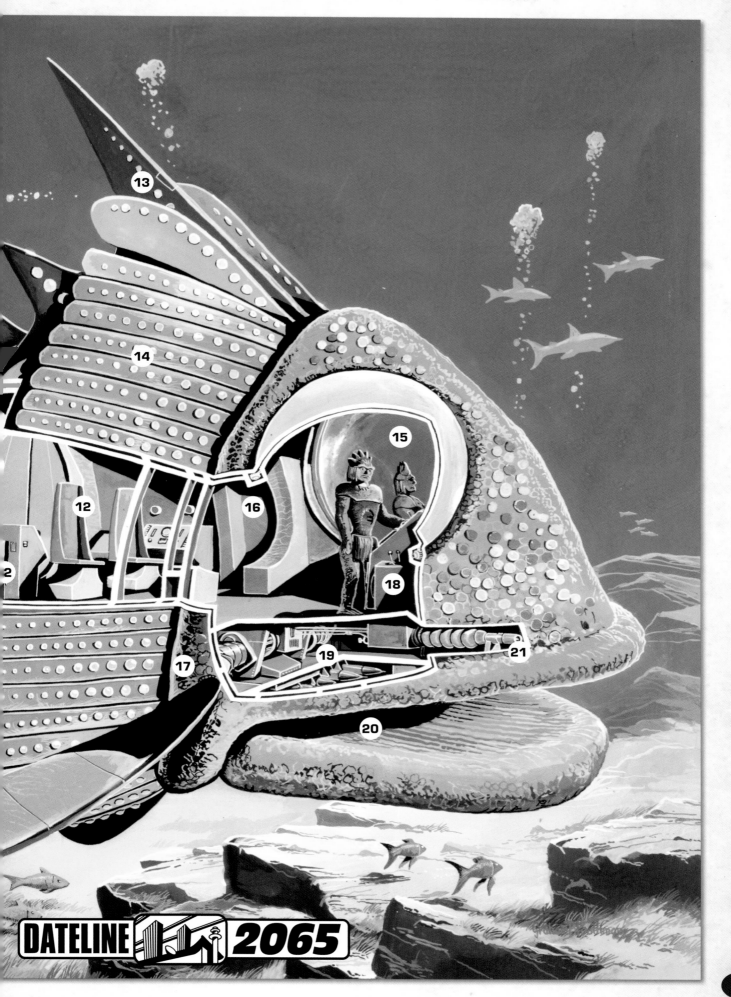

DATELINE 2065

AQUATRAZ

Prepared from reports by Troy Tempest, this illustration shows part of Titan's undersea prison called Aquatraz, from which until recently no-one has escaped.

Very little is known about the prison, and its discovery has posed many questions for Marineville's scientists. It remains a mystery, for example, why trouble was taken to repair and chemically preserve old terrainean vessels, rather than build new installations on the sea bed. Each vessel has been internally gutted and refurbished with new prison cells and security systems, and somehow towed to the new prison site. How the older ships - some dating back to the early nineteenth century - have survived also remains undisclosed.

Aquatraz is believed to hold around 2500 prisoners, almost all from other undersea races.

1. One of several galleons used as power plants, surveillance and communications stations. **2.** Communications antenna. **3.** Early warning sonar (retractable). **4.** Sea bed to surface missile launch system. **5.** Life support and power plant monitoring station. **6.** Geo-thermal power plant supplies energy to life support systems in all ships via micro cables embedded within travel tube walls. **7.** Travel tube, carrying maximum security tubeway car. **8.** Guard room. **9.** Boundary torpedo defence system. **10.** Maximum security cells, with video surveillance system. **11.** Lift to all decks. **12.** Missile storage bay. **13.** Sixteen inch naval guns preserved and modified to fire missiles. **14.** Missile guidance observation point. **15.** Double walled hull: the original steel hull is chemically preserved and repaired to prevent further decay, although superficial structures above top deck level have been allowed to rot. The interior wall is new, built to accommodate prison and interrogation cells, barracks, offices and other facilities. **16.** Travel tube terminus and airlock. **17.** One of several Terror Fish docking bays. **18.** Prison governor's office. **19.** One of several interrogation chambers. **20.** Life support monitoring station. **21.** Surveillance room.

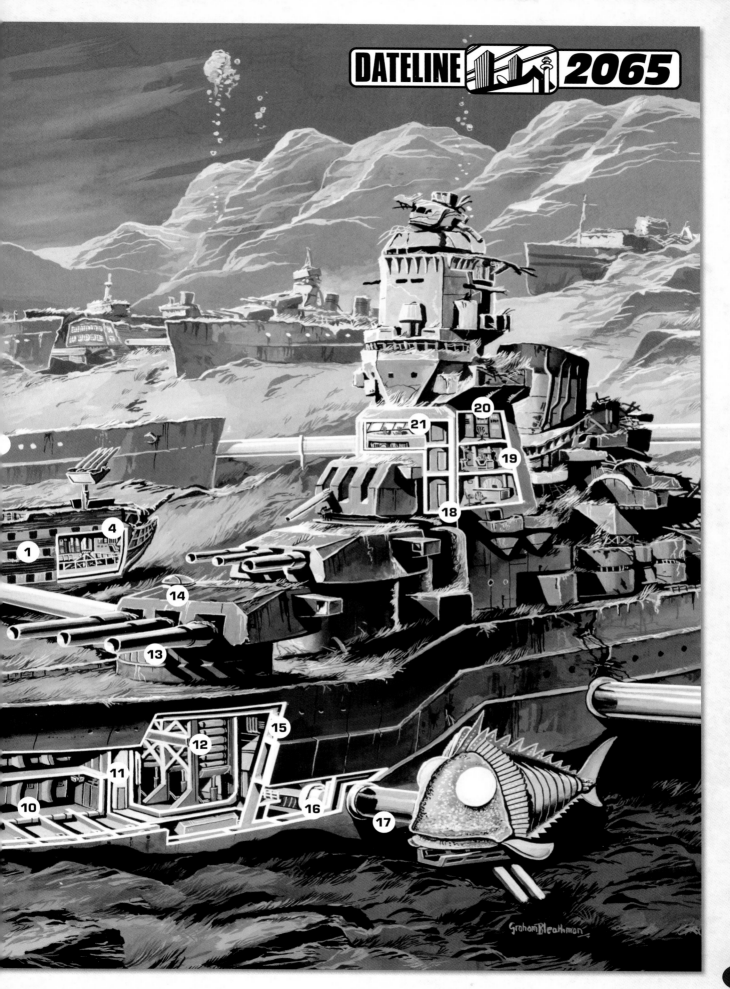

Graham Bleathman

THE GHOST SHIP

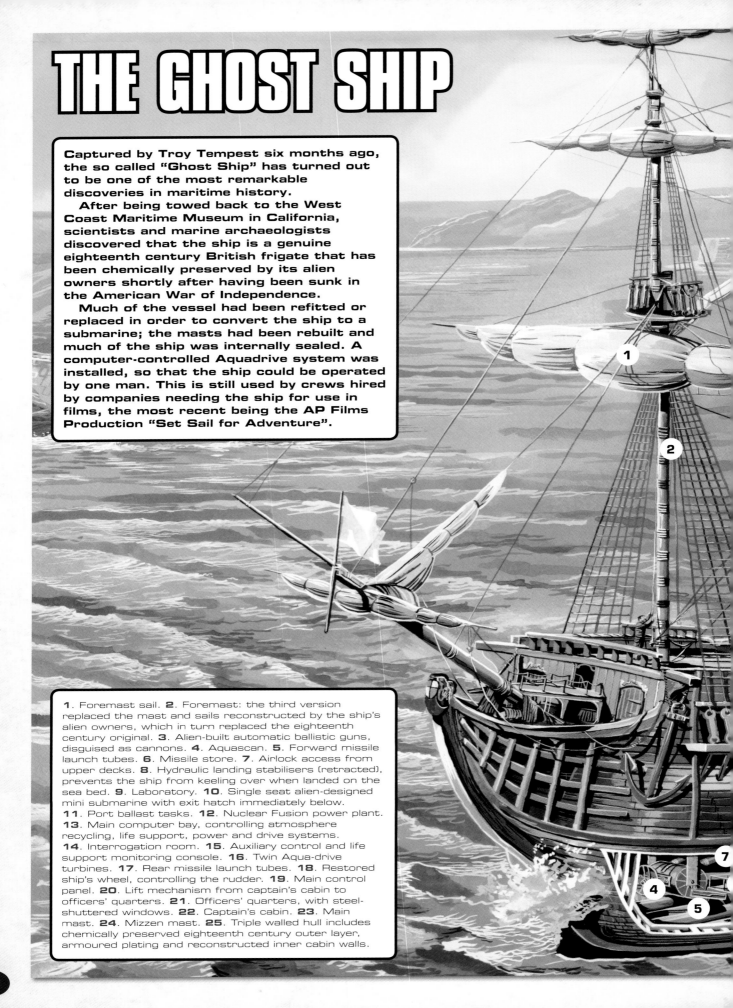

Captured by Troy Tempest six months ago, the so called "Ghost Ship" has turned out to be one of the most remarkable discoveries in maritime history.

After being towed back to the West Coast Maritime Museum in California, scientists and marine archaeologists discovered that the ship is a genuine eighteenth century British frigate that has been chemically preserved by its alien owners shortly after having been sunk in the American War of Independence.

Much of the vessel had been refitted or replaced in order to convert the ship to a submarine; the masts had been rebuilt and much of the ship was internally sealed. A computer-controlled Aquadrive system was installed, so that the ship could be operated by one man. This is still used by crews hired by companies needing the ship for use in films, the most recent being the AP Films Production "Set Sail for Adventure".

1. Foremast sail. 2. Foremast: the third version replaced the mast and sails reconstructed by the ship's alien owners, which in turn replaced the eighteenth century original. 3. Alien-built automatic ballistic guns, disguised as cannons. 4. Aquascan. 5. Forward missile launch tubes. 6. Missile store. 7. Airlock access from upper decks. 8. Hydraulic landing stabilisers (retracted), prevents the ship from keeling over when landed on the sea bed. 9. Laboratory. 10. Single seat alien-designed mini submarine with exit hatch immediately below. 11. Port ballast tasks. 12. Nuclear Fusion power plant. 13. Main computer bay, controlling atmosphere recycling, life support, power and drive systems. 14. Interrogation room. 15. Auxiliary control and life support monitoring console. 16. Twin Aqua-drive turbines. 17. Rear missile launch tubes. 18. Restored ship's wheel, controlling the rudder. 19. Main control panel. 20. Lift mechanism from captain's cabin to officers' quarters. 21. Officers' quarters, with steel-shuttered windows. 22. Captain's cabin. 23. Main mast. 24. Mizzen mast. 25. Triple walled hull includes chemically preserved eighteenth century outer layer, armoured plating and reconstructed inner cabin walls.

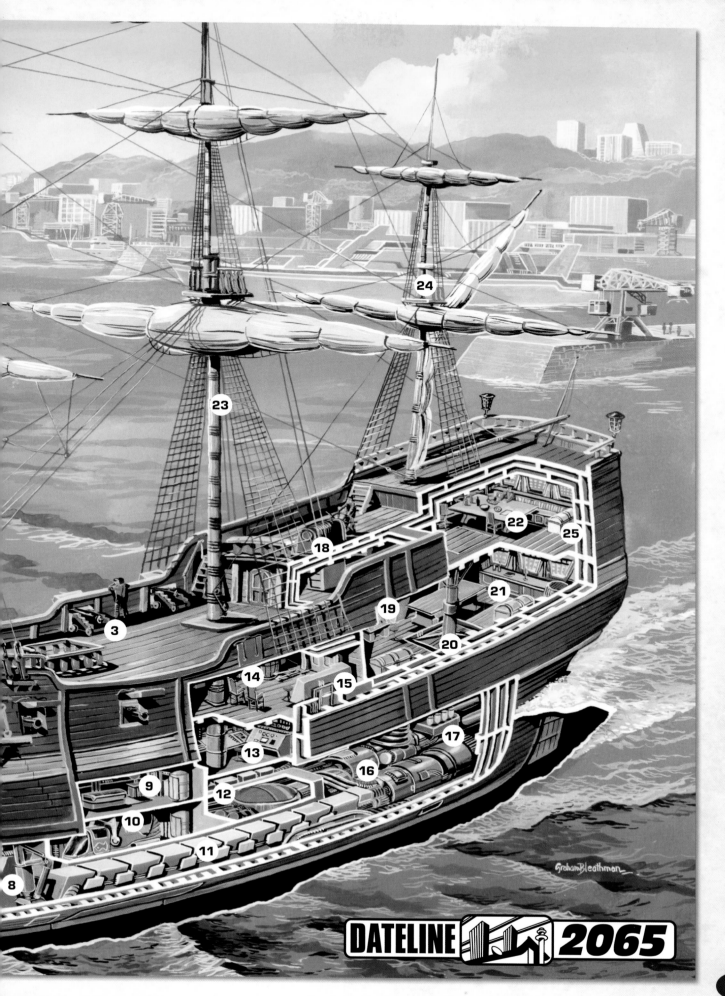

DATELINE 2065

PACIFICA

Located in the Pacific Ocean, Pacifica is ruled by Marina's father Aphony, and his elected Inner Council. It is a city of peace, learning and wealth, whose economy is based on undersea agriculture and trade with other subterranean peoples.

It is also the third city of that name, having been recently rebuilt after a devastating attack by Titan. Although the city has few defences, Pacifica's scientists have recently developed a force field system to deflect missiles, and most of the population now lives below the sea bed.

1. Administration building: upper levels contain city archives, laboratories and government offices. **2**. Lower levels contain financial, social and civil service offices. **3**. Primary laboratories. **4**. Library and records office. **5**. Aphony's throne room. **6**. Banqueting room. **7**. Police and law offices. **8**. Undersea traffic control. **9**. Underground corridor linking seabed buildings. **10**. Rock face door concealing defence system. **11**. One of ten force field projectors to deflect enemy missiles. **12**. Geo-thermal power plant. **13**. Airlock pumping station. **14**. Airlock docking bay door. **15**. Airlocks to Aphony's palace. **16**. Submarine turning area. **17**. Living accommodation. **18**. Tunnel leading to submarine pens, docks and industrial area. **19**. Ruling council conference chamber. **20**. One of five market areas. **21**. Travel tube. **22**. Air and water recycling and purification plant. **23**. Leisure centres, galleries and living accommodation.

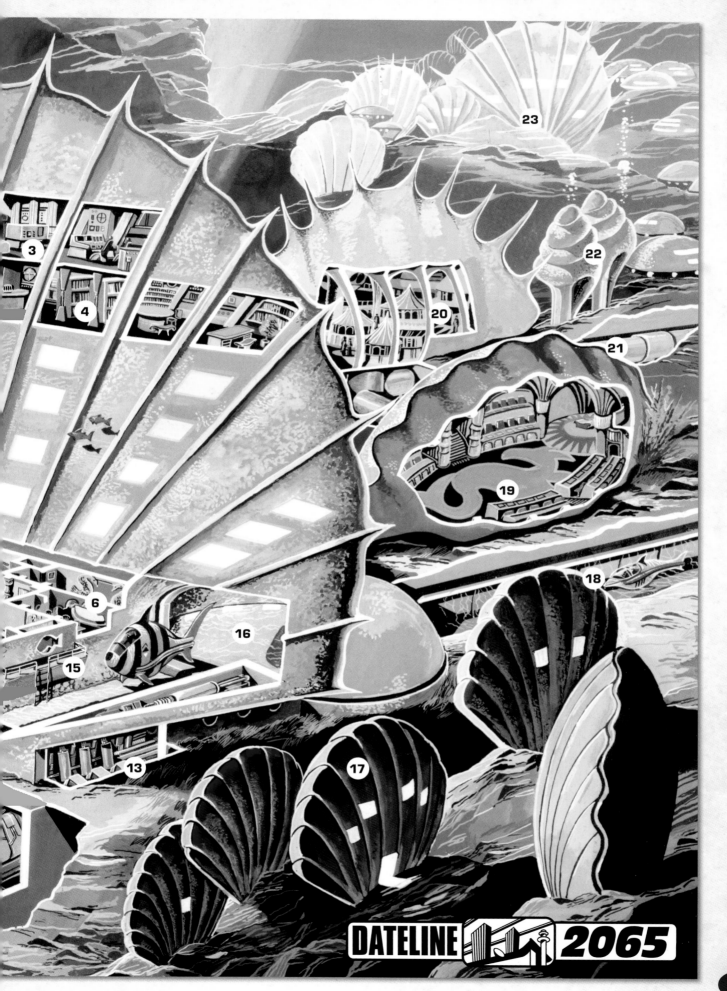

DATELINE 2065

SPECTRUM PURSUIT VEHICLE

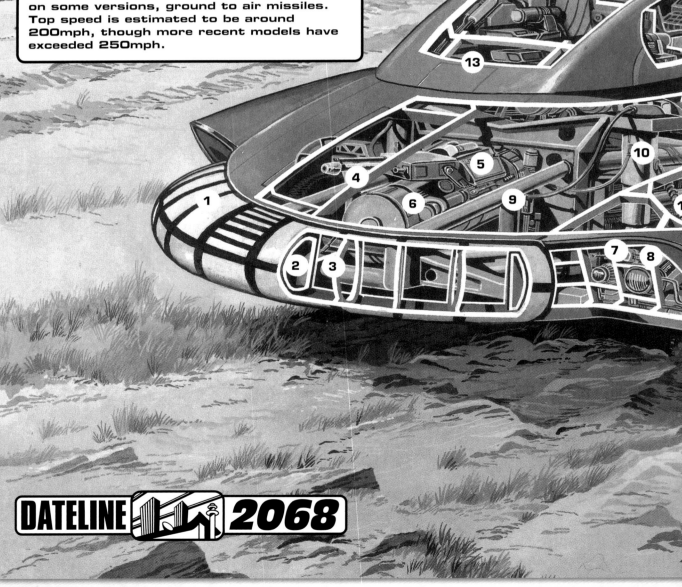

Spectrum was originally created as an additional global security force by the World Government, but in 2068 it is now tasked with fighting the Mysterons from Mars. Leading that fight is Captain Scarlet, a Spectrum agent rendered indestructible by the Mysterons but free of their influence.

Originally developed from the World Army Zeus Combat Tank, the S.P.Vs constitute Spectrum's main earthbound combat vehicle. Because of their complexity of design and equipment, they are specially hand-built in a number of security installations and housed in a variety of secret locations throughout the world.

The power unit is detachable and can be used to power a thruster pack and other on-board equipment. Twin aqua-jets mounted at the rear provide power for amphibious travel. Armaments consist of laser cannons and electrode ray guns, and on some versions, ground to air missiles. Top speed is estimated to be around 200mph, though more recent models have exceeded 250mph.

DATELINE 2068

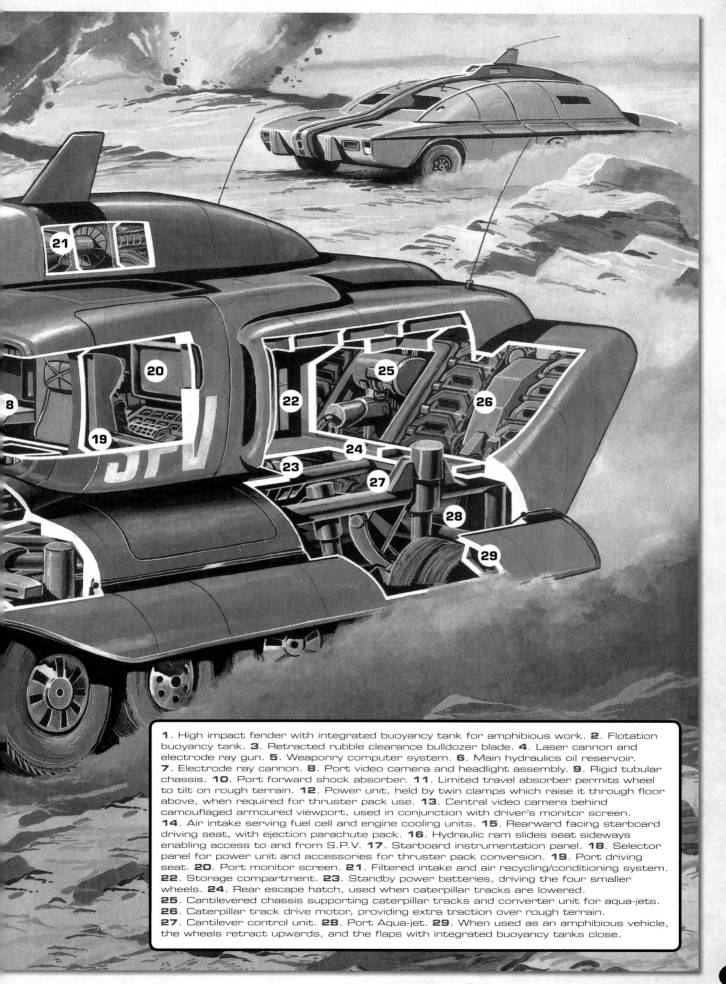

1. High impact fender with integrated buoyancy tank for amphibious work. **2**. Flotation buoyancy tank. **3**. Retracted rubble clearance bulldozer blade. **4**. Laser cannon and electrode ray gun. **5**. Weaponry computer system. **6**. Main hydraulics oil reservoir. **7**. Electrode ray cannon. **8**. Port video camera and headlight assembly. **9**. Rigid tubular chassis. **10**. Port forward shock absorber. **11**. Limited travel absorber permits wheel to tilt on rough terrain. **12**. Power unit, held by twin clamps which raise it through floor above, when required for thruster pack use. **13**. Central video camera behind camouflaged armoured viewport, used in conjunction with driver's monitor screen. **14**. Air intake serving fuel cell and engine cooling units. **15**. Rearward facing starboard driving seat, with ejection parachute pack. **16**. Hydraulic ram slides seat sideways enabling access to and from S.P.V. **17**. Starboard instrumentation panel. **18**. Selector panel for power unit and accessories for thruster pack conversion. **19**. Port driving seat. **20**. Port monitor screen. **21**. Filtered intake and air recycling/conditioning system. **22**. Storage compartment. **23**. Standby power batteries, driving the four smaller wheels. **24**. Rear escape hatch, used when caterpillar tracks are lowered. **25**. Cantilevered chassis supporting caterpillar tracks and converter unit for aqua-jets. **26**. Caterpillar track drive motor, providing extra traction over rough terrain. **27**. Cantilever control unit. **28**. Port Aqua-jet. **29**. When used as an amphibious vehicle, the wheels retract upwards, and the flaps with integrated buoyancy tanks close.

MAXIMUM SECURITY VEHICL

The four-seater, high speed Maximum Security Vehicle is used to transport VIPs in utmost safety. Twenty-four feet long and capable of 200mph, this unique Spectrum craft is bullet proof, weighs eight tonnes and is equipped with a variety of survival and communications systems. In the event of an attack, the craft can be hermetically sealed by time lock only to open on ultimate completion of mission. Like the Spectrum Pursuit Vehicles, the MSVs are secretly housed at strategic locations and Spectrum bases throughout the world.

DATELINE 2068

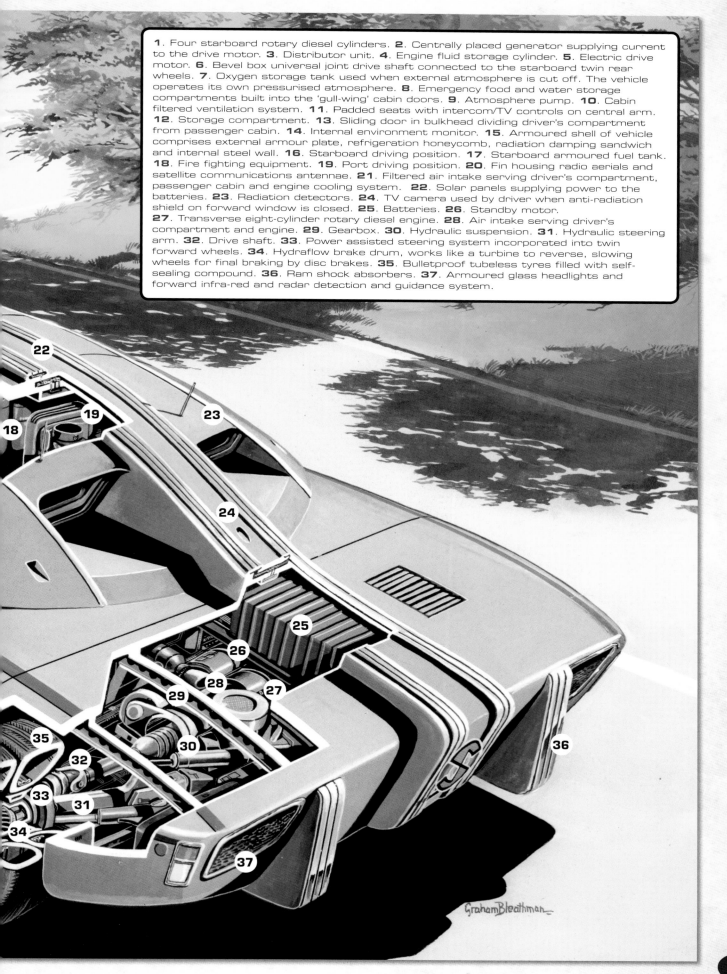

1. Four starboard rotary diesel cylinders. 2. Centrally placed generator supplying current to the drive motor. 3. Distributor unit. 4. Engine fluid storage cylinder. 5. Electric drive motor. 6. Bevel box universal joint drive shaft connected to the starboard twin rear wheels. 7. Oxygen storage tank used when external atmosphere is cut off. The vehicle operates its own pressurised atmosphere. 8. Emergency food and water storage compartments built into the 'gull-wing' cabin doors. 9. Atmosphere pump. 10. Cabin filtered ventilation system. 11. Padded seats with intercom/TV controls on central arm. 12. Storage compartment. 13. Sliding door in bulkhead dividing driver's compartment from passenger cabin. 14. Internal environment monitor. 15. Armoured shell of vehicle comprises external armour plate, refrigeration honeycomb, radiation damping sandwich and internal steel wall. 16. Starboard driving position. 17. Starboard armoured fuel tank. 18. Fire fighting equipment. 19. Port driving position. 20. Fin housing radio aerials and satellite communications antennae. 21. Filtered air intake serving driver's compartment, passenger cabin and engine cooling system. 22. Solar panels supplying power to the batteries. 23. Radiation detectors. 24. TV camera used by driver when anti-radiation shield on forward window is closed. 25. Batteries. 26. Standby motor. 27. Transverse eight-cylinder rotary diesel engine. 28. Air intake serving driver's compartment and engine. 29. Gearbox. 30. Hydraulic suspension. 31. Hydraulic steering arm. 32. Drive shaft. 33. Power assisted steering system incorporated into twin forward wheels. 34. Hydraflow brake drum, works like a turbine to reverse, slowing wheels for final braking by disc brakes. 35. Bulletproof tubeless tyres filled with self-sealing compound. 36. Ram shock absorbers. 37. Armoured glass headlights and forward infra-red and radar detection and guidance system.

SPECTRUM SALOON CAR

The Spectrum Saloon Car provides high speed mobility for Spectrum personnel. Designed to Spectrum specifications, incorporating speed and safety, this car is designed to carry five persons. All cars are fitted with special transistorised ultra high frequency transceiver radios maintaining constant contact with Cloudbase and the Angels.

The lightweight, resilient Fleetonium alloy is used in the bodywork construction. The rear floor raises to give mechanics access to the gas turbines situated below. Hot air gas from the combustion chamber drives compressor and power turbines before being ejected through the rear grill. All wheels are swung independently.

Braking is by special magnetic brake drums where opposing magnetic fields are generated by means of electro-magnets.

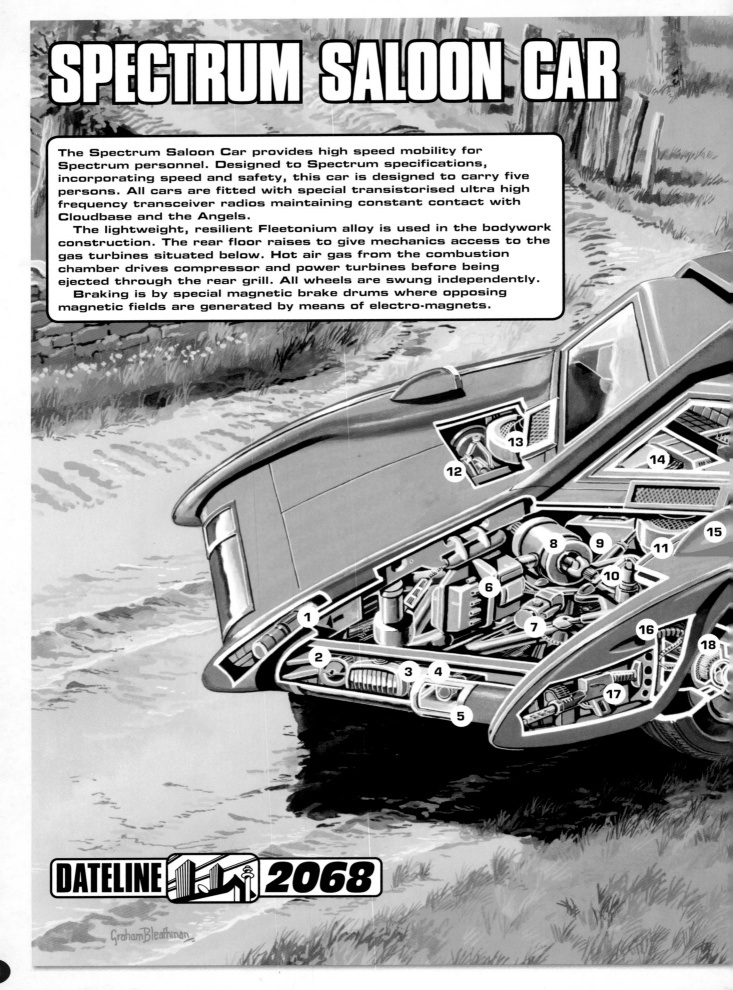

DATELINE 2068

Graham Bleathman

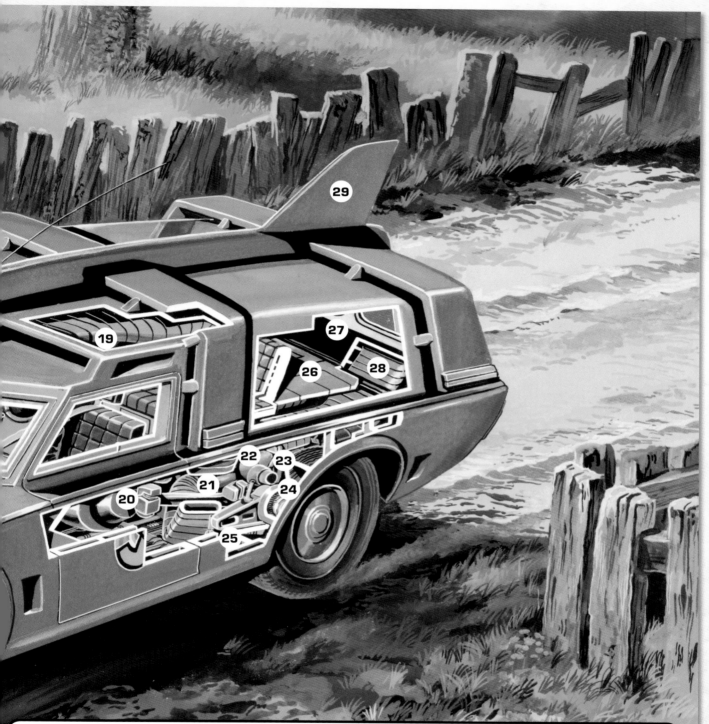

1. Cahelium strengthened hydraulic bolt, can be extended forwards within tubular chassis to ram suspected Mysteron vehicles. The bolt can retract into the body of the car in the event of accidental collision, whereupon the nose collapses to prevent unnecessary injury to occupant of other vehicle. **2**. Port infra-red scanner, used to regulate distances between vehicles in conjunction with Motorway Traffic Speed control systems. **3**. Port head-light. **4**. Laser projector and telescopic camera linked to onboard TV monitor. **5**. Sidelights and trafficators. **6**. Twin shaft six speed gearbox. **7**. Oil reservoir for powered steering. **8**. Bevel and crown wheel drive to front axles. **9**. Compressed non-flammable gas tank, used to inflate collision crash bags located under dashboard. **10**. Port font wheel suspension linkage. **11**. Port oil cooler. **12**. Starboard front wheel steering linkage. **13**. Starboard oil cooler and air intake. **14**. Central computer monitoring engine and cabin environment via micro sensors located throughout the vehicle. **15**. Port driving mirror fairing. **16**. Air intake to reduce tyre friction heat. **17**. Rapid fire small arm, can be removed via access panel and hand held if necessary. **18**. Magnetic brakes. **19**. Port air intake supplying air to gas turbine. **20**. Transverse gearbox driving rear wheels with take off shaft for front drive. **21**. Combustion chamber. **22**. Compressor and power turbines. **23**. Emergency braking system utilising quick drying adhesive sprayed onto tyres forming a second tread with road adhesion qualities. Second tread can be cut with integrated blade as the wheel rotates, if driver wishes to continue journey. **24**. Magnetic brake drum. **25**. Independent suspension cantilever. **26**. Rear storage compartment with access panels for turbine servicing. **27**. Double hatchback doors. **28**. Exhaust filter and grill throws exhaust clear of other vehicles. Grill closes when rear doors open. **29**. Stabilising fin.

CLOUDBASE

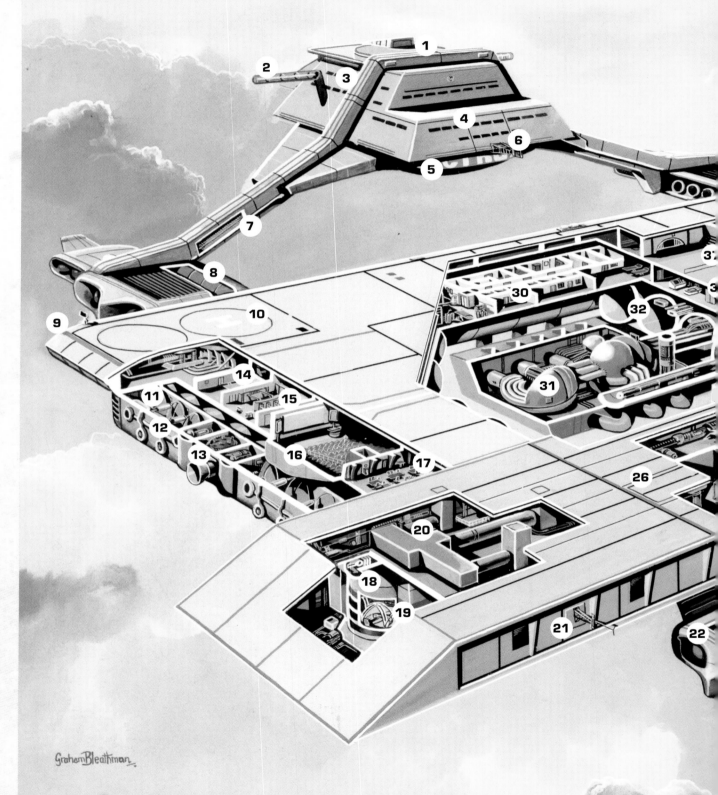

GrahamBleathman.

DATELINE 2068

1500 metres up in the sky, in a classified and occasionally changing location, Cloudbase is the headquarters of Spectrum. A masterpiece of functional design and engineering complexity, Cloudbase has twenty sophisticated engine units providing power and life-support systems.

Based here under the command of Colonel White, are some 600 personnel, including the main captains, Angel Interceptor pilots, technicians, flight engineers, security personnel and administration support services.

Cloudbase's aerial position is maintained via the four hover combines. Using solar energy, the powerful engines suck in air, forcing it downwards. In conjunction with anti-gravity generators the combines enable the headquarters to remain stable.

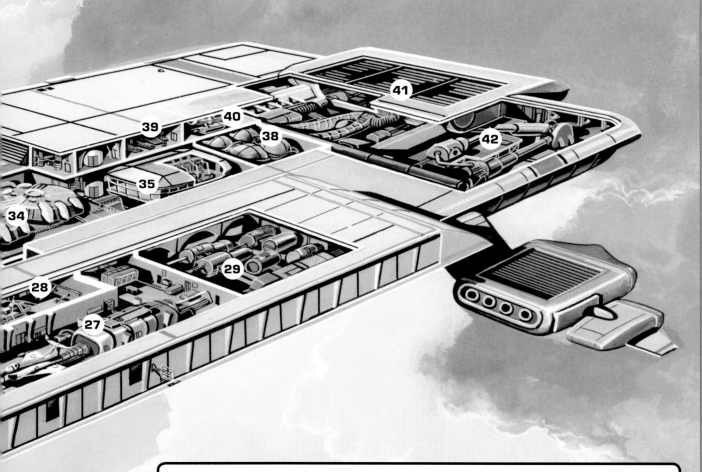

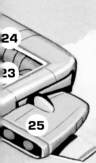

1. Helicopter landing pad. 2. Observation tube. 3. Control centre, including Colonel White's control room, communications and information centre. 4. Officers' rest rooms, recreation facilities and stores. 5. Captains' cabins and VIP guest suites. 6. Primary radar and communications antennae. 7. Escalators built into control centre support stanchions. 8. Maintenance and access corridors behind hover combine leading to escalators. 9. Aircraft beam guidance sensor. 10. Helicopter landing pad with direct access to hospital. 11. Refrigeration unit. 12. Air-conditioning inlets and outlets. 13. Filtered waste disposal unit. 14. Recreation room. 15. One of three gymnasiums. 16. Conference room and 3-D cinema. 17. One of three staff canteens. 18. Amber Room where Angel pilots stand by. 19. Lifts to interceptors via switch back system. 20. Interceptor pilot switch back system takes Angel pilots from lift in three different directions up to their aircraft. 21. Auxiliary radar antennae. 22. Twin manoeuvring jets, either side of the hover combine. 23. Solar powered fan sucks air through grille to hover combine creating down draught. 24. Maintenance corridor and access passage to stabiliser jet nacelle. 25. Stabiliser jet nacelle. 26. Aircraft service lift to Interceptor service bay. 27. Interceptor service bay. 28. Aircraft repair bay and emergency spare parts store. 29. Solar energy conversion turbines. 30. Part of the Cloudbase medical bay. 31. Atomic fusion reactors. 32. Water, air, fuel and gas storage tubes. 33. Air conditioning, water and life-support systems. 34. Auxiliary anti-gravity power generators. 35. Engine room control centre. 36. One of six laboratories. 37. Sports courts. 38. Compressed air tanks for Spectrafan. 39. Recreation rooms. This deck level contains personnel accommodation, recreation facilities, shop, restaurants plus additional hangars for passenger jets and helicopters. 40. Helicopter hangar. 41. Spectrafan lifts hydraulically to stop incoming aircraft in emergency landing situations. 42. Hydraulic lift system of Spectrafan.

CLOUDBASE BRIDGE

DATELINE 2068

The **Cloudbase Command Centre** is effectively the "bridge" of Cloudbase - the nerve centre from which all of Spectrum's activities are controlled. The interior features Colonel White's Control Room, Spectrum Information Centre, Communications and Observation Rooms, plus Environment and life support control systems. Living accommodation for the Spectrum captains and Angels is located here in addition to rooms for lieutenants in charge of security, fire crews and VIP/guest suites.

Covering the surface of the Command Centre are non-reflective solar cells which, together with auxiliary generators, keep the bridge functioning if all power has to be diverted to engines and hover nacelles.

1. Observation tube. 2. Control room featuring the Cloudbase computer manned by Lt. Green, and Colonel White's revolving control desk, a super computer running a programme tailored to his personality. A colour LCD screen behind the desk can display diagrams, video images and other information from the Spectrum information Centre. 3. Cloudbase computer self repair systems. 4. VIP lift to airlock and heli-jet landing pad. 5. Spectrum Information Centre, using seventh generation super computers and liquid plasma information storage systems. 6. Maintenance access to heli-jet landing pad. 7. Observation Room, from which information can be relayed to Lt. Green's console and Spectrum Information Centre. 8. Lift to all decks. 9. Security and Fire control Centre. 10. Maintenance Environmental Control Centre. 11. Service ducts and steam pipes providing power from solar cells covering the Command Centre and other parts of the Cloudbase. 12. Conference room. 13. Auxiliary sick bay: located below the conference room, this is used by Spectrum officers or as an emergency back up unit when the main Medical Bay is working at full capacity. 14. Stairs and escalators to upper decks. 15. Escalator to lower decks. 16. Robot maintenance service ducts. 17. Guest room and VIP suite. 18. Promenade deck. 19. Foam, carbon dioxide and halon storage tanks used to extinguish fires, can be pumped via Cloudbase's extensive piping system to anywhere on the base. 20. Officers' restaurant. 21. Secondary promenade deck. 22. Officers' lounge. 23. Communications console in the lounge provides world TV reception, newspaper printouts and computer facilities. 24. Swimming pool. 25. Women's changing room. 26. Men's changing facilities 27. Gymnasium. 28. Main Communications Room. 29. Emergency lift shaft between the Communications Room and Colonel White's suite. 30. Service ducts provide space for Cloudbase's electronics, heating and plumbing services, allowing access for human and robot maintenance personnel. Computerised self-repair systems are located here, along with solar energy storage banks. 31. Spectrum officer's cabins: a system of prisms and mirrors in each room reflects the view from the six central windows. 32. Colonel White's suite, incorporating a stand-by mini office console and direct access to the Communications Room. 33. Communications antennae.

DATELINE 2068

CLOUDBASE MEDICAL CENTRE

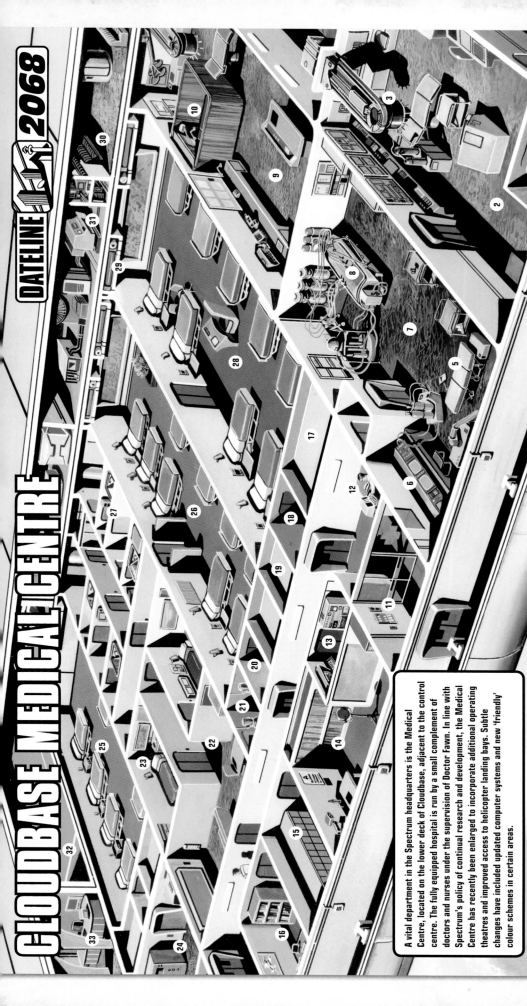

A vital department in the Spectrum headquarters is the Medical Centre, located on the lower deck of Cloudbase, adjacent to the control centre. The fully equipped hospital is run by a small complement of doctors and nurses under the supervision of Doctor Fawn. In line with Spectrum's policy of continual research and development, the Medical Centre has recently been enlarged to incorporate additional operating theatres and improved access to helicopter landing bays. Subtle changes have included updated computer systems and new 'friendly' colour schemes in certain areas.

1. Access corridor from helicopter landing pad to emergency operating theatre. 2. Operating theatre. 3. One of two 'auto-docs' used to assist Doctor Fawn and his colleagues in emergency surgery. System incorporates laser scalpels, mini video and 3D cameras which can be operated automatically, or by specialists in ground based hospitals via computer link. Operating table lighting is supplied via the central hub of the auto-doc. 4. Main access corridor, encircling the perimeter of Cloudbase's lower deck. 5. Auxiliary operating table. 6. X-ray computer and 3D monitor. 7. Main operating theatre. 8. Life recovery unit, although used as a computer-aided operating table, the unit is also employed for the recovery of Captain Scarlet. 9. Pathological and medical laboratory. 10. Standby operating theatre. 11. Decontamination unit, one of several placed at all exits. 12. Medical Centre reception. 13. Computer room, continually checks and monitors the Medical Centre personnel medical micro files. 16. Doctor Fawn's office. 17. Sterilised equipment store. 18. Access to men's pre and post operational ward, and equipment store. 19. Equipment and linen store. 20. Access to women's pre and post operational wards, and linen stores. 21. Robot nurse storage bay. 22. Nurses' quarters. 23. Nurses sleeping quarters. 24. Medical Centre laundry, leading to food preparation bay beyond. 25. General recovery ward. 26. Women's pre and post operational ward. 27. Bathroom facilities, with spa and physiotherapeutic aids. 28. Men's pre and post operational wards. 29. Ceiling mounted privacy screens, located directly above each bed. 30. One of several upper deck rest and recreation rooms. 31. Laboratory. 32. Soundproofed sports hall. 33. Reception for sports hall.

CLOUDBASE AMBER ROOM

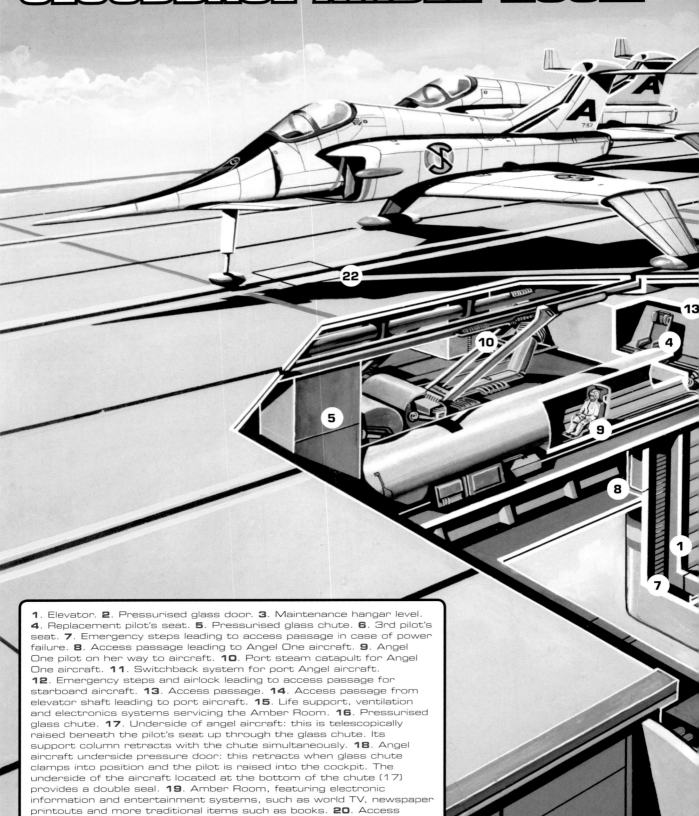

1. Elevator. 2. Pressurised glass door. 3. Maintenance hangar level. 4. Replacement pilot's seat. 5. Pressurised glass chute. 6. 3rd pilot's seat. 7. Emergency steps leading to access passage in case of power failure. 8. Access passage leading to Angel One aircraft. 9. Angel One pilot on her way to aircraft. 10. Port steam catapult for Angel One aircraft. 11. Switchback system for port Angel aircraft. 12. Emergency steps and airlock leading to access passage for starboard aircraft. 13. Access passage. 14. Access passage from elevator shaft leading to port aircraft. 15. Life support, ventilation and electronics systems servicing the Amber Room. 16. Pressurised glass chute. 17. Underside of angel aircraft: this is telescopically raised beneath the pilot's seat up through the glass chute. Its support column retracts with the chute simultaneously. 18. Angel aircraft underside pressure door: this retracts when glass chute clamps into position and the pilot is raised into the cockpit. The underside of the aircraft located at the bottom of the chute (17) provides a double seal. 19. Amber Room, featuring electronic information and entertainment systems, such as world TV, newspaper printouts and more traditional items such as books. 20. Access passage to the rest of Cloudbase. 21. Pressurised water and foam pumps servicing hangars and flight decks. 22. Flight deck hatch.

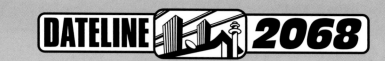
18

12

11

16

14

17

21

15

2

19

20

The Amber room is located beneath the main flight deck of Spectrum's Cloudbase headquarters. It is a warm, restful area set aside as the standy bay for the Angel pilots.

Launching the three Angels is a complicated process, but it takes less than a minute to complete. As Spectrum's first line of defence, the five pilots work four hour shifts, with one of them taking turns to be permanently stationed in the lead aircraft in the flight deck - Angel One.

To reach this Interceptor, the pilot enters the left hand side of the elevator (1) located behind the pressurised glass doors (2). The seated pilot is carried up to the switchback system maintenance hangar level (3), and is rotated ninety degrees to face forward. At this point a replacement pilot's seat (4) located in the shaft leading to the starboard aircraft, is lowered to the bottom of the elevator shaft in readiness for the other pilots to board their craft. The lead Angel reaches the bottom of the pressurised glass chute (5) which extends up through the flight deck hatch (22) to the bottom of the Angel Interceptor. The other Angels use the replacement seat (4) and the right hand seat (6) to gain access to their jets.

GrahamBleathman

ANGEL INTERCEPTOR

The Angel Interceptor is a single seater strike aircraft developed by International Engineering from the World Air Force Viper jet, but the exact specification of its complex systems and panel remain on the secret list.

High capacity fuel tanks enable the Angel Interceptor to complete any mission without refuelling. Entry to the cockpit is by hydraulic lift from the Amber Room, up through the hull of the craft.

Instruments and gunsights are arranged within easy reach of the pilot who has all-round visibility. Behind the pilot's seat is the flight computer and auto-pilot.

1. Emergency braking retro rocket. 2. Braking jet, using bled air from turbine. 3. Pitch jets. 4. Rear-mounted ram-jet, served by twin turbo-jet compressors, one each side of the fuselage. 5. Main inboard fuel tank. 6. Combustion chamber. 7. Cabin pressurisation nitrogen cylinder. 8. Starboard engine multi-compressors. 9. Starboard aileron. 10. Starboard fuel tanks, located below upper wing-frame support. 11. Wing brace housing, containing fuel feed pipes to engine and aileron control electronics. 12. Electronics bay and oxygen cylinder for cabin pressurisation. 13. Starboard docking sensor ensures Interceptor's safe landing on Cloudbase using beam guidance system. 14. Starboard air intake. 15. Starboard undercarriage nacelle containing landing wheel, docking clamp and beam guidance sensor. 16. Flight computer and auto pilot. 17. Canopy jacks. 18. Gunsight grouping. 19. Starboard air-to-air and air-to-ground missile battery. 20. Main centrally placed cannon, firing a variety of ammunition including tracer, armour-piercing and rocket shells. 21. Nose probe containing sensor systems, including wind speed and gust detectors, skin temperature, radar and radio equipment. 22. Forward stabilisers maintain aircraft steadiness at high speeds, preventing nose dip when full throttle is applied suddenly.

DATELINE 2068

SPECTRUM PASSENGER JET

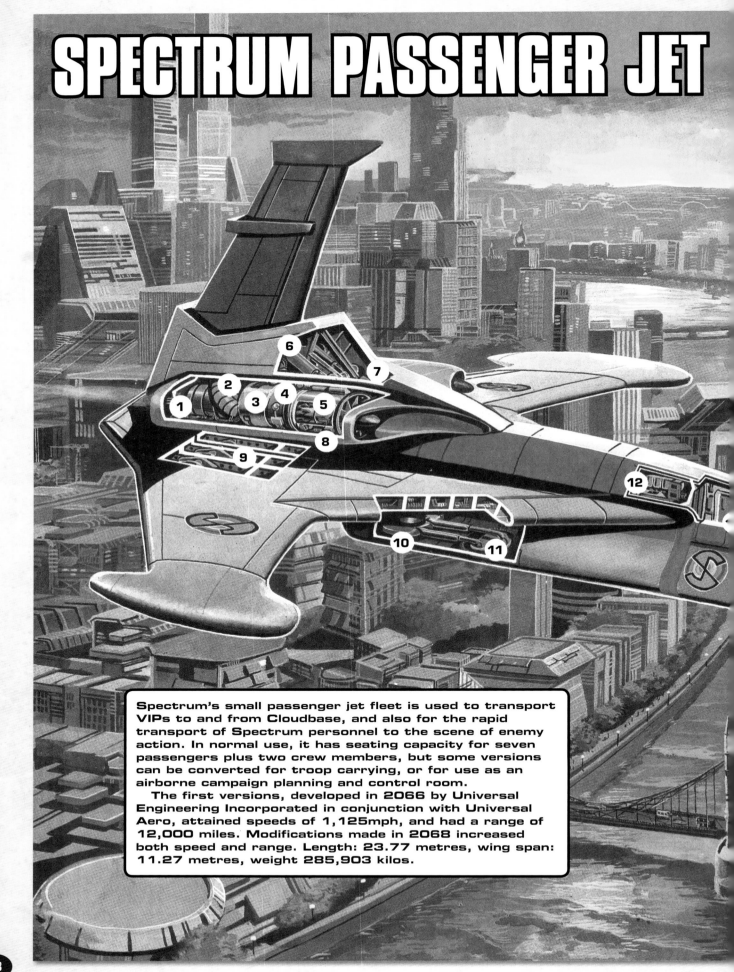

Spectrum's small passenger jet fleet is used to transport VIPs to and from Cloudbase, and also for the rapid transport of Spectrum personnel to the scene of enemy action. In normal use, it has seating capacity for seven passengers plus two crew members, but some versions can be converted for troop carrying, or for use as an airborne campaign planning and control room.

The first versions, developed in 2066 by Universal Engineering Incorporated in conjunction with Universal Aero, attained speeds of 1,125mph, and had a range of 12,000 miles. Modifications made in 2068 increased both speed and range. Length: 23.77 metres, wing span: 11.27 metres, weight 285,903 kilos.

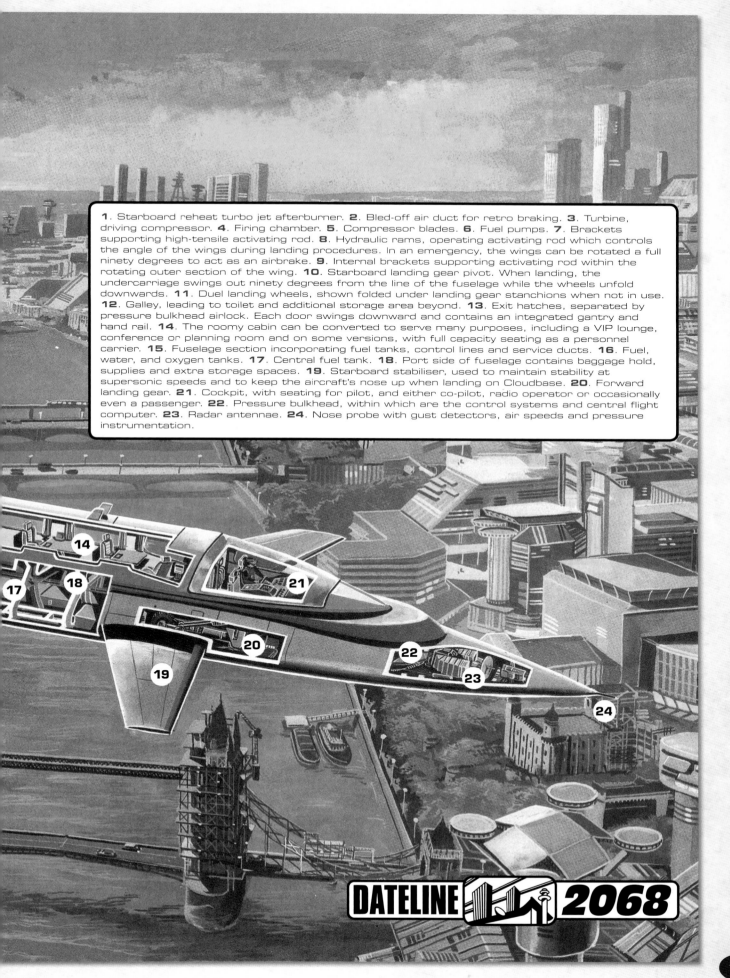

1. Starboard reheat turbo jet afterburner. **2**. Bled-off air duct for retro braking. **3**. Turbine, driving compressor. **4**. Firing chamber. **5**. Compressor blades. **6**. Fuel pumps. **7**. Brackets supporting high-tensile activating rod. **8**. Hydraulic rams, operating activating rod which controls the angle of the wings during landing procedures. In an emergency, the wings can be rotated a full ninety degrees to act as an airbrake. **9**. Internal brackets supporting activating rod within the rotating outer section of the wing. **10**. Starboard landing gear pivot. When landing, the undercarriage swings out ninety degrees from the line of the fuselage while the wheels unfold downwards. **11**. Duel landing wheels, shown folded under landing gear stanchions when not in use. **12**. Galley, leading to toilet and additional storage area beyond. **13**. Exit hatches, separated by pressure bulkhead airlock. Each door swings downward and contains an integrated gantry and hand rail. **14**. The roomy cabin can be converted to serve many purposes, including a VIP lounge, conference or planning room and on some versions, with full capacity seating as a personnel carrier. **15**. Fuselage section incorporating fuel tanks, control lines and service ducts. **16**. Fuel, water, and oxygen tanks. **17**. Central fuel tank. **18**. Port side of fuselage contains baggage hold, supplies and extra storage spaces. **19**. Starboard stabiliser, used to maintain stability at supersonic speeds and to keep the aircraft's nose up when landing on Cloudbase. **20**. Forward landing gear. **21**. Cockpit, with seating for pilot, and either co-pilot, radio operator or occasionally even a passenger. **22**. Pressure bulkhead, within which are the control systems and central flight computer. **23**. Radar antennae. **24**. Nose probe with gust detectors, air speeds and pressure instrumentation.

DATELINE 2068

SPECTRUM HELICOPTER

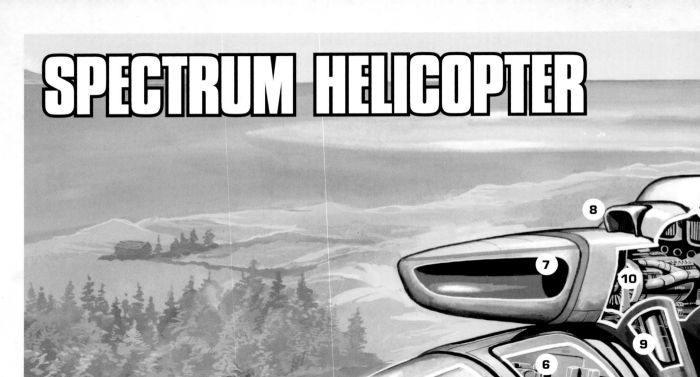

1. Flight instruments measuring windspeed, air pressure and temperature. 2. Wide angle dual-dish radar system. 3. Variable gun attachment, normally carrying a high explosive rocket projectile launcher. 4. Control console, featuring LCD navigation screen and auto pilot situated directly beneath. 5. Central pilot's seat. 6. Passenger seats with service access to electronics bay and storage compartments. 7. Port air intake. 8. Air intake for gearbox cooling system. 9. Cabin air and pressurisation system. 10. Port turbojet driving rotor. 11. Gearbox transmitting drive from turbojets to rotor. 12. Rotor drive shaft housing. 13. Rotor head. 14. Port exhaust bleed off system. 15. Oil cooler. 16. Electronics bay. 17. Fuel tanks. 18. Exhaust outlet for cooling air with bleed off pump serving floats. 19. Booster jet for attaining maximum speed in forward flight. 20. Emergency rocket booster. 21. Rocket fuel tank. 22. Actuator for variable incident tail vanes. 23. Pump regulator controlling air flow to floats. 24. Port float – these can be inflated to any pressure required according to the landing terrain. Air is contained in an inner tube protected by a Maylon armoured outer skin bonded to the metal shoe on top of the float.

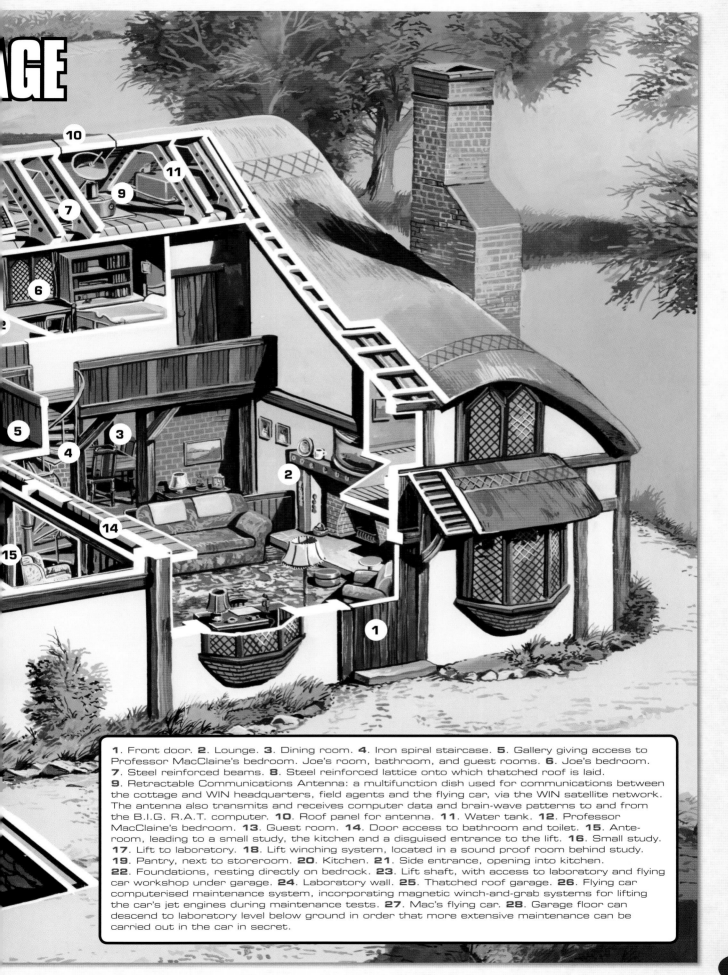

1. Front door. **2**. Lounge. **3**. Dining room. **4**. Iron spiral staircase. **5**. Gallery giving access to Professor MacClaine's bedroom. Joe's room, bathroom, and guest rooms. **6**. Joe's bedroom. **7**. Steel reinforced beams. **8**. Steel reinforced lattice onto which thatched roof is laid. **9**. Retractable Communications Antenna: a multifunction dish used for communications between the cottage and WIN headquarters, field agents and the flying car, via the WIN satellite network. The antenna also transmits and receives computer data and brain-wave patterns to and from the B.I.G. R.A.T. computer. **10**. Roof panel for antenna. **11**. Water tank. **12**. Professor MacClaine's bedroom. **13**. Guest room. **14**. Door access to bathroom and toilet. **15**. Ante-room, leading to a small study, the kitchen and a disguised entrance to the lift. **16**. Small study. **17**. Lift to laboratory. **18**. Lift winching system, located in a sound proof room behind study. **19**. Pantry, next to storeroom. **20**. Kitchen. **21**. Side entrance, opening into kitchen. **22**. Foundations, resting directly on bedrock. **23**. Lift shaft, with access to laboratory and flying car workshop under garage. **24**. Laboratory wall. **25**. Thatched roof garage. **26**. Flying car computerised maintenance system, incorporating magnetic winch-and-grab systems for lifting the car's jet engines during maintenance tests. **27**. Mac's flying car. **28**. Garage floor can descend to laboratory level below ground in order that more extensive maintenance can be carried out in the car in secret.

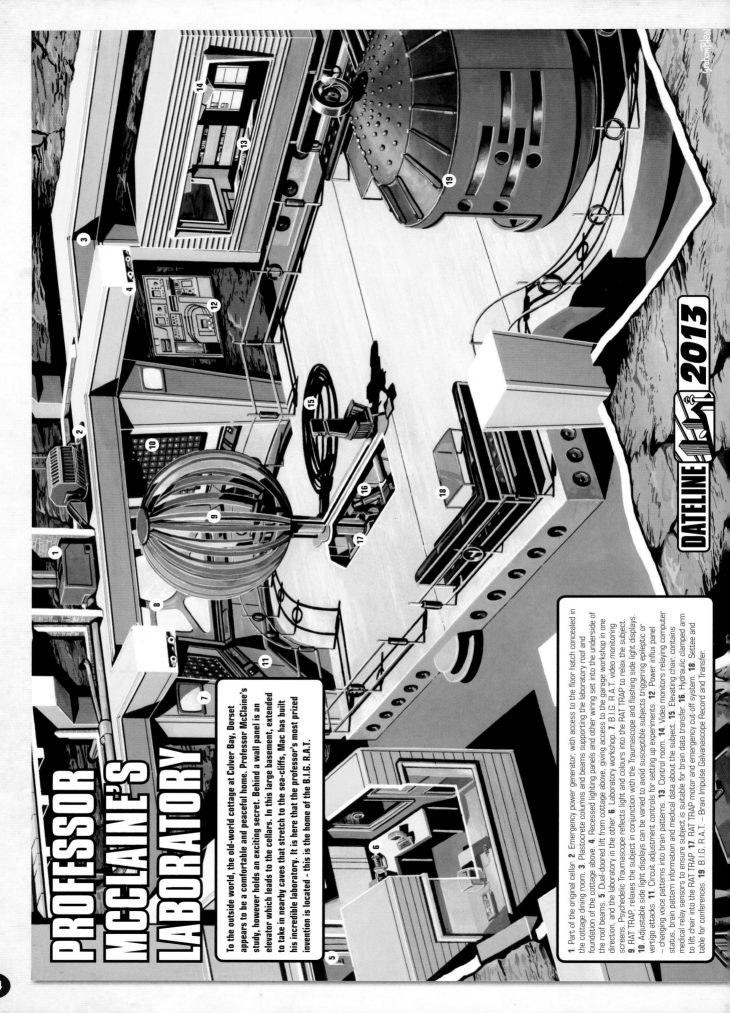

PROFESSOR MCCLAINE'S LABORATORY

To the outside world, the old-world cottage at Culver Bay, Dorset appears to be a comfortable and peaceful home. Professor McClaine's study, however holds an exciting secret. Behind a wall panel is an elevator which leads to the cellars. In this large basement, extended to take in nearby caves that stretch to the sea-cliffs, Mac has built his incredible laboratory. It is here that the professor's most prized invention is located – this is the home of the B.I.G. R.A.T.

DATELINE 2013

1. Part of the original cellar: 2. Emergency power generator; with access to the floor hatch concealed in the cottage dining room. 3. Plastocrete columns and beams supporting the laboratory roof and foundation of the cottage above. 4. Recessed lighting panels and other wiring set into the underside of the roof beams. 5. Dual-doored lift from cottage above, giving access to the garage workshop in one direction, and the laboratory in the other: 6. Laboratory workshop. 7. B.I.G. R.A.T. video monitoring screens. Psychedelic Traumascope reflects light and colours into the RAT TRAP to relax the subject. 9. RAT TRAP, relaxes the subject: in conjunction with the Traumascope and flashing side light displays. 10. Adjustable side light displays can be varied to avoid susceptible subjects triggering epileptic or vertigo attacks. 11. Circuit adjustment controls for setting up experiments. 12. Power influx panel – changing voice patterns into brain patterns. 13. Control room. 14. Video monitors relaying computer status, brain pattern information and medical data about the subject. 15. Elevating chair, contains medical relay sensors to ensure subject is suitable for brain data transfer: 16. Hydraulic clamped arm to lift chair into the RAT TRAP. 17. RAT TRAP motor and emergency cut-off system. 18. Settee and table for conferences. 19. B.I.G. R.A.T. – Brain Impulse Galvanascope Record and Transfer.

THE B.I.G. R.A.T. COMPUTER

DATELINE 2013

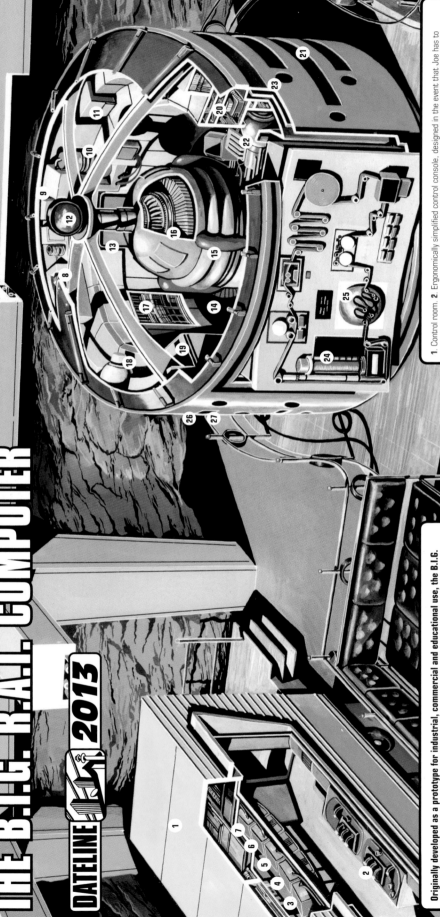

Originally developed as a prototype for industrial, commercial and educational use, the B.I.G. R.A.T. was created after Convex Computers asked Professor McClaine to invent a computer to effect knowledge transference. McClaine turned their down stating that such a computer would take at least four years to develop while Convex wanted to have it in mass production in two years. In the end, B.I.G. R.A.T. or Brain Impulse Galvanascope Record and Transfer took five years to complete and is installed in the Professor's laboratory under his cottage in Dorset.

In the world of micro computers, the most striking aspect of the B.I.G. R.A.T. is its size. Because it is a prototype, there was no need to produce a miniature version. Retrieving brain patterns for W.I.N's use is carried out with portable antennae, some of which are disguised and hand-held. The information is beamed from any point on Earth via W.I.N satellites to the Receiving Dish on McClaine's cottage roof - then down to the computer itself. The relevant information is analysed, selected and stored, ready for transmission to the electrodes fitted to the chair in the RAT TRAP. The RAT TRAP and Traumascope - which emits flashing lights and sounds - are used to relax the subject while the impulses are fed into his brain. By wearing specially prepared spectacles, also fitted with information-triggering electrodes, Joe is ready to carry out his mission, whilst still retaining his personality. Without the glasses, Joe remembers none of the information fed to him from the B.I.G. R.A.T.

1 Control room. **2** Ergonomically simplified control console, designed in the event that Joe has to operate the computer without the aid of his glasses. **3** Control systems monitor. **4** B.I.G. R.A.T. computer systems monitor. **5** Rat Trap systems monitor. **6** Medical monitor relaying heartbeat, pulse and temperature of subject. **7** Brain scanning monitor; relays three-dimensional image of brain, with information from the computer about the subject's suitability for brain pattern transfer. **8** Input recording system. **9** Data Input Receiver; relaying brain patterns from external sources via portable scanning devices or roof antenna. **10** Master switch gear operated from control room. **11** Overload re-routing units. **12** Plasma-surge damper. **13** Access hatch at rear landing for someone to climb into it for maintenance. **14** Maintenance gangway; the computer is large enough for someone to climb into it for maintenance and inspection purposes. The internal space also increases the air circulation via ventilation ports (21) needed to maintain low operating temperatures. **15** Super cooled insulated Memory Bank Chamber. **16** Master Memory Bank; brain pattern information, stored on micro-disk, can be monitored and edited if necessary in the control room before or during transfer to the subject. **17** Feedback Correction Channels. **18** Vacuum pump, used to maintain a dust free internal environment within the computer by periodically pumping the air out to clean it. **19** Power Distribution Box. **20** Medical monitor and brain scanner. Linked to the subject's electrodes, the scanner ensures that the brain pattern transfer will have no detrimental effects, such as causing epilepsy. **21** Ventilation ports. **22** Impulse Magnifier. **23** Electro-encephaloid. **24** Sliding panel cover (retracted). **25** Manual Switch Gear. **26** Professional standard self-feed video tape, onto which the Traumascope lighting and sound effects are recorded. **27** Helium pump refrigeration unit. **28** Under-floor cables leading to power supply, control room and Rat Trap. **29** Cable junction box. **30** Rat Trap chair floor slot.

W.I.N. HEADQUARTERS - LONDON

DATELINE 2013

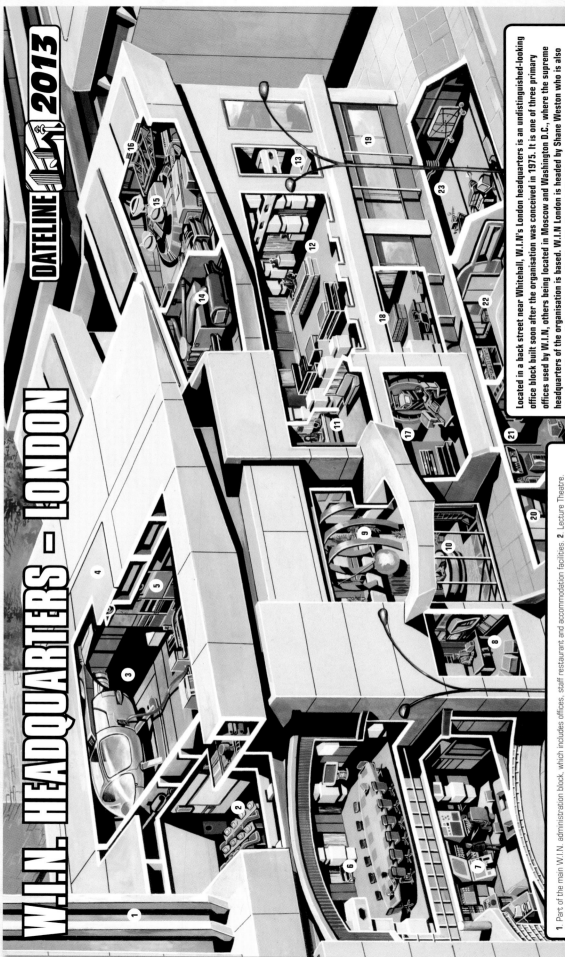

Located in a back street near Whitehall, W.I.N's London headquarters is an undistinguished-looking office block built soon after the organisation was conceived in 1975. It is one of three primary offices used by W.I.N, others being located in Moscow and Washington D.C, where the supreme headquarters of the organisation is based. W.I.N London is headed by Shane Weston who is also the deputy director of the main organisation. His deputy is Sam Loover.

Around one hundred people work at the London offices, and included a wide variety of personnel from catering and cleaning staff through to secretaries, administrators, agents and scientists. Whatever their role within the organisation, all have signed Britain's Official Secrets Act, and have been rigorously screened by the Personnel department. Most of W.I.N's agents originate from the now disbanded M.I.5, C.I.A, and K.G.B organisations. Those who did not obtain one hundred percent in W.I.N's proficiency tests were debriefed and returned to civilian life.

As well as adminstrative offices, the London H.Q also incorporates laboratories and weapons testing facilities, and a heli-jet landing pad for emergency use.

1. Part of the main W.I.N. administration block, which includes offices, staff restaurant and accommodation facilities. 2. Lecture Theatre. 3. W.I.N. heli-jet docked in sound-proofed hangar. 4. Hangar doors. 5. Heli-jet maintenance bay and aviation fuel pumps leading to below ground storage tanks. 6. Conference room. 7. Main computer and communications bay. 8. Guard room, with video monitoring equipment linked to all rooms and corridors. 9. First floor reception hall balcony, with corridors leading to various W.I.N. offices. 10. Reception. 11. Shane Weston's outer office. 12. Shane Weston's office. 13. Computerised records office. 14. W.I.N offices and field agents via the W.I.N. satellite network. 16. Solar energy receiving and broadcasting signals and messages to other W.I.N offices used by senior W.I.N. personnel. 18. W.I.N. security chief's office. 19. W.I.N. security panels. 17. Security reception bay, giving access to offices used by senior W.I.N. personnel. 18. W.I.N. security chief's office. 19. W.I.N. security administration offices. 20. Access door to W.I.N. forensic and micro-biological offices. 21. Security reception bay, giving access to Weapons Research Laboratory. 22. Weapons Research Laboratory, where Joe 90's briefcase weaponry was developed. 23. Weapons testing laboratory.

SAM LOOVER'S CAR

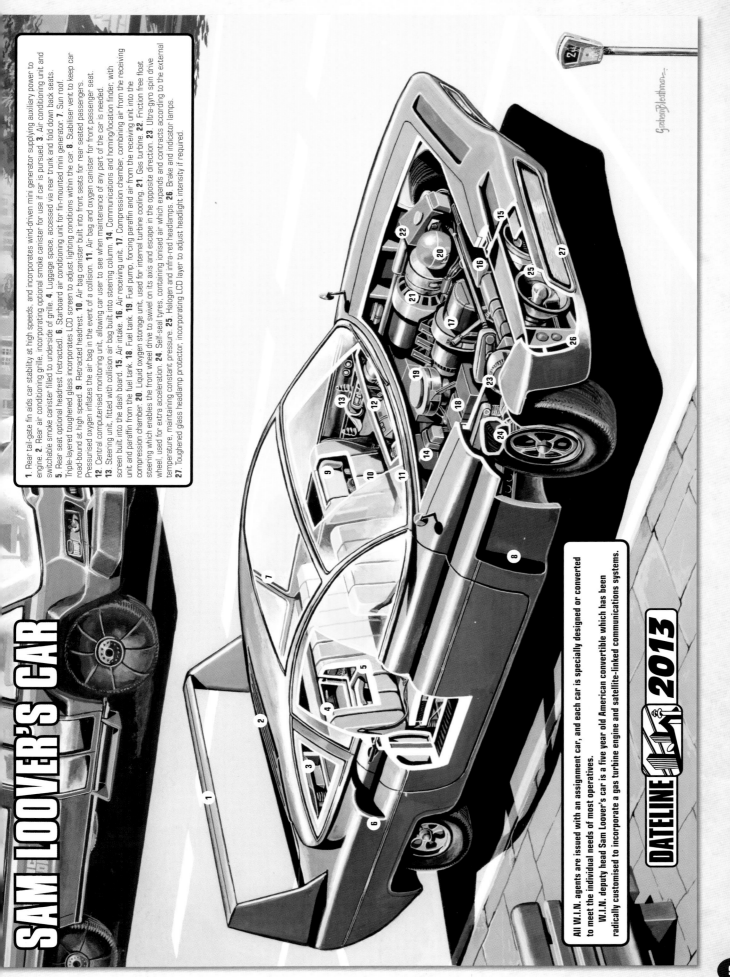

1. Rear tail-gate fin aids car stability at high speeds, and incorporates wind-driven mini generator supplying auxiliary power to engine. 2. Rear air conditioning grille, incorporating optional smoke canister for use if car is pursued. 3. Air conditioning unit and switchable smoke canister filled to underside of grille. 4. Luggage space, accessed via rear trunk and fold down back seats. 5. Rear seat optional headrest (retracted). 6. Starboard air conditioning unit for fin-mounted mini generator. 7. Sun roof. Triple-layered toughened glass incorporates LCD screen to adjust lighting conditions within the car. 8. Stabiliser vent to keep car road-bound at high speed. 9. Retracted headrest. 10. Air bag canister built into front seats for rear seated passengers. Pressurised oxygen inflates the air bag in the event of a collision. 11. Air bag and oxygen canister for front passenger seat. 12. Central computerised monitoring unit, allowing car user to see when maintenance of any part of the car is needed. 13. Steering unit, fitted with collision air bag built into steering column. 14. Communications and homing/location finder, with screen built into the dash board. 15. Air intake. 16. Air receiving unit. 17. Compression chamber, combining air from the receiving unit and paraffin from the fuel tank. 18. Fuel tank. 19. Fuel pump, forcing paraffin and air from the receiving unit into the compression chamber. 20. Liquid oxygen storage unit, used for internal turbine cooling. 21. Gas turbine. 22. Friction free float steering which enables the front wheel drive to swivel on its axis and escape in the opposite direction. 23. Ultra-gyro spin drive wheel, used for extra acceleration. 24. Self-seal tyres, containing ionised air which expands and contracts according to the external temperature, maintaining constant pressure. 25. Halogen and infra-red headlamps. 26. Brake and indicator lamps. 27. Toughened glass headlamp protector, incorporating LCD layer to adjust headlight intensity if required.

DATELINE 2013

All W.I.N. agents are issued with an assignment car, and each car is specially designed or converted to meet the individual needs of most operatives.

W.I.N. deputy head Sam Loover's car is a five year old American convertible which has been radically customised to incorporate a gas turbine engine and satellite-linked communications systems.

JOE 90: WORLD INTELLIGENCE NETWORK

97

WORLD GOVERNMENT HQ IN UNITY CITY

Built on the site of Hamilton in Bermuda, Unity City is the capital of the world; the centre of World Government.

It is a small city in comparison to national capitals, but nearly all of its population of around 100,000 have some involvement in the administration of the Government, which has been in power since 2012.

Most of the world's security, military, social and economic organisations have offices here, even though their respective headquarters are dotted throughout the globe. The World Army Airforce, for example, is based in Boscombe, Wiltshire, England, whilst the World Navy is based in Sydney, Australia, not far from the headquarters of Universal Engineering Incorporated.

The World President is Nikita Bandranaik, who came to power in 2012 and has been re-elected ever since.

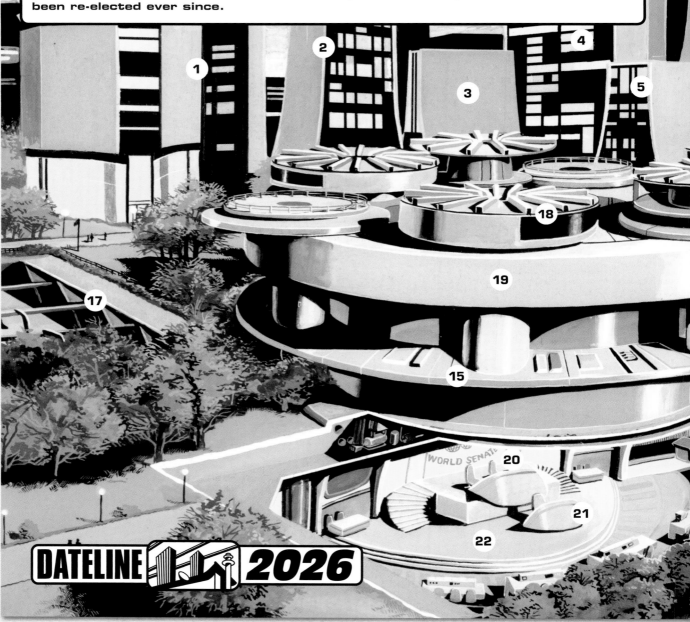

DATELINE 2026

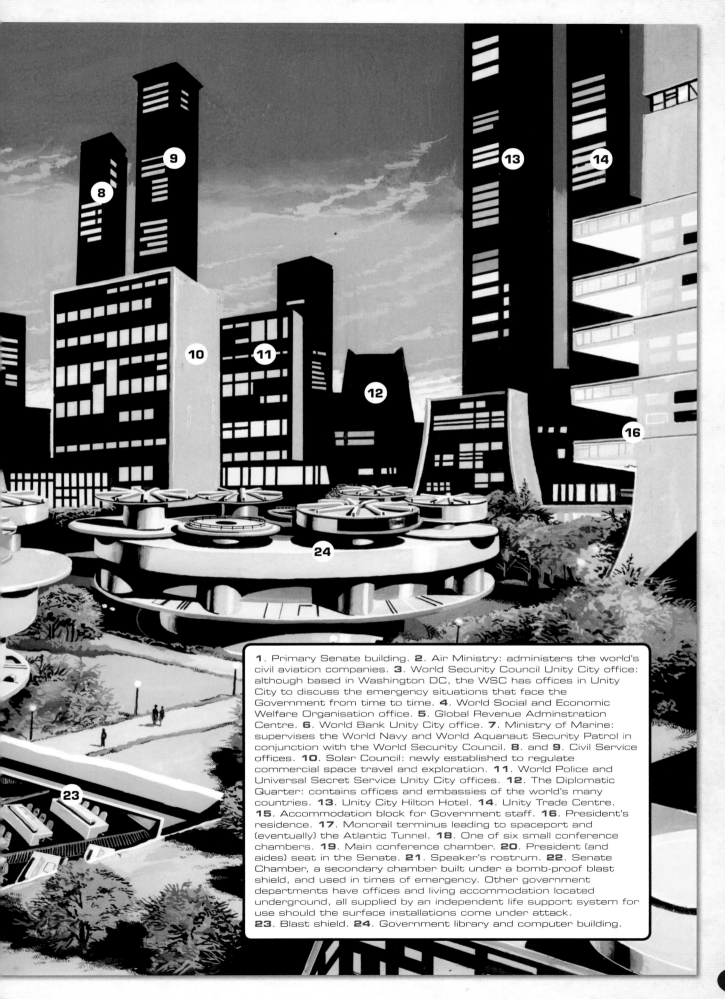

1. Primary Senate building. **2**. Air Ministry: administers the world's civil aviation companies. **3**. World Security Council Unity City office: although based in Washington DC, the WSC has offices in Unity City to discuss the emergency situations that face the Government from time to time. **4**. World Social and Economic Welfare Organisation office. **5**. Global Revenue Adminstration Centre. **6**. World Bank Unity City office. **7**. Ministry of Marine: supervises the World Navy and World Aquanaut Security Patrol in conjunction with the World Security Council. **8**. and **9**. Civil Service offices. **10**. Solar Council: newly established to regulate commercial space travel and exploration. **11**. World Police and Universal Secret Service Unity City offices. **12**. The Diplomatic Quarter: contains offices and embassies of the world's many countries. **13**. Unity City Hilton Hotel. **14**. Unity Trade Centre. **15**. Accommodation block for Government staff. **16**. President's residence. **17**. Monorail terminus leading to spaceport and (eventually) the Atlantic Tunnel. **18**. One of six small conference chambers. **19**. Main conference chamber. **20**. President (and aides) seat in the Senate. **21**. Speaker's rostrum. **22**. Senate Chamber, a secondary chamber built under a bomb-proof blast shield, and used in times of emergency. Other government departments have offices and living accommodation located underground, all supplied by an independent life support system for use should the surface installations come under attack.
23. Blast shield. **24**. Government library and computer building.

U87 WORLD ARMY TRANSPORT VEHICLE

DATELINE 2013

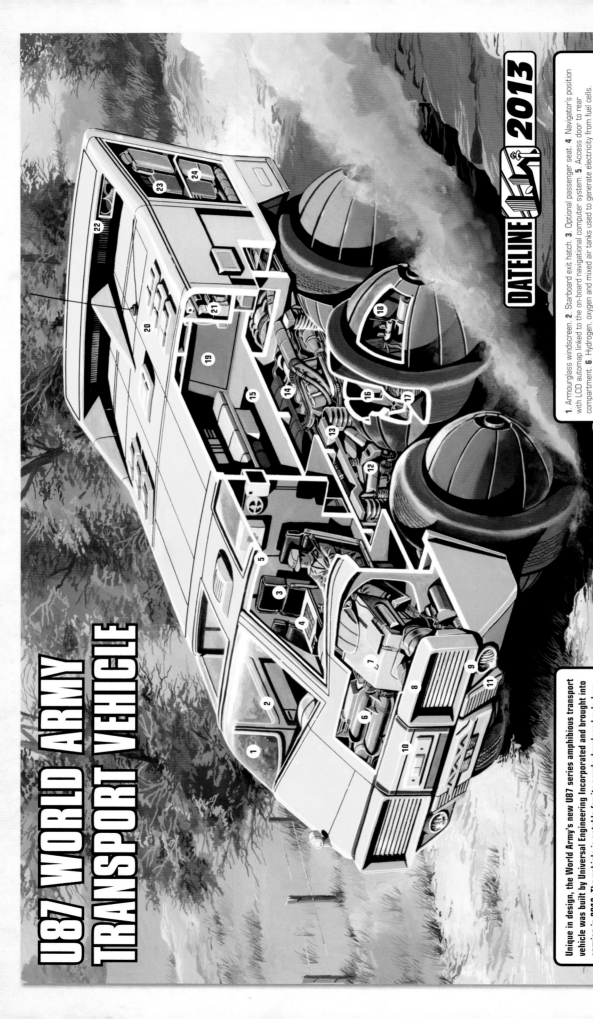

1. Armourglass windscreen. 2. Starboard exit hatch. 3. Optional passenger seat. 4. Navigator's position with LCD automap linked to the on-board navigational computer system. 5. Access door to rear compartment. 6. Hydrogen, oxygen and mixed air tanks used to generate electricity from fuel cells. 7. Navigational and on-board systems analysis systems analysis computer. 8. Halogen and infra-red head lamps. 9. Indicator lights. 10. Infra-red and radar scanner. 11. Forward filtered air intakes can optionally cool engine and/or driver's cabin. 12. Axle-less wheel support system allowing total flexibility of wheel movement. 13. Newly developed Frictionless Free Float suspension system. 14. One of three fuel cells. 15. Rear compartment can be converted to carry troops, or used to transport supplies. Some versions can be transported to ambulance use. 16. Air-tight flotation tanks used for water travel. 17. All-terrain self-sealing central wheel with built in hydraulic braking. 18. Flotation chamber air pump and regulator, eight in each wheel maintaining constant air pressure. 19. Rear exit hatch. 20. Emergency solar power cells. 21. Communications console. 22. Rear-mounted air intake behind tail plane grille. 23. Port fuel cell. 24. Air pump and compressor relaying air from rear intake to engine and wheel flotation tanks.

Unique in design, the World Army's new U87 series amphibious transport vehicle was built by Universal Engineering Incorporated and brought into service in 2012. The vehicle is notable for its newly developed axle-less wheel support system that allows for greater flexibility of wheel movement over rough terrain. This, in conjunction with the new Frictionless Free Float suspension means the U87 series is ideal as a military ambulance if the vehicle is fitted out for that purpose.

The transporter is capable of travelling at great speeds on water, thanks to the built in flotation and buoyancy tanks in each wheel, and the Aqua-jet propulsion unit fitted to the underside of the rear.

JUMPING JACK HELI-JET

Built by Universal Engineering Incorporated, the Jumping Jack helijet has become the workhorse of passenger and freight carrying organisations all over the world, and as such has been produced in many liveries. The Jumping Jack is also in use in US divisions of the World Army, where its swift lift and land facilities, coupled with an ability to operate in almost any weather conditions have proven invaluable in troop-carrying operations.

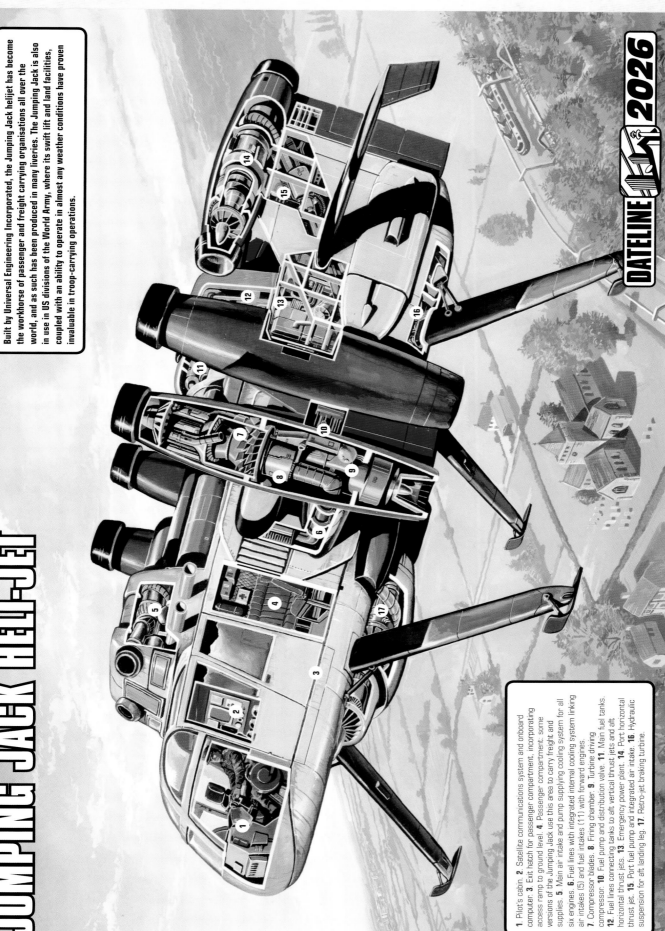

1. Pilot's cabin. 2. Satellite communications system and onboard computer. 3. Exit hatch for passenger compartment, incorporating access ramp to ground level. 4. Passenger compartment; some versions of the Jumping Jack use this area to carry freight and supplies. 5. Main air intake and pump supplying cooling system for all six engines. 6. Fuel lines with integrated internal cooling system linking air intakes (5) and fuel intakes (11) with forward engines. 7. Compressor blades. 8. Firing chamber: 9. Turbine driving compressor: 10. Fuel pump and distribution valve. 11. Main fuel tanks. 12. Fuel lines connecting tanks to aft vertical thrust jets and aft horizontal thrust jets. 13. Emergency power plant. 14. Port horizontal thrust jet. 15. Port fuel pump and integrated air intake. 16. Hydraulic suspension for aft landing leg. 17. Retro-jet braking turbine.

SIDEWINDER

Twenty huge 'Jungle Cat' class Sidewinders have recently gone into service with U.S. Army units of the World Army Airforce. Following trials of a prototype Sidewinder in June 2026, several improvements have been made to the original design in these production versions. Built by Universal Engineering Incorporated, and powered by atomic batteries, the gyroscopically balanced Sidewinder can clear whole areas of jungle or forest creating landing sites for helijets and troop carrying aircraft.

Improvements made since the initial prototype tests include the addition of vertical thrust hover jets. This modification stabilises the progress of the machine. In battle conditions, forcefield projection generators protect the legs from enemy gunfire.

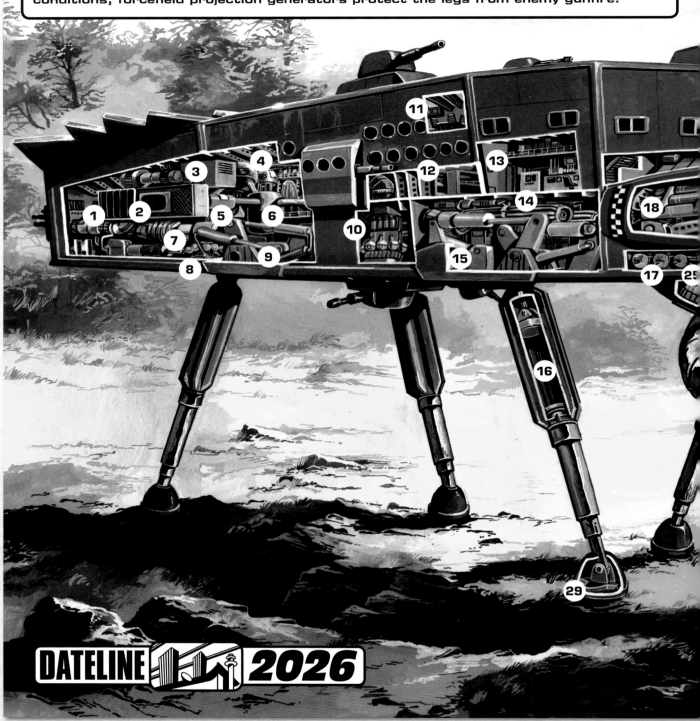

DATELINE 2026

1. Standby turbojet generator. 2. Heat disposal unit.
3. Main pump. 4. Condenser rectifier. 5. Heat exchanger.
6. Atomic battery. 7. Distributor valve. 8. Emergency
starboard aft vertical thrust hover combine: one of five
enabling Sidewinder to hover at ground level if the legs are
damaged or removed. 9. Hydraulic walk gearing for
starboard aft leg. 10. Forward starboard emergency vehicle
thrust hover combine. 11. Crews' quarters: recreation
area. 12. Crews' quarters: sleeping area. 13. Computer
and gyroscope monitoring station, below officers' quarters.
14. Hold, containing two spare retracted legs and auto
repair systems. 15. Hydraulic walk gearing for starboard
forward leg. 16. Cahelium-strengthened leg containing
hydraulic suspension system. 17. Starboard force field
projection generator (retracted) protecting the underside of
Sidewinder in battle conditions. 18. Starboard missile firing
system behind searchlight. 19. Searchlight retracts to allow
missile firing. 20. Operations room. 21. Automatic missile
firing system for topside forward guns, controlled from the
operations room. 22. Access lift to all floors: one of several
that projects via a retractable tube to ground level allowing
access to the craft. 23. Control room. 24. Force field
generators double as particle beam guns. 25. Centrally
placed forward emergency vertical thrust hover combine.
26. Grab control gearing. 27. Cahelium-strengthened
interlocking grab control mechanism. 28. Grab pincers
containing laser cutters in addition to cahelium-strengthened
'teeth'. 29. Internal pivoting system in feet containing
sensors to register ground conditions. The system
automatically selects the strongest patch of ground within a
10 metre radius split seconds before the foot touches
down. If the ground cannot support the weight of the foot
and the rest of the vehicle above, the emergency vertical
thrust hover jets automatically cut in.

WORLD NAVY
CLAM SUBMARINE

Clam-class submarines are gradually being phased out by the World Navy in favour of the newer 'Barracuda' class vessels. Clam submarines have been in service for over 40 years and were upgraded in the 2050s when the bridge and conning tower sections were redesigned. Additionally, extra missile launchers were installed along with onboard VTOL aircraft for use when the vessel has surfaced. Although most of the Clam submarines are in the process of being decommissioned, a small number have been seconded to Spectrum, who will continue to operate them for a further five years.

DATELINE 2065

WORLD NAVY WARSHIP SEA LEOPARD

When the USN Sentinel was launched in the mid 2020s, it was the first of a new breed of warship – the high speed surface vessel , achieving 200 knots. Now, over 35 years later, with the emergence of the hostile undersea races, the defence tactics have changed. Now fast support ships rather than conventional fleet vessels are needed. To support its over-worked submarines, WASP has developed its own high speed surface vessels, known as Sea Leopard series. Designed by Embleton Associates and built by Universal Engineering Incorporated, "Sea Leopard 1" was launched over a year ago and has already seen action against Titan's Terror Fish.

Its twin Seaspirit Aquajets can achieve speeds of over 300 knots and together with its **10** multi-purpose missile launchers and **16** "Hummingbird" strike aircraft, it has already proved to be a formidable force against Titan's forces.

1. Starboard missile launcher control system and auto missile loading units. 2. Missile launchers, can be rotated 120 degrees for aerial targets, and reversed to face seaward for underwater targets. Launchers can be operated separately or in combination. 3. Cahelium-strengthened hangar doors slide across hangar entrances in poor weather conditions. 4. Auto crash unit includes fire fighting equipment, crash nets and force-field generator to aid returning aircraft damaged in combat. 5. Aircraft launch catapult. 6. Aircraft launch blast shield. 7. Forward recovery bay workshop, accessed via aircraft lift. 8. Forward recovery bay lifting cranes and maintenance services. 9. Port weapons store. 10. Maintenance crane and auto fuel injection system. 11. Lifeboats. 12. Blue Whale Air Sea Rescue helijet. 13. Rear recovery bay used for helijets only. 14. V.I.P. or visiting personnel lounge. 15. Weaponry control centre. 16. Canteen. 17. Conference room. 18. Visiting personnel quarters. 19. Control room and communications station. 20. Operations room, incorporating Hydrographic Battle Strategy Auto-chart, and computer monitoring station. 21. Officers' mess. 22. Recreation room. 23. Crew's quarters. 24. Pilot's quarters. 25. Satellite communications system and sensor dome. 26. Life support systems and central computer. 27. Access lift to computer and communications dome, used for maintenance only. 28. Central stabilising fin. 29. Graphite-shielded atomic fusion reactor. 30. Atomic fuel store - also radiation shield. 31. Heat exchanger. 32. Port 'Seasprint' Aquajet. 33. Port stabilising fin. 36. One of sixteen WASP "Hummingbird" fighter aircraft. 37. World Air Force Bomber. 38. Part of Marineville's coastal base, located ten miles from the Ocean Doors.

KATANNIA, CAPITAL OF BEREZNIK

DATELINE 2026

Carved out of civil war-torn central Europe in 2010, the state of Bereznik occupies an area covering the eastern regions of Germany, parts of Czechoslovakia and the Ukraine, and virtually all of Poland. Its capital is Katania named after the daughter of the Bereznik dictator, General Berenora.

The city was built to accommodate Bereznik's government departments, including social welfare, civil service, military and police agencies. Agents for the World Government's Universal Secret Service report that the secret police and intelligence services are also located here, in buildings adjacent to the State Prison and Scientific Research Unit.

1. Civil Service headquarters. 2. Katania Nval Base, home to Bereznik's Baltic Fleet. 3. Military heli-jet. 4. Bereznik Naval Ministry. 5. Scientific Research Unit. 6. Weapons Research laboratories. 7. Biological warfare laboratories. 8. Lecture theatre. 9. Conference room. 10. Computer room: contains monitors from secret surveillance systems installed in all government departments. 11. Turbo-lift to all floors. 12. Protective bomb-proof shield: one of four surrounding the main tower that can be raised to cover the entire building in the event of an air attack. 13. Power, sanitation and water service pipes automatically shut down when the shield is raised. The building's own emergency supplies cut in when the shield is in place. 14. Prison cells. 15. Prisoner interrogation cell. 16. Prison cells, with guards' recreation room below. 17. Main building of the Bereznik State Prison. 18. Bereznik Secret Police headquarters.

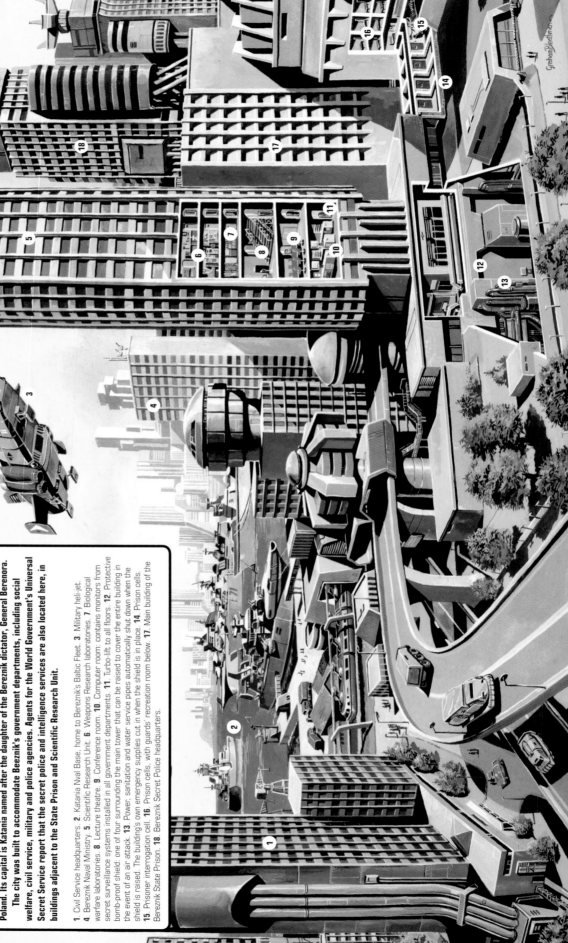

BEREZNIK BATTLE TANK

Built by Matthias Gmbh in Bautzin for the Bereznik Army, the Berenova MK III Battle Tank has recently gone into service on the east and west borders of Bereznik. Normally manned by a crew of three, the tanks can be operated by the driver only, as all armament controls are duplicated at the drivers seat. It is capable of travelling up to 80mph, and weighs 320 tonnes. World Government sources estimate that 200 of these vehicles will be in service by the end of 2027.

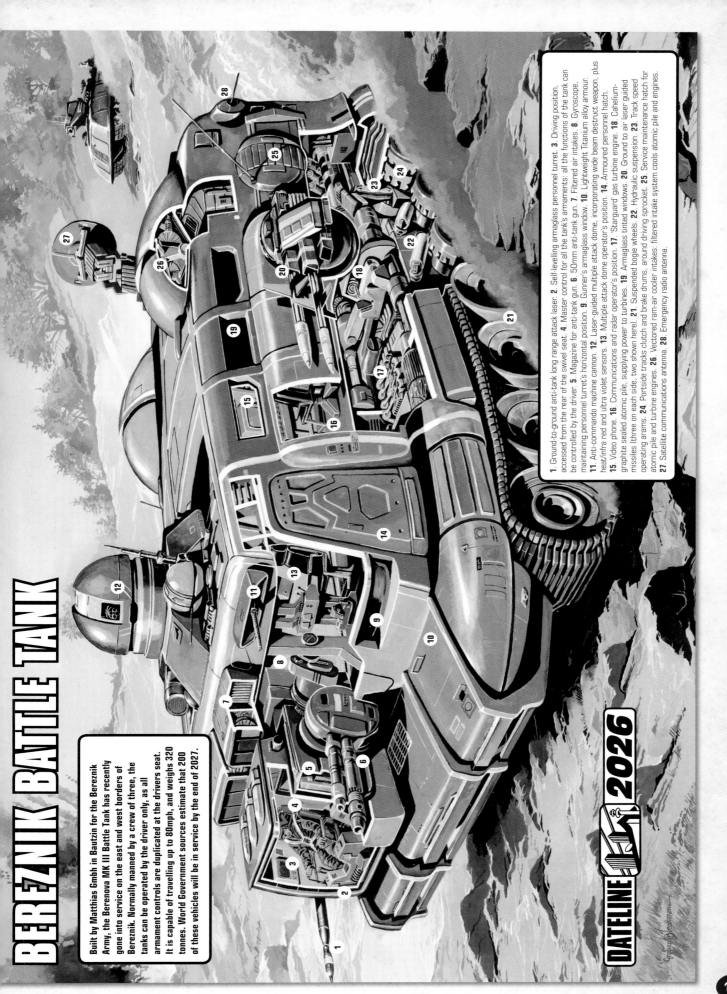

1. Ground-to-ground anti-tank long range attack laser: 2. Self-levelling armaglass personnel turret. 3. Driving position, accessed from the rear of the swivel seat. 4. Master control for all the tank's armaments: all the functions of the tank can be controlled by the driver. 5. Magazine for anti-tank gun. 6. 50mm anti-tank gun. 7. Filtered air intakes. 8. Gyroscope, maintaining personnel turret's horizontal position. 9. Gunner's armaglass window. 10. Lightweight Titanium alloy armour. 11. Anti-commando machine cannon. 12. Laser-guided multiple attack dome, incorporating wide beam destruct weapon, plus heat/infra red and ultra violet sensors. 13. Multiple attack dome operator's position. 14. Armoured personnel hatch. 15. Video phone. 16. Communications and radar operator's position. 17. 'Starguard' gas turbine engine. 18. Cahelium-graphite sealed atomic pile, supplying power to turbines. 19. Armaglass tinted windows. 20. Ground to air laser guided missiles (three on each side, two shown here). 21. Suspended bogie wheels. 22. Hydraulic suspension. 23. Track speed operating arams. 24. Portside tracks clutch and brake drums, around driving sprocket. 25. Service maintenance hatch for atomic pile and turbine engines. 26. Vectored ram-air cooler intakes: filtered intake system cools atomic pile and engines. 27. Satellite communications antenna. 28. Emergency radio antenna.

DATELINE 2026

WORLD SECURITY PATROL BUILDING, WASHINGTON

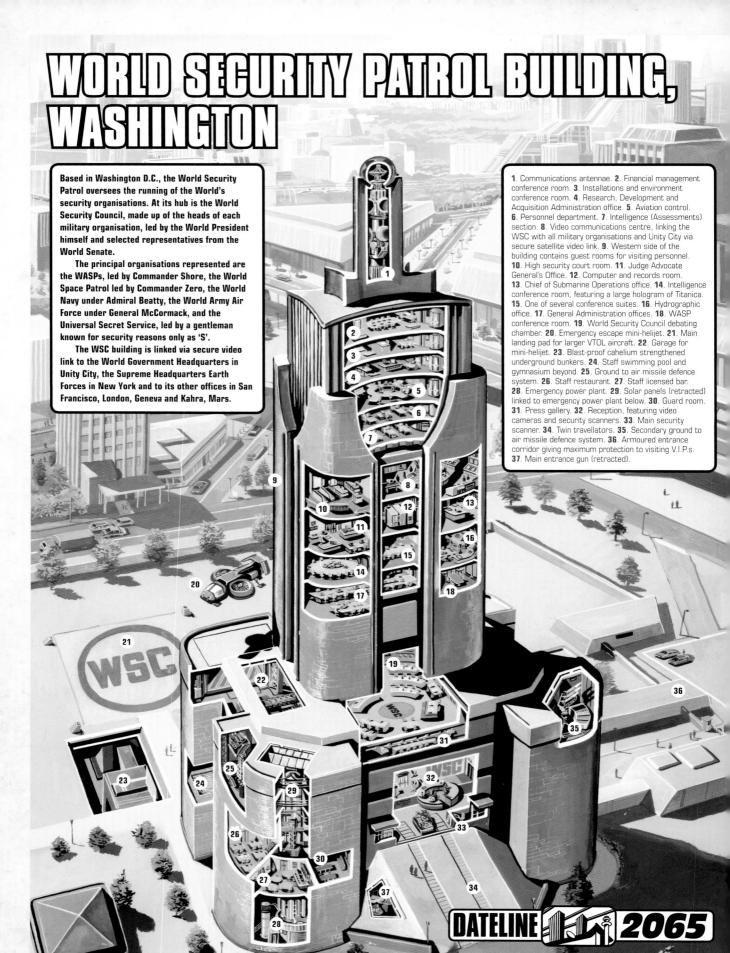

Based in Washington D.C., the World Security Patrol oversees the running of the World's security organisations. At its hub is the World Security Council, made up of the heads of each military organisation, led by the World President himself and selected representatives from the World Senate.

The principal organisations represented are the WASPs, led by Commander Shore, the World Space Patrol led by Commander Zero, the World Navy under Admiral Beatty, the World Army Air Force under General McCormack, and the Universal Secret Service, led by a gentleman known for security reasons only as 'S'.

The WSC building is linked via secure video link to the World Government Headquarters in Unity City, the Supreme Headquarters Earth Forces in New York and to its other offices in San Francisco, London, Geneva and Kahra, Mars.

1. Communications antennae. 2. Financial management conference room. 3. Installations and environment conference room. 4. Research, Development and Acquisition Administration office. 5. Aviation control. 6. Personnel department. 7. Intelligence (Assessments) section. 8. Video communications centre, linking the WSC with all military organisations and Unity City via secure satellite video link. 9. Western side of the building contains guest rooms for visiting personnel. 10. High security court room. 11. Judge Advocate General's Office. 12. Computer and records room. 13. Chief of Submarine Operations office. 14. Intelligence conference room, featuring a large hologram of Titanica. 15. One of several conference suites. 16. Hydrographic office. 17. General Administration offices. 18. WASP conference room. 19. World Security Council debating chamber. 20. Emergency escape mini-helijet. 21. Main landing pad for larger VTOL aircraft. 22. Garage for mini-helijet. 23. Blast-proof cahelium strengthened underground bunkers. 24. Staff swimming pool and gymnasium beyond. 25. Ground to air missile defence system. 26. Staff restaurant. 27. Staff licensed bar. 28. Emergency power plant. 29. Solar panels (retracted) linked to emergency power plant below. 30. Guard room. 31. Press gallery. 32. Reception, featuring video cameras and security scanners. 33. Main security scanner. 34. Twin travellators. 35. Secondary ground to air missile defence system. 36. Armoured entrance corridor giving maximum protection to visiting V.I.P.s. 37. Main entrance gun (retracted).

DATELINE 2065

MOVING THE EMPIRE STATE BUILDING

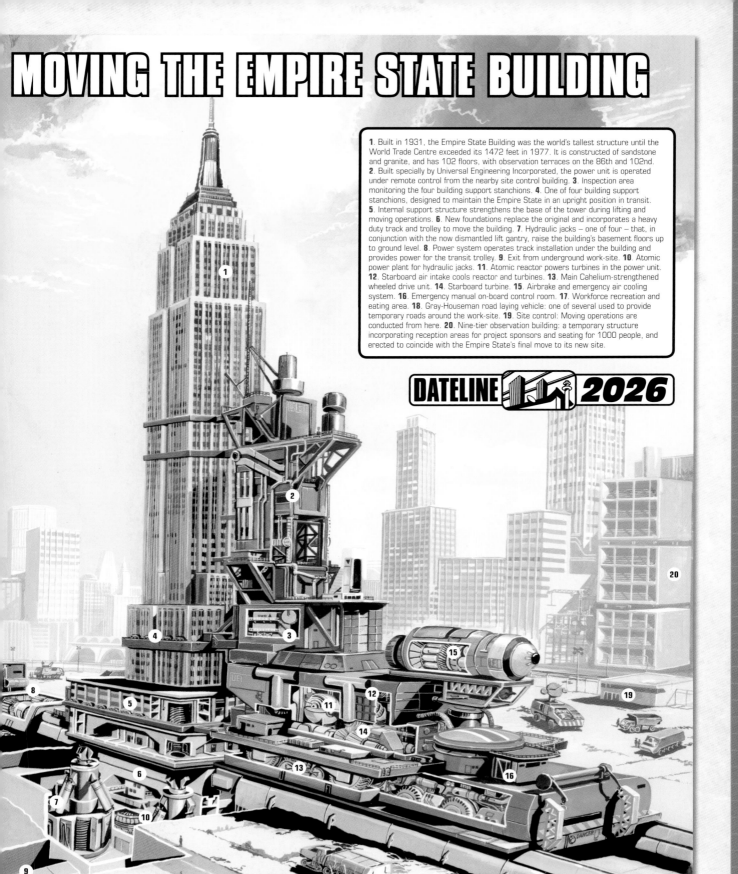

1. Built in 1931, the Empire State Building was the world's tallest structure until the World Trade Centre exceeded its 1472 feet in 1977. It is constructed of sandstone and granite, and has 102 floors, with observation terraces on the 86th and 102nd. **2**. Built specially by Universal Engineering Incorporated, the power unit is operated under remote control from the nearby site control building. **3**. Inspection area monitoring the four building support stanchions. **4**. One of four building support stanchions, designed to maintain the Empire State in an upright position in transit. **5**. Internal support structure strengthens the base of the tower during lifting and moving operations. **6**. New foundations replace the original and incorporates a heavy duty track and trolley to move the building. **7**. Hydraulic jacks – one of four – that, in conjunction with the now dismantled lift gantry, raise the building's basement floors up to ground level. **8**. Power system operates track installation under the building and provides power for the transit trolley. **9**. Exit from underground work-site. **10**. Atomic power plant for hydraulic jacks. **11**. Atomic reactor powers turbines in the power unit. **12**. Starboard air intake cools reactor and turbines. **13**. Main Cahelium-strengthened wheeled drive unit. **14**. Starboard turbine. **15**. Airbrake and emergency air cooling system. **16**. Emergency manual on-board control room. **17**. Workforce recreation and eating area. **18**. Gray-Houseman road laying vehicle: one of several used to provide temporary roads around the work-site. **19**. Site control: Moving operations are conducted from here. **20**. Nine-tier observation building: a temporary structure incorporating reception areas for project sponsors and seating for 1000 people, and erected to coincide with the Empire State's final move to its new site.

DATELINE 2026

THE CRABLOGGER

Built to order by Robotics International Limited, and designed by James Lucas, the Crablogger series of forest clearing machinery have proven to be fast and effective in clearing areas of forest in preparation for road laying.

 Split into two, the first section cuts and uproots trees, cutting the trunks into planks and incinerating leaves.

 Planks are passed through to the aft section where they are either stored for collection or, together with larger branches, pulped for later use in paper-making.

 Soon after the beginning of the 21st century, a global ban on rainforest destruction was introduced. Crabloggers are allowed to operate on the basis that felled trees must be replaced in alternative areas, so that the balance of forests in the world is not upset.

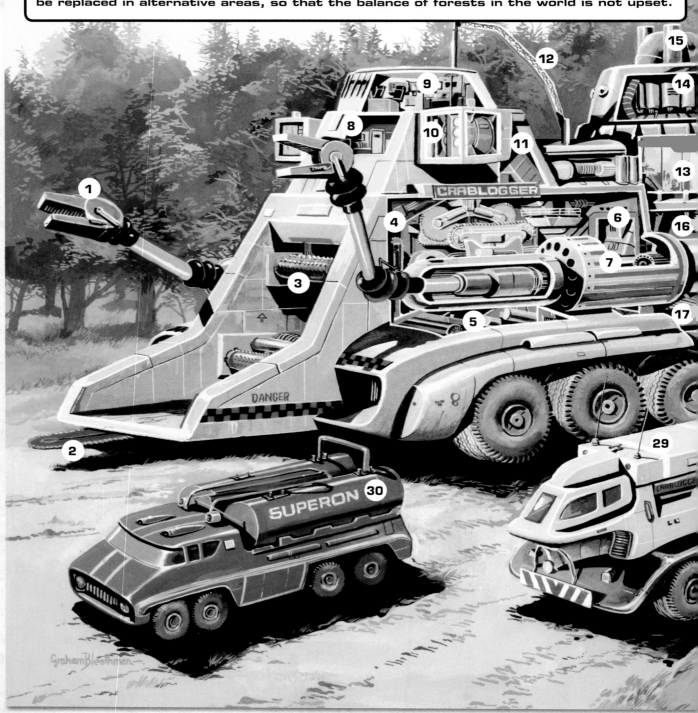

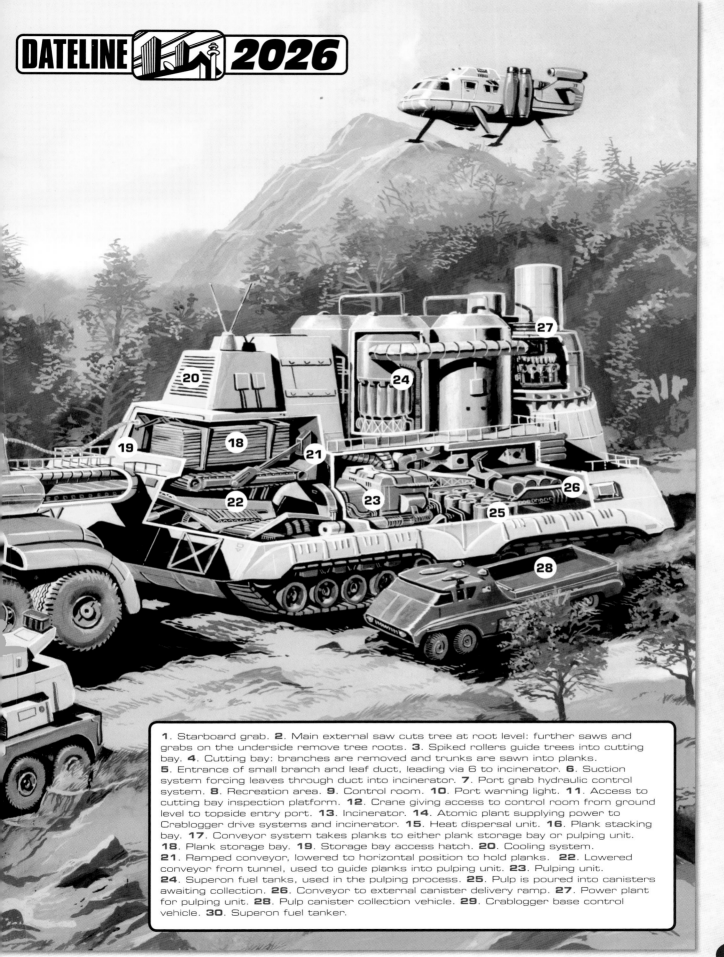

DATELINE 2026

1. Starboard grab. **2**. Main external saw cuts tree at root level: further saws and grabs on the underside remove tree roots. **3**. Spiked rollers guide trees into cutting bay. **4**. Cutting bay: branches are removed and trunks are sawn into planks.
5. Entrance of small branch and leaf duct, leading via 6 to incinerator. **6**. Suction system forcing leaves through duct into incinerator. **7**. Port grab hydraulic control system. **8**. Recreation area. **9**. Control room. **10**. Port warning light. **11**. Access to cutting bay inspection platform. **12**. Crane giving access to control room from ground level to topside entry port. **13**. Incinerator. **14**. Atomic plant supplying power to Crablogger drive systems and incinerator. **15**. Heat dispersal unit. **16**. Plank stacking bay. **17**. Conveyor system takes planks to either plank storage bay or pulping unit. **18**. Plank storage bay. **19**. Storage bay access hatch. **20**. Cooling system.
21. Ramped conveyor, lowered to horizontal position to hold planks. **22**. Lowered conveyor from tunnel, used to guide planks into pulping unit. **23**. Pulping unit.
24. Superon fuel tanks, used in the pulping process. **25**. Pulp is poured into canisters awaiting collection. **26**. Conveyor to external canister delivery ramp. **27**. Power plant for pulping unit. **28**. Pulp canister collection vehicle. **29**. Crablogger base control vehicle. **30**. Superon fuel tanker.

GRAY HOUSEMAN ROAD BUILDER

DATELINE 2026

The Highway Delva series of road laying vehicles are the latest and most efficient means of motorway construction in use today. Doing away with traditional bulldozers, diggers and road-rollers, and a large workforce, these machines analyse and clear the ground, laying their own road as they go. In forest or jungle regions, Crabloggers are often used to clear the way for Highway Delvas: the two machines are in fact built by the same company, Robotics International Limited. The Gray and Houseman Construction Company took delivery of the first Highway Delvas in 2024. Today they are in use in Australia, South America and Central Europe.

1. Transporter garage. 2. Retractable ramp leading to: 3. Garage. 4. Automatic loading system demolition gun, used to clear obstacles from the path of the road builder. 5. Jumping Jack reconnaissance helijet. 6. Hangar with access to: 7. Control room. 8. Satellite communications system. 9. Recreation and sleeping quarters plus offices and canteen. 10. Nuclear fusion reactor supplying power to atomic motor immediately below it. 11. Ultrasound probes and spectrometers measure depth and composition of ground. 12. Laser system vaporises ground, instantly excavating a channel. 13. Cahelium vacuum funnel ingests vaporised soil and rock. 14. Cooling tubes pass vapour on to: 15. Reconstitution chamber, where chemical structure of a vapour is augmented. 16. Augmented vapour is liquidised and added to mineral store. 17. Secondary laser system shears smooth sides of the channel. 18. Funnel spreads bedrock from mineral store. 19. Pressure cylinder firms bedrock down. 20. Entry hatch and elevator to hangar and control room beyond. 21. Robot gang lays steel reinforcing bars. 22. Funnel spreads road surface from mineral store. 23. Funnel spreads Tarmac substitute from: 24. Tarmac storage tank. 25. Supercooled roller firms Tarmac. 26. Air jet cools Tarmac. 27. Portside compressed air tank. 28. Paint tanks supply spray jet markers with heat resistant paint for road markings. 29. Secondary cooling system ensures Tarmac is ready for use almost instantaneously. 30. Four lane highway, virtually ready for use. 31. Explosives truck used to create a path for the on-coming road builder; and often used in conjunction with Crablogger.

THE ATLANTIC TUNNEL

Begun in late 2026 and completed ten years later, the Atlantic Tunnel is mankind's biggest single civil engineering project to date, and was conceived by the World Senator for Mexico, the late Clive Malaques. Budgeted at 27 billion UK pounds, the construction work took five years longer than anticipated, costing an estimated extra ten billion pounds.

Revolutionary in design, the tunnel is floated for two thirds of its length approximately one mile below the surface of the Atlantic, in order to avoid the hazards of the Mid-Atlantic Ridge, one of the world's earthquake-producing zones. The tunnel's position in the water is maintained by a system of buoyancy tanks within its walls whilst turbines ensure the structure does not bend beyond the built-in flexibility of its construction.

TUNNEL CONSTRUCTION MINING SPURS

1. Vents from flood tanks. 2. Lateral Deviation Corrector Turbine, one of 200 maintaining the position of the tunnel in the water. 3. One of 200 emergency flood doors, each with built-in escape locks. 4. Three lane westbound highway. Each lane features an integrated radar guidance system which in conjunction with vehicle on-board computers, controls traffic flow and speed, preventing driver's fatigue. 5. Pneumo-transport tubes for passenger and freight Pneumatic trains. 6. Train monorail system. 7. Central laser duct tube, supplying trans-Atlantic communications and tunnel lighting. 8. Air pipes and pumps servicing the tunnel's air conditioning and neutral buoyancy correction compartments. 9. Service road used by engineers or emergency services. 10. Eastbound three-lane highway. 11. Buoyancy correction compartments. 12. Air conditioning and pneumo-tube booster plant. 13. Exit road to Biscay Hotel and Services station. 14. Parking area. 15. Reception lounge, bar and shopping mall. 16. Lift to all floors. 17. Life support systems. 18. Biscay Hotel and Services station, one of twelve along the tunnel's length. 19. Navigation warning lights. 20. Hotel bedrooms. 21. Observation dome. 22. Hilton Hotel bedrooms. 23. Reception area and lounge. 24. Air conditioning tower leading to surface pumping station. 25. Hotel restaurant, lounge and leisure facilities. 26. "Seaview" restaurant. 27. Tunnel maintenance vessel. 28. Tunnel maintenance offices and workshops. 29. WASP tunnel defence base.

Main picture shows the Biscay Hotel and Services complex at the eastern end of the tunnel, built in 2052. A WASP base, built nearby, guards against undersea terrorist attack. Inset: profits from the leased mining spurs shown on the plan (created during the tunnel's construction) will ensure the tunnel will have paid for itself by 2097.

DATELINE 2065

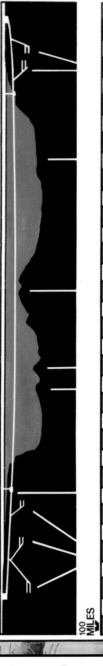

100 MILES

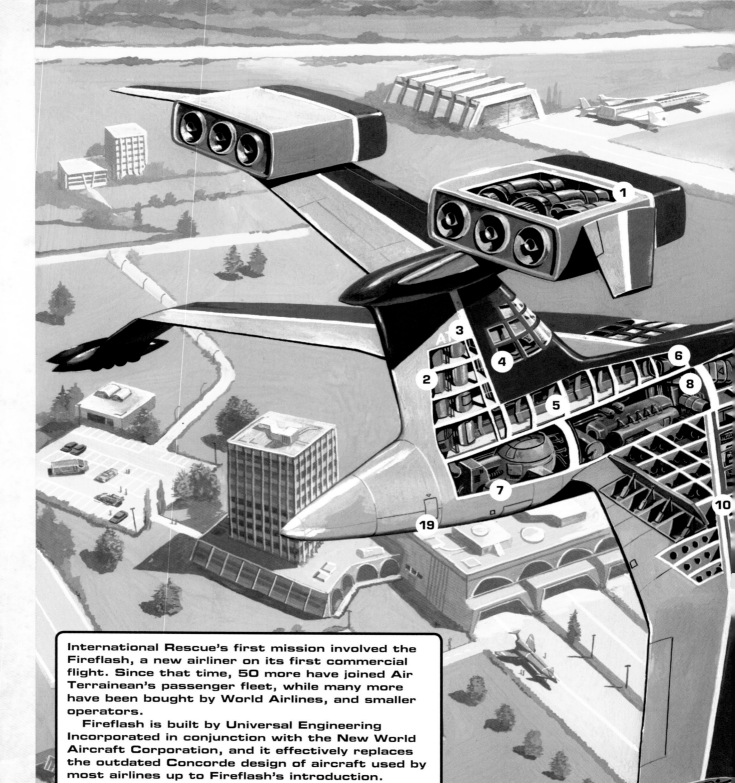

International Rescue's first mission involved the
Fireflash, a new airliner on its first commercial
flight. Since that time, 50 more have joined Air
Terrainean's passenger fleet, while many more
have been bought by World Airlines, and smaller
operators.

Fireflash is built by Universal Engineering
Incorporated in conjunction with the New World
Aircraft Corporation, and it effectively replaces
the outdated Concorde design of aircraft used by
most airlines up to Fireflash's introduction.

Fireflash can travel at over 2800mph and can
carry up to 600 passengers.

DATELINE 2026

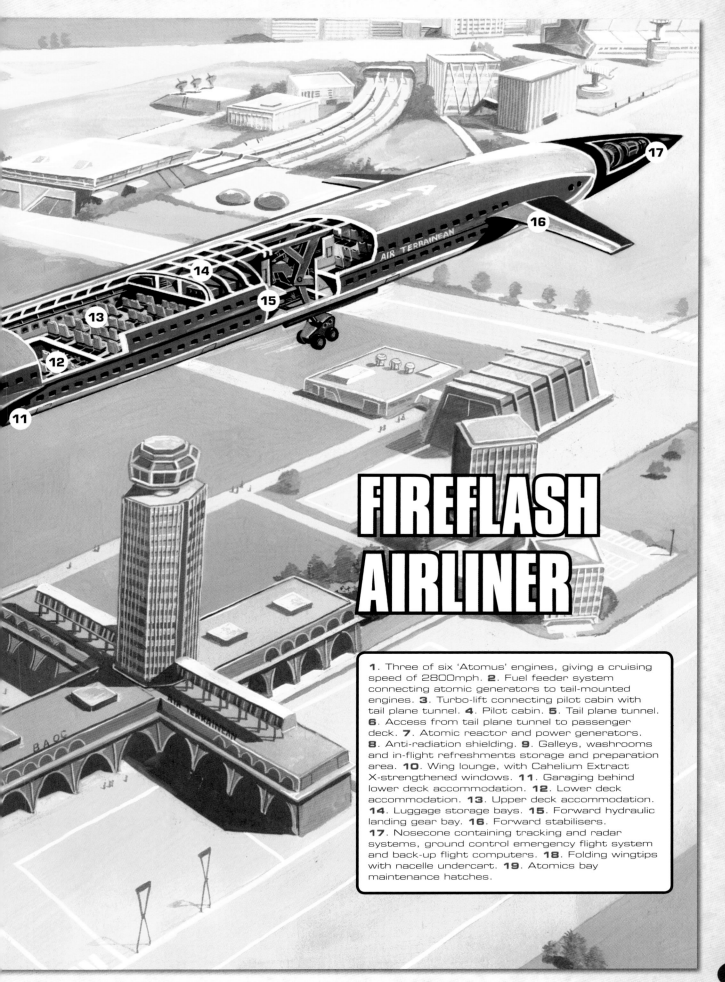

FIREFLASH AIRLINER

1. Three of six 'Atomus' engines, giving a cruising speed of 2800mph. **2**. Fuel feeder system connecting atomic generators to tail-mounted engines. **3**. Turbo-lift connecting pilot cabin with tail plane tunnel. **4**. Pilot cabin. **5**. Tail plane tunnel. **6**. Access from tail plane tunnel to passenger deck. **7**. Atomic reactor and power generators. **8**. Anti-radiation shielding. **9**. Galleys, washrooms and in-flight refreshments storage and preparation area. **10**. Wing lounge, with Cahelium Extract X-strengthened windows. **11**. Garaging behind lower deck accommodation. **12**. Lower deck accommodation. **13**. Upper deck accommodation. **14**. Luggage storage bays. **15**. Forward hydraulic landing gear bay. **16**. Forward stabilisers. **17**. Nosecone containing tracking and radar systems, ground control emergency flight system and back-up flight computers. **18**. Folding wingtips with nacelle undercart. **19**. Atomics bay maintenance hatches.

DT19 AIRLINER

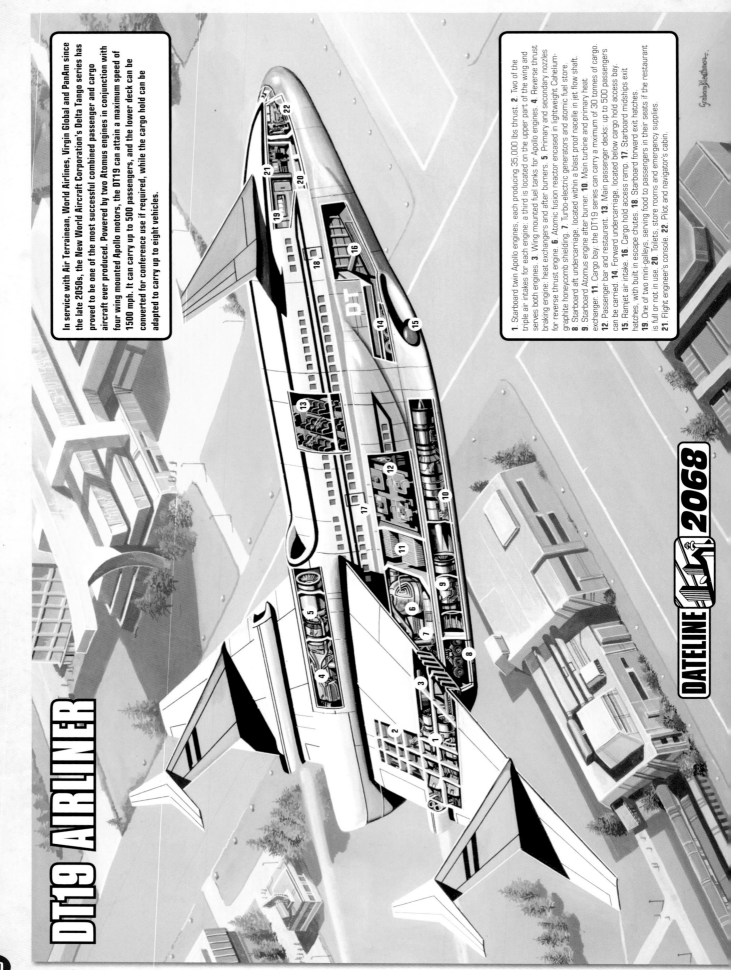

In service with Air Terrainean, World Airlines, Virgin Global and PanAm since the late 2050s, the New World Aircraft Corporation's Delta Tango series has proved to be one of the most successful combined passenger and cargo aircraft ever produced. Powered by two Atomus engines in conjunction with four wing mounted Apollo motors, the DT19 can attain a maximum speed of 1500 mph. It can carry up to 500 passengers, and the lower deck can be converted for conference use if required, while the cargo hold can be adapted to carry up to eight vehicles.

1. Starboard twin Apollo engines, each producing 35,000 lbs thrust. 2. Two of the triple air intakes for each engine: a third is located on the upper part of the wing and serves both engines. 3. Wing mounted fuel tanks for Apollo engines. 4. Reverse thrust braking engine: heat exchangers and after burners. 5. Primary and secondary nozzles for reverse thrust engine. 6. Atomic fusion reactor encased in lightweight Cahelium-graphite honeycomb shielding. 7. Turbo-electric generators and atomic fuel store. 8. Starboard aft undercarriage, located within a blast proof nacelle in jet flow shaft. 9. Starboard Atomus engine after burner. 10. Main turbine and primary heat exchanger. 11. Cargo bay: the DT19 series can carry a mximum of 30 tonnes of cargo. 12. Passenger bar and restaurant. 13. Main passenger decks: up to 500 passengers can be carried. 14. Forward undercarriage, located below cargo hold access bay. 15. Ramjet air intake. 16. Cargo hold access ramp. 17. Starboard midships exit hatches, with built in escape chutes. 18. Starboard forward exit hatches. 19. One of two mini-galleys, serving food to passengers in their seats if the restaurant is full or not in use. 20. Toilets, store rooms and emergency supplies. 21. Flight engineer's console. 22. Pilot and navigator's cabin.

DATELINE 2068

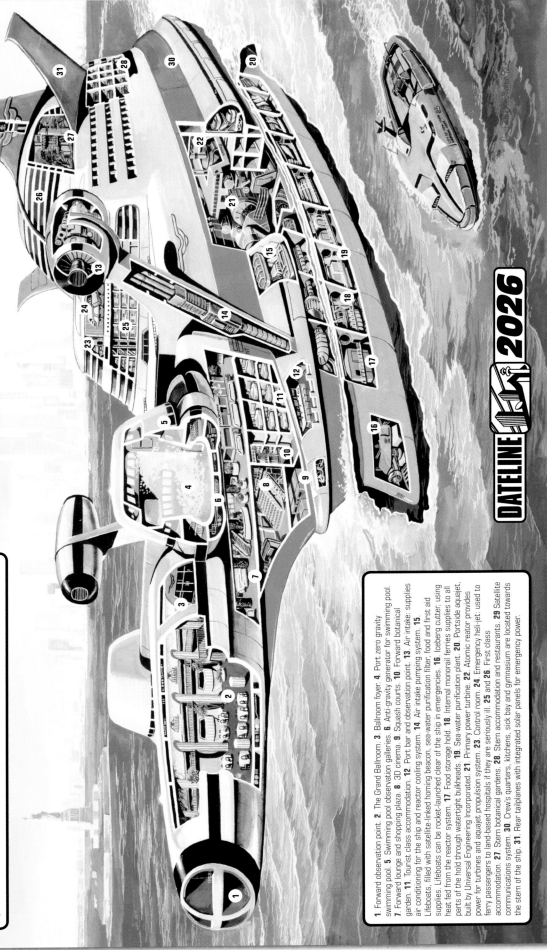

THE PRESIDENT OCEAN LINER

Launched by World President Nikita Bandranaik, 'The President' is one of the most luxurious and up to date ocean liners ever commissioned. Built for Cunard by New England Industries Inc., the 50,000 ton ship is 1,200 feet long and has accommodation for up to 2000 passengers and 500 crew. On speed trails in New York Harbour (below) 'The President' attained a cruising speed of 150 knots.

DATELINE 2026

1. Forward observation point. 2. The Grand Ballroom. 3. Ballroom foyer. 4. Port zero gravity swimming pool. 5. Swimming pool observation galleries. 6. Anti-gravity generator for swimming pool. 7. Forward lounge and shopping plaza. 8. 3D cinema. 9. Squash courts. 10. Forward botanical garden. 11. Tourist class accommodation. 12. Port bar and observation point. 13. Air intake: supplies air conditioning for the ship and reactor cooling system. 14. Air intake pumping system. 15. Lifeboats, filled with satellite-linked homing beacon, sea-water purification filter, food and first aid supplies. Lifeboats can be rocket-launched clear of the ship in emergencies. 16. Iceberg cutter; using heat fed from the reactor system. 17. Food storage hold. 18. Internal monorail ferries supplies to all parts of the hold through watertight bulkheads. 19. Sea-water purification plant. 20. Portside aquajet, built by Universal Engineering Incorporated. 21. Primary power turbine. 22. Atomic reator provides power for turbines and aquajet propulsion system. 23. Control room. 24. Emergency heli-jet: used to ferry passengers to land-based hospitals if they are seriously ill. 25 and 26. First class accommodation. 27. Stern botanical gardens. 28. Stern accommodation and restaurants. 29. Satellite communications system. 30. Crew's quarters, kitchens, sick bay and gymnasium are located towards the stern of the ship. 31. Rear tailplanes with integrated solar panels for emergency power.

THE BRITISH MONORAIL

DATELINE 2026

In early 2026, World Railways took over a monorail system operated by the bankrupt Pacific Atlantic Monorail Company. Following thorough testing and safety trials, the American Travel Safety Committee granted World Railways the licence to develop the system worldwide.

In Britain, Network UK undertook extensive track renewal, and in cooperation with other railway companies throughout Europe, replaced the old dual track system with monorails. Monorail systems were also constructed in the Channel Tunnel and the nearly complete Atlantic Tunnel - so it soon became possible to travel non-stop from San Francisco to Moscow via Britain by rail. In many countries, however, dual track systems would remain in use on local services, often using rolling stock originally built in the 1980s.

1. Cahelium-strengthened monorail. 2. Forward drive nacelle containing electro-magnetic hover unit, enabling train to travel without touching the rail itself. 3. Emergency override and braking system computer. 4. Control cabin: although the train is completely automated, it can be manually controlled in the event of delays, re-routing of services or emergencies. 5. Main power monitoring unit, maintains and optimises the performance of the turbine. 6. Main power turbine drives engine unit of the train up to 300mph. 7. Air intake to cool turbine. 8. Monitoring system for atomic power unit. 9. Atomic pile in cahelium-graphite anti-collision shielding, supplying power to electricity generating turbine. The shielding can withstand impact of up to 700 mph. 10. Exit to bar and passenger accommodation. 11. Bar, serving non-alcoholic drinks and food. 12. Portside exit hatch and ramp to first class accommodation and bar. 13. Luggage storage area, accessed from exit hatch and via external door. 14. First class accommodation. 15. Bar and staffroom. 16. High-impact anti-gravity collision absorbers. 17. Toilet. 18. Ramp to exit hatch. 19. Standard accommodation. 20. Computer-controlled signalling system. 21. Bristol Temple Meads Station, originally built by Isambard Kingdom Brunel in 1863, now adapted for monorail use. 22. Rebuilt platforms raised to accommodate monorail system. 23. Passenger information visual screen and loudspeaker. 24. Old intercity train relegated to regional use only.

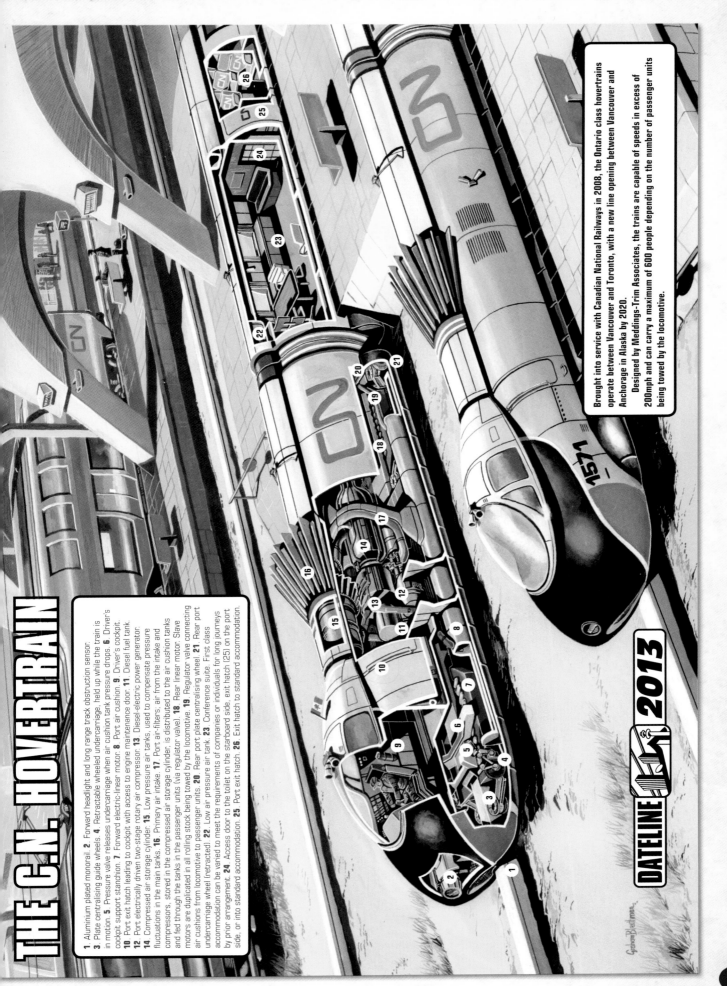

THE C.N. HOVERTRAIN

1. Aluminium plated monorail. 2. Forward headlight and long range track obstruction sensor:
3. Plate centralising guide wheels. 4. Retractable wheeled undercarriage, held up while the train is
in motion. 5. Pressure valve releases undercarriage when air cushion tank pressure drops. 6. Driver's
cockpit support stanchion. 7. Forward electric-linear motor: 8. Port air cushion. 9. Driver's cockpit.
10. Port exit hatch leading to cockpit with access to engine maintenance door: 11. Diesel fuel tank.
12. Port electrically driven two-stage rotary air compressor: 13. Diesel-electric power generator:
14. Compressed air storage cylinder: 15. Low pressure air tanks, used to compensate pressure
fluctuations in the main tanks. 16. Primary air intake. 17. Port air-filters; air from the intake and
compressors, stored in the compressed air storage cylinder; is distributed to the air cushion tanks
and fed through the tanks in the passenger units (via regulator valve). 18. Rear linear motor: Slave
motors are duplicated in all rolling stock being towed by the locomotive. 19. Regulator valve connecting
air cushions from locomotive to passenger units. 20. Rear port plate centralising wheel. 21. Rear port
undercarriage wheel (retracted). 22. Low air pressure air tank 23. Conference suite. First class
accommodation can be varied to meet the requirements of companies or individuals for long journeys
by prior arrangement. 24. Access door to the toilet on the starboard side, exit hatch (25) on the port
side, or into standard accommodation. 25. Port exit hatch. 26. Exit hatch to standard accommodation.

DATELINE 2013

Brought into service with Canadian National Railways in 2008, the Ontario class hovertrains
operate between Vancouver and Toronto, with a new line opening between Vancouver and
Anchorage in Alaska by 2020.

Designed by Meddings-Trim Associates, the trains are capable of speeds in excess of
200mph and can carry a maximum of 600 people depending on the number of passenger units
being towed by the locomotive.

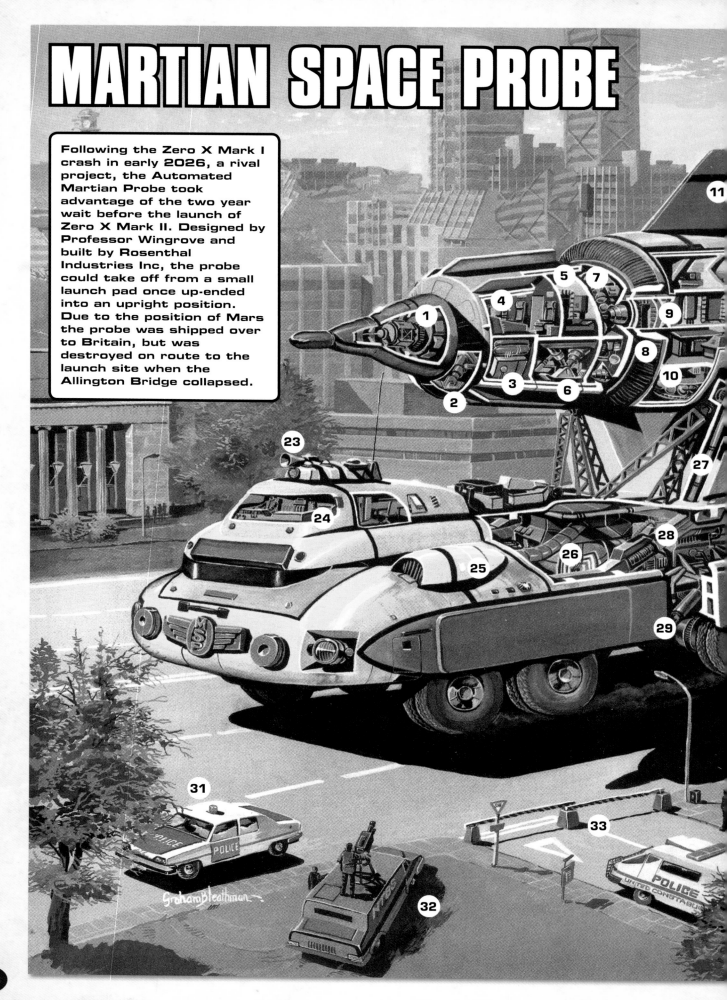

MARTIAN SPACE PROBE

Following the Zero X Mark I crash in early 2026, a rival project, the Automated Martian Probe took advantage of the two year wait before the launch of Zero X Mark II. Designed by Professor Wingrove and built by Rosenthal Industries Inc, the probe could take off from a small launch pad once up-ended into an upright position. Due to the position of Mars the probe was shipped over to Britain, but was destroyed on route to the launch site when the Allington Bridge collapsed.

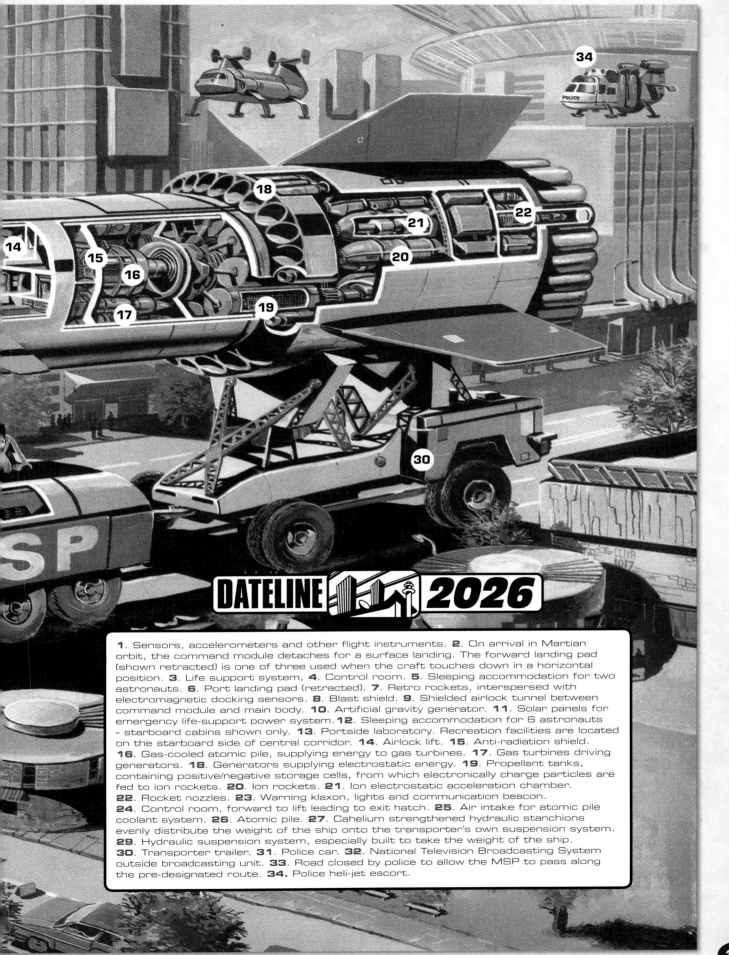

DATELINE 2026

1. Sensors, accelerometers and other flight instruments. 2. On arrival in Martian orbit, the command module detaches for a surface landing. The forward landing pad (shown retracted) is one of three used when the craft touches down in a horizontal position. 3. Life support system, 4. Control room. 5. Sleeping accommodation for two astronauts. 6. Port landing pad (retracted). 7. Retro rockets, interspersed with electromagnetic docking sensors. 8. Blast shield. 9. Shielded airlock tunnel between command module and main body. 10. Artificial gravity generator. 11. Solar panels for emergency life-support power system. 12. Sleeping accommodation for 6 astronauts – starboard cabins shown only. 13. Portside laboratory. Recreation facilities are located on the starboard side of central corridor. 14. Airlock lift. 15. Anti-radiation shield. 16. Gas-cooled atomic pile, supplying energy to gas turbines. 17. Gas turbines driving generators. 18. Generators supplying electrostatic energy. 19. Propellant tanks, containing positive/negative storage cells, from which electronically charge particles are fed to ion rockets. 20. Ion rockets. 21. Ion electrostatic acceleration chamber. 22. Rocket nozzles. 23. Warning klaxon, lights and communication beacon. 24. Control room, forward to lift leading to exit hatch. 25. Air intake for atomic pile coolant system. 26. Atomic pile. 27. Cahelium strengthened hydraulic stanchions evenly distribute the weight of the ship onto the transporter's own suspension system. 29. Hydraulic suspension system, especially built to take the weight of the ship. 30. Transporter trailer. 31. Police car. 32. National Television Broadcasting System outside broadcasting unit. 33. Road closed by police to allow the MSP to pass along the pre-designated route. 34. Police heli-jet escort.

125

ZERO X

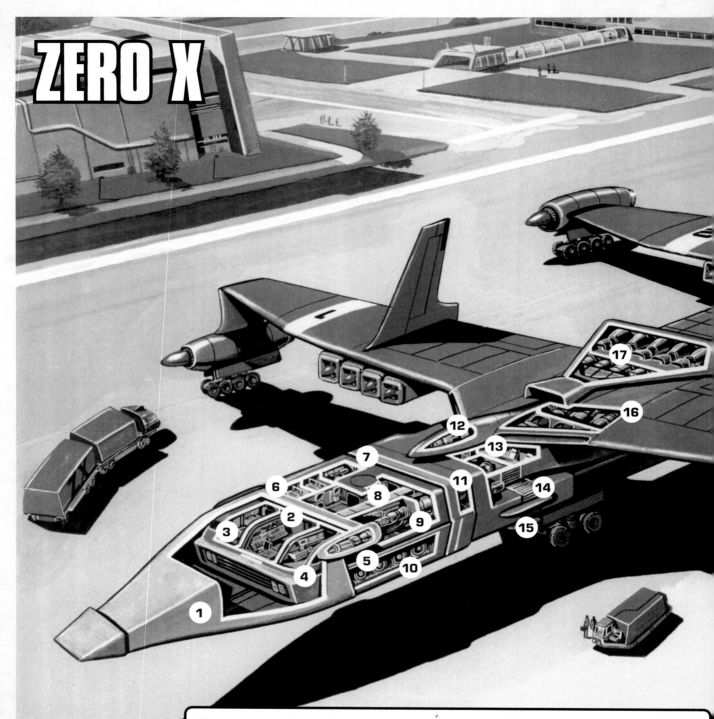

Graham Bleathman

Built by the New World Aircraft Corporation, the Zero X series of spacecraft has been in service for forty years. The first version was built in the early 2020s and was used to carry a crew of five on Man's first mission to Mars. The great ship was destroyed on take-off due to sabotage by the Hood, and it was not until two years later that the Zero X MKII successfully reached the Red Planet. This, too, was destroyed on its return to Earth. As in the first disaster, the crew ejected to safety.

2027 saw the first flights of Zero X MKIII, using upgraded fuel and faster engines for more practical and widespread exploration of the Solar System. By 2030, a Hyperdrive had been fitted to allow interstellar exploration. Since then, several more Zero X craft have been built, including a freighter version used for travel between Earth and the new Martian colonies.

The Martian Excursion Vehicle, or MEV, has now been manufactured separately at the Martian Capital of Kahra for use on the surface of the planet.

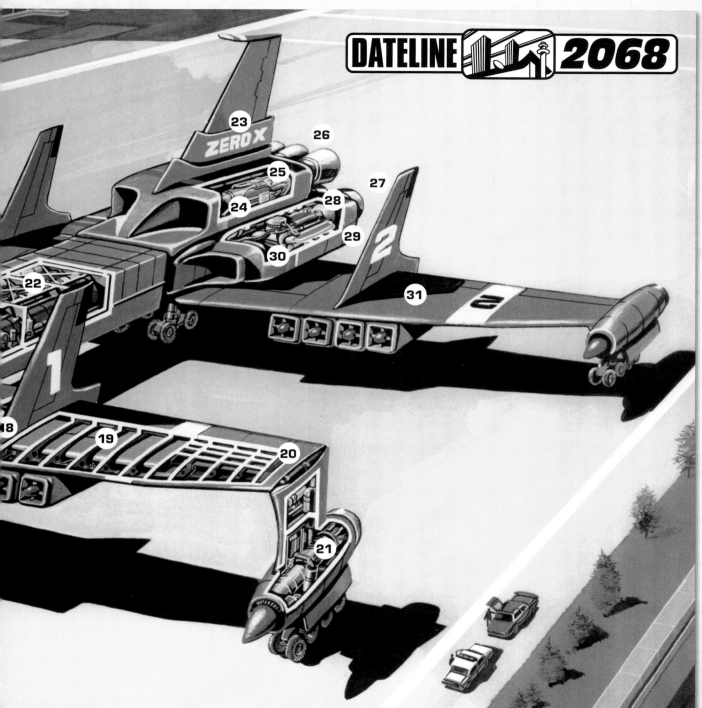

DATELINE 2068

1. Detachable nose cone. Cahelium strengthened and heat resistant. **2**. Computer control cockpit for Martian Excursion Vehicle. **3**. Living accommodation, including video and computer library. **4**. Laboratory. **5**. Port nose cone rocket incorporating remote guidance system for controlled return to Earth, plus docking sensor locking the nose cone to the MEV crew. **6**. Living accommodation for MEV crew. **7**. Retractable rocket launcher. **8**. Abort mission emergency capsule. **9**. Life support system including atmosphere and waste recycling plant, and artificial gravity generator. **10**. Retracted caterpillar tracks descend for planetary exploration. **11**. Docking sensor and lock-on mechanism securing MEV to Main Body. **12**. Remote control unit and auto pilot to control Lift Body when detached. **13**. Command centre, for use when MEV has left Main Body in orbit. Further living accommodation, life support systems and laboratories are located behind the command centre. **14**. Retracted stub wing used to 'skip' Main Body clear of atmosphere if in grazing orbit. **15**. Port undercarriage. **16**. Lift Body control jet intakes. **17**. Bank of five jets used to control manoeuvrability of the Lift Body on glide path return. **18**. Port turbo-ram jet. **19**. Wing fuel tanks. **20**. Hinge enabling wing tip to be in dropped position for take-off. **21**. Port booster jet and wing tip undercarriage nacelle. **22**. Main Body, behind command centre and crew's quarters - a complex of fuel tanks, auxiliaries and life-support systems. Later versions of Zero X incorporate a Hyperdrive located here. **23**. Retractable tail fin. **24**. Air intake and compressors. If it is necessary to use the main motors in the atmosphere, these allow air to be used as an oxidant, leaving the liquid oxygen in the fuel tanks for space propulsion. **25**. Firing chambers. **26**. Bank of three main propulsion units. **27**. Bank of five secondary propulsion units. **28**. Firing chambers of secondary propulsion units. **29**. Stub wing (retracted). **30**. Air intake and compressors for secondary propulsion units. **31**. Secondary Lift Body.

Dedicated to the memory of
David Watmough
1960-2014

EGMONT

This collection first published in Great Britain 2014 by Egmont UK Limited
The Yellow Building, 1 Nicholas Road, London W11 4AN
Thunderbirds ™ and © ITC Entertainment Group Limited 1964, 1999 and 2014.
Licensed by ITV Ventures Limited. All rights reserved.

A GERRY ANDERSON PRODUCTION

Written and illustrated by Graham Bleathman

The vehicles and locations depicted in this book were designed by the following;
Derek Meddings, Mike Trim, Reg Hill, Bob Bell, Frank Bellamy, Ron Embleton and Martin Bower,
with additional contributions from Alan Fennell, Eric Eden, Mike Noble, Ron Turner and Graham Bleathman.

Graham Bleathman would like to thank the following for their help in the preparation of this book;
David Watmough, Ian Boyce, Mike Jones, Ronald Kroon, Graeme Bassett, Katie Bleathman
and my editor, Jude Exley and my designer, Martin Aggett.

ISBN 978 1 4052 2765 0
57473/1
Printed in Singapore.

Please note: Whilst some corrections have been made and a small amount of explanatory text
has been added, the majority of the cutaway captions in this book have been republished as they
were written nearly 25 years ago. In some cases, these may contradict information presented
in cutaways produced subsequently. Most of the cutaways have been reproduced
from original artwork, the quality of those that haven't may vary.

MIX
Paper from
responsible sources
FSC® C018306

CONTENTS

INTRODUCTION

Helgoland, and her three sisters, *Thüringen, Ostfriesland* and *Oldenburg,* were the first German battleships to mount 30.5cm (12in) guns, and the navy's second class of all-big-gun 'dreadnought' battleships. *Helgoland* was named after the eponymous North Sea island, ceded to Germany by Great Britain in 1890, and since developed as a major naval base; her sisters were named after two Prussian provinces, and the grand duchy of Oldenburg.

THE GENESIS OF THE GERMAN DREADNOUGHT

The first modern true battleships of the German navy were the *Brandenburg* class of the 1889/90 naval construction programme, exceptionally heavily armed with six 28cm (11in) guns in twin turrets on the centre line. However, their successors, the *Kaiser Friedrich III* and *Wittelsbach* classes (1894–1900 programmes), carried the predreadnought-standard four main guns, but of the unusually light 24cm (9.4in) calibre. German doctrine assumed engagements at close range, where volume of fire, both from the main battery and the 15cm (5.9in) secondary guns, was regarded as likely to be more effective than individually heavier shells fired less frequently by bigger main guns.

Thus, even when main calibres were increased in the *Braunschweig* and *Deutschland* classes (1901–1905 programmes), it was only back to 28cm, rather than up the 30.5cm bore that was by now effectively the world standard; secondary guns were, however, increased to 19cm (6.7in). The 28cm calibre was thus the baseline when consideration began to be given to the design to be used for the ships of the 1906 programme.

However, by this time, the fitting of guns of calibres intermediate between those of the main and secondary batteries was becoming common in overseas navies. The US battleships of the 1900–1904 programmes and Italian vessels of the 1898, 1901 and 1902 programmes all carried 8in (20.3cm) guns, French ships 19.4cm (7.6in) weapons, and the British vessels of 1901/02 and 1902/03 estimates 9.2in (23.4cm) guns. Accordingly, the first proposals for the successors to the *Deutschland* class had intermediate batteries of up to sixteen 21cm, or ten 24cm (9.4in) guns, in addition to the 'standard' pair of 28cm twin turrets. This crystallised into a scheme with two twin 28cm and four twin 21cm turrets, plus four single 21cm guns in casemates, and was approved by the Kaiser on 7 January 1904. However, an intelligence report was then received that the new British *Lord Nelson* class would have a secondary battery of ten 10in (254mm) guns (in reality they had 9.2in weapons), that they would displace 18,000 tons (actually 16,500), and that the next generation of ships would be even more heavily armed. Accordingly, a new round of designs was instituted, either with the 21cm guns arranged in six twin turrets, or replacing the intermediate battery with four more 28cm guns, in single turrets on the beam. The latter were then

replaced by twins, giving the final main battery of a dozen guns, arrived at almost by accident.

This 'hexagonal' arrangement of main guns was less 'economical' than the layouts found in the other 'first generation' dreadnoughts. Thus, the US *Michigan*, with four turrets in pairs superimposed fore and aft, could bring their entire main battery of eight 12in to bear on the broadside, while *Dreadnought*, with three centre line mountings and one pair of wing turrets, could fire eight out ten guns on the broadside. In contrast, *Nassau* could only deploy eight out of twelve guns thus, although it was argued that there was an advantage in having unused guns on the disengaged side, either to guard against attacks from this direction, or acting as a reserve against damage.

Unlike *Dreadnought*, which had nothing between her 12in and 12pdr anti-torpedo-boat guns, the German design retained a secondary battery of 15cm guns (downgraded from the *Deutschlands'* 19cm weapons), still intended for use against other battleships at the anticipated short battle ranges. For use against torpedo craft, the traditional 8.8cm (3.5in) tertiary battery (going back to the *Brandenburg* class) was retained. The first of four ships, *Nassau*, was ordered on 31 May 1906, although construction did not actually begin until July. *Nassau* commissioned on 1 October 1909, her sister *Westfalen* following in November, and *Rheinland* and *Posen* in April and May 1910. By the latter month, the UK had commissioned seven dreadnought battleships and three battlecruisers.

HELGOLAND AND HER SISTERS

Although it was early recognised that the 28cm-armed *Nassau*s were under-armed, as compared with the universal employment of 30.5cm guns in dreadnoughts built or building abroad, the financial impact of another step-change closely following on from the shift from predreadnought to dreadnought (*Nassau* cost 50 per cent more than a *Deutschland*) made it impossible to contemplate any move to a bigger gun until the 1908 programme. Financial pressures were compounded by the fact that size of the German navy had been legally fixed by Fleet Laws, passed in 1898 and 1900, and a 1908 amendment to the latter, which brought forward the date at which existing ships became due for replacement, meant that the battleship-construction drumbeat would be increased from the current two ships a year, to three during the 1908–1911 programmes.

Accordingly, since simply enlarging the *Nassau* design to mount 30.5cm guns had been calculated to require an extra 4000 tons, a number of smaller, and thus hopefully cheaper, ten-gun alternatives were also considered, with guns in a variety of (sometimes novel) configurations (see opposite). Eventually, however, the *Nassau* turret arrangement was accepted after all (with a cost increase of 20 per cent), with Scheme 13d2 adopted on 16 December 1907 as the basis for final detail work. *Ersatz-Siegfried* (to be *Helgoland*), *Ersatz-*

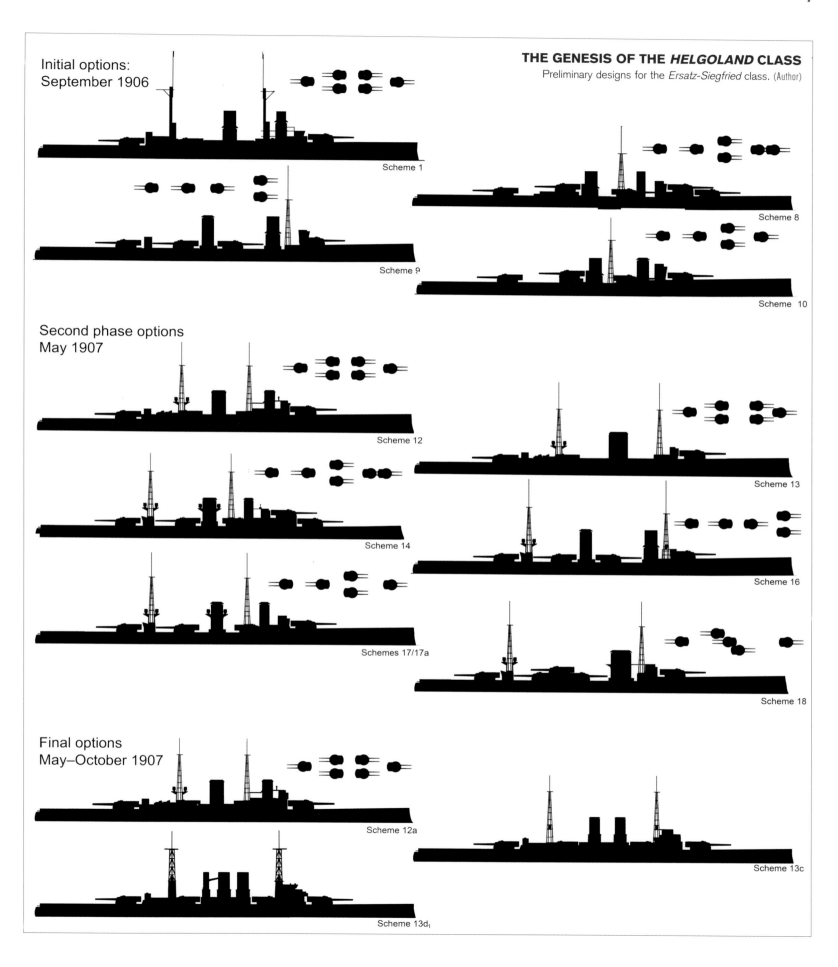

Initial options:
September 1906

Scheme 1

Scheme 9

THE GENESIS OF THE *HELGOLAND* CLASS
Preliminary designs for the *Ersatz-Siegfried* class. (Author)

Scheme 8

Scheme 10

Second phase options
May 1907

Scheme 12

Scheme 14

Schemes 17/17a

Scheme 13

Scheme 16

Scheme 18

Final options
May–October 1907

Scheme 12a

Scheme 13c

Scheme 13d$_1$

Oldenburg (*Ostfriesland*) and *Ersatz-Beowulf* (*Thüringen*) were ordered under the 1908 programme, with *Ersatz-Frithjof* (*Oldenburg*) following in 1909. The '*Ersatz*' names reflected the fact that the ships were, legally-speaking, replacements for old coast-defence vessels launched between 1884 and 1891, although far exceeding them in size and capability.

STRUCTURE

Although essentially similar to the *Nassau*s, the *Helgoland*s looked very different from them, with three funnels amidships (as in the

Braunschweig and *Deutschland* class predreadnoughts, rather than the two widely spaced uptakes in the preceding class). The hull was flush-decked, except at the extreme stern, where it was cut down one deck aft of the rearmost pair of 8.8cm guns. Internally, the ships were divided into seventeen watertight compartments, with a double bottom covering 86 per cent of the length. As built, and like most capital ships of their generation, they carried anti-torpedo nets, but these were removed after the summer of 1916, experience at Jutland having shown that battle damage could lead to nets coming loose and potentially fouling the propellers.

ARMAMENT

The main battery comprised twelve of the new 30.5cm SK L/50 C/08 gun, in twin DrL C/08 mountings. 'SK' (Schnellade Kannonne) designated a quick-firing (QF) gun, using cartridged propellant, 'L' the barrel length (not bore length, as in most foreign practice), 'DrL' (Drillig Lafette) a twin mounting, and 'C' the year of introduction. Each gun weighed 51.85 tons, and had a muzzle velocity of 855m/sec, giving a maximum range of 19,200m at the mountings' full elevation of 13.5°; maximum depression was -8°. Mountings were modified from 1916 onwards to alter the elevation/depression limits to +16°/-5.5°,

PROFILE SMS *POSEN*

The first German dreadnoughts of the *Nassau* class introduced the hexagonal arrangement of main turrets to the German navy, in which they were followed in the contemporary armoured cruiser *Blücher*, and by *Helgoland* and her sisters. The *Nassau* class operated alongside the *Helgoland*s in the I. Squadron, *Westfalen*, *Rheinland* and *Posen* being allocated to the UK in 1920; this longitudinal section belongs to the latter. While she and *Westfalen* were both brought to the UK and sold for scrapping there (although *Posen*'s sale was cancelled and she was re-sold to be broken up in the Netherlands), *Rheinland* was unfit to cross the North Sea, following damage from grounding in April 1918. She was accordingly sold direct to Dutch breakers, who also took the Japanese-allocated *Nassau*.(M0980)

SMS *POSEN*: TYPICAL STRUCTURE OF EARLY GERMAN DREADNOUGHTS

The left drawing represents the midships section, Station 54, of the ship, at the transverse bulkhead between the after two groups of boilers, the right Station 40, the section at the forward end of the engine room, directly adjacent to the magazines and shell rooms of the after pair of wing turrets. The Station 54 image

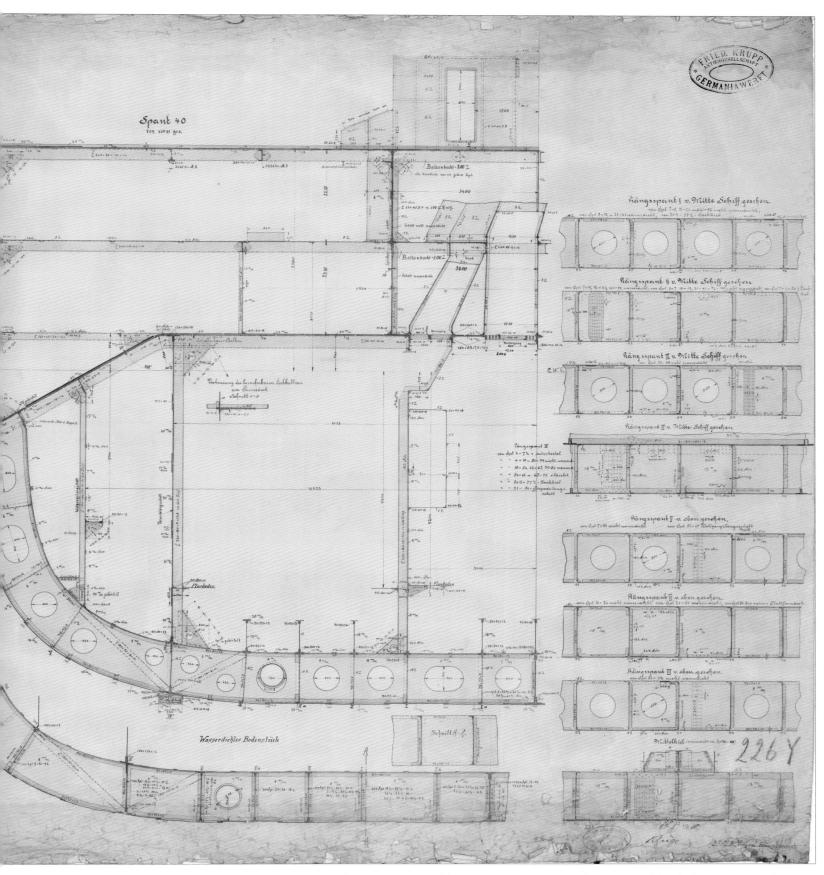

shows the bulkhead is solid, interrupted only by the middle passage (for whose purpose, see page 93) on the far right. Visible in both sections are the main belt, 290mm thick at the waterline and tapering above to 160mm and below to 170mm, with a wooden backing between it and the ship's structure, and the armour deck, flat over the centreline spaces, and sloping down to the bottom of the belt at the sides. (M0981)

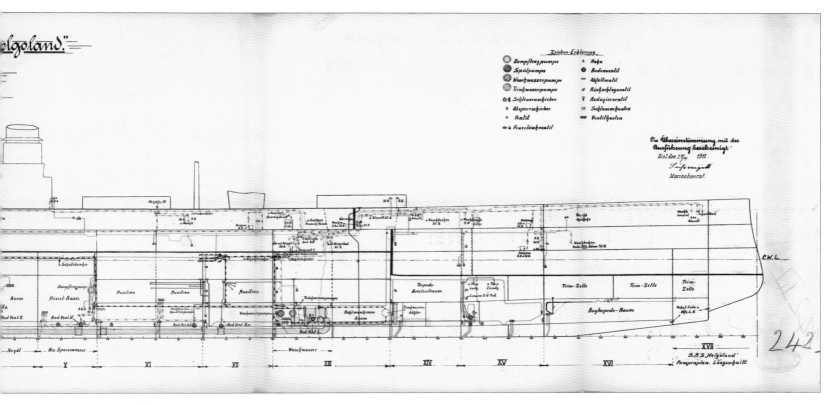

PUMPING DIAGRAM, PROFILE VIEW

The various pipe-networks aboard *Helgoland* are shown here, ranging from damage control through to the distribution of drinking water, and colour-coded accordingly. (M0950)

ENLARGEMENT OF KEY ABOVE

Steam bilge pump	Dampflenzpumpe	
Flushing pump	Spülpumpe	
Washing water pump	Waschwasserpumpe	
Drinking water pump	Trinkwasserpumpe	
Sluice gate valve	Schleusenschieber	
Gate valve	Absperrschieber	
Valve	Ventil	
Fire main valve	Feuerlöschventil	

Hahn	Tap	
Bodenventil	Bottom valve	
Abfallventil	Waste valve	
Rückschlagventil	Check valve	
Reduzierventil	Reducing valve	
Schlammkasten	Mud box	
Ventilkasten	Valve box	

connected through manifolds to each of the three fire and bilge pumps and through two cross connections to the main drain line. In addition, many compartments, especially those on the Platform Deck and above, had gravity drain pipes, with valves to compartments having direct suctions from parts of the secondary drain. Between the two systems, a total of eleven pumps could be used to evacuate water from *Helgoland*'s hull; some were specifically intended for the purpose of leak management, others as a secondary role.

Alongside these pumping arrangements, the ship was extensively subdivided, with seventeen transverse watertight sections, all bounded by unpierced bulkheads. The longitudinal bulkheads separating the three engine rooms were also unpierced, although those dividing each of the boiler rooms into three sections were provided with watertight

doors. War experience showed that in some cases the subdivision was *too* extensive, causing problems of access and/or isolation of damage. Some later vessels had oversized submerged torpedo rooms that could not be subdivided, which contributed to the loss of *Lützow* and the near-loss of *Bayern*.

As for the effectiveness of these systems, while *Helgoland* did not receive any underwater damage (although taking on 80 tons of water after a hit above the waterline at Jutland), her sister *Ostfriesland* was mined on the way back from Jutland. The explosion took place under the starboard forward wing turret, opening a hole approximately 12m x 5m, extending down from the edge of the belt. Wing compartments were flooded over a length of 35m, and the torpedo bulkhead was bulged and torn, causing water to enter the magazine behind;

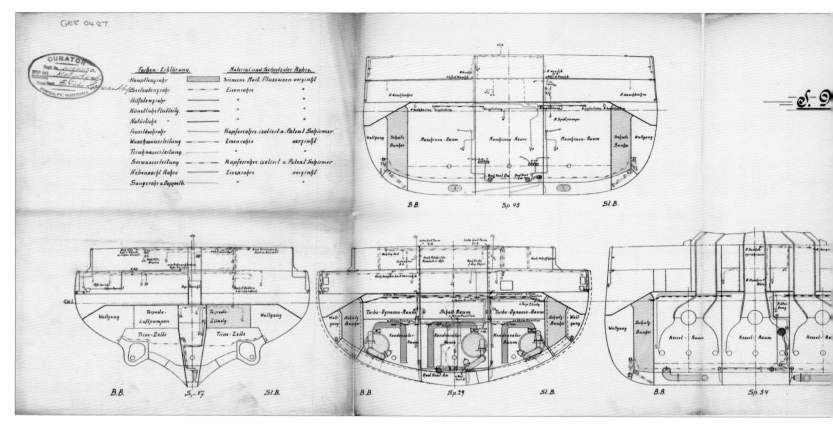

ENLARGEMENT OF KEY ABOVE

Key			Material and protection of the piping
Main drainage pipe	Hauptlenzrohr	Siemens Mart. Flusseisen verzinkt	Galvanized Siemens-Martin process mild steel
Wing drainage pipe	Seitenlenzrohr	Eisenrohre "	Galvanized iron piping
Subsidiary drainage pipe	Hilfslenzrohr	" "	Galvanized iron piping
Manual flood control	Künstliche Flutleitg.	" "	Galvanized iron piping
Natural flood control	Natürliche "	" "	Galvanized iron piping
Fire main	Feuerlöschrohr	Kupferrohre isoliert n. Patent Schirmer	Copper piping isolated by Schirmer patent (system)
Washing water pipe	Waschwasserleitung	Eisenrohre verzinkt	Galvanized iron piping
Drinking water pipe	Trinkwasserleitung	" "	Galvanized iron piping
Sea water pipe	Seewasserleitung	Kupferrohre isoliert n. Patent Schirmer	Copper piping isolated by Schirmer patent (system)
Peripheral piping	Nebensächl. Rohre	Eisenrohre verzinkt	Galvanized iron piping
Suction pipe in double bottom	Saugerohr a.Doppelb.	" "	Galvanized iron piping

altogether 400 tons of water came aboard. The starboard protective bunkers, wings and one series of double bottom compartments were flooded from around Frame 62 to Frame 92. Initially, the damage caused little trouble, but at 11.20, when off Heligoland, an emergency turn away from an imaginary submarine caused the damaged part of the torpedo bulkhead to open further, causing more flooding and a 4.75° list. Speed was reduced, but gradually built up to 10kts, the ship reaching Wilhelmshaven at 17.15.

FIRE CONTROL

At the time the *Helgoland*s were designed, the German navy still envisaged that battles would be fought at comparatively short ranges in

view of the likely restricted visibility in the anticipated battleground of the southern North Sea. This was reflected partly in the use of smaller calibre main guns with higher muzzle velocities and relatively lower maximum elevations of these guns as compared with their British equivalents. Unlike the Royal Navy, the Germans also retained secondary guns between the main and anti-torpedo boat batteries, on the basis that they would be effective against other capital ships at the battle-ranges envisaged.

A further implication of this was that, unlike the British with their tripod masts and the Americans with their cage masts, no raised fire control positions were provided in German ships. This was owing to a suspicion that masthead spotting was unreliable, or might even spoil

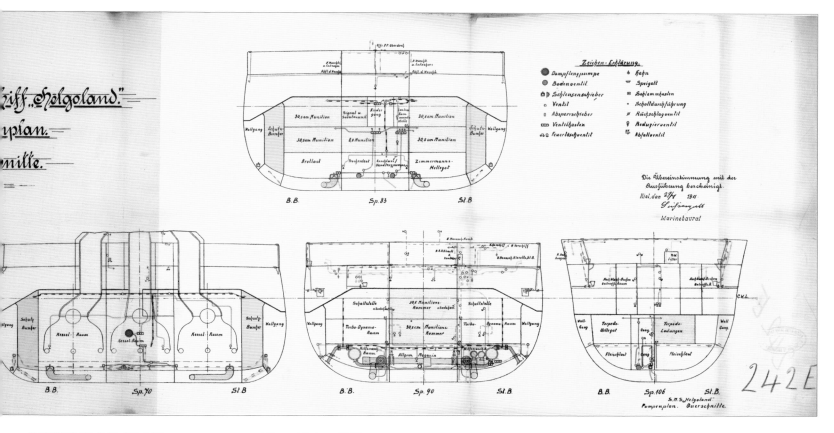

PUMPING DIAGRAM, SECTIONAL VIEWS

The various piping systems are here shown as they pass through key sections of the ship, including the key runs under the boiler rooms. In the event of damage, these would have been important in removing any water that entered these compartments. (M0951)

ENLARGEMENT OF KEY ABOVE

Zeichen-Erklärung.

Key			
Steam bilge pump	Dampflenzpumpe	Hahn	Tap
Bottom valve	Bodenventil	Speigatt	Scupper
Sluice gate valve	Schleusenschieber	Schlammkasten	Mud box
Valve	Ventil	Schottdurchführung	Bulkhead lead-through
Gate valve	Absperrschieber	Rückschlagventil	Check valve
Valve box	Ventilkasten	Reduzierventil	Reducing valve
Fire main valve	Feuerlöschventil	Abfallventil	Waste valve

a fire control solution reached according to the navy's standard gunnery-control rules.

However, around 1912, trials with longer-range gunnery suggested that an aloft rangefinder in addition to those at superstructure level would be useful, the first installation being atop a tripod mast installed in the armoured cruiser *Blücher*, then being used as a gunnery training and trials vessel. This was then followed by one in the heavy tubular mast fitted in *Kronprinz*, the last ship of the 1914-completed *König* class. The rest of that class were later retrofitted similarly, as were two of the preceding *Kaiser* class, while new construction and the surviving *Derfflinger* class battlecruisers received tripods. However, the remaining three *Kaiser*s had not been refitted by the end of the war,

and no plans appear to have been made to modify the *Helgoland*s or *Nassau*s.

While central calculation of range and bearing was undertaken, there was no equivalent of the British director system. Rather, data was transmitted from the conning towers, via a *Verbindungsstelle* (transmitting station) below the armoured deck, between the boiler and engine rooms, to each of the gun mountings via an AC-current based synchro system produced by the Siemens & Halske concern. Controls were duplicated in each of the conning towers, which were later fitted with stereoscopic rangefinders on their roofs. In action, the gunnery officer's station was close to the ship's commanding officer in the conning tower.

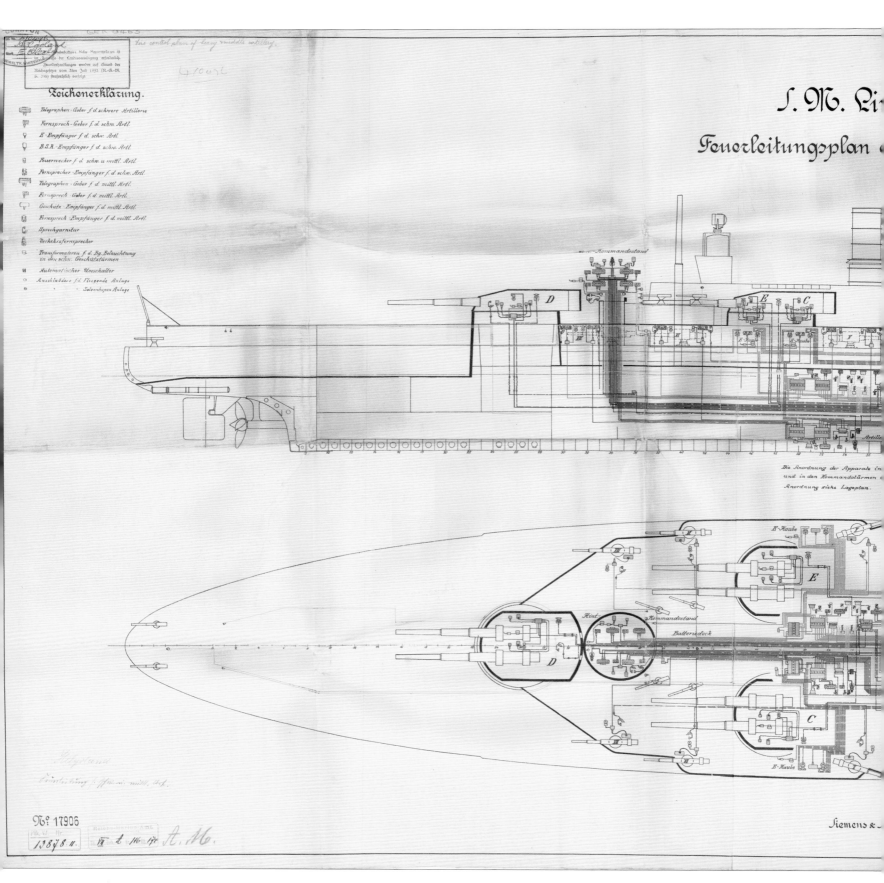

MAIN AND SECONDARY ARMAMENT CONTROL SYSTEMS, PROFILE AND PLAN
This diagram shows the various communications circuits between the conning towers and I. Battle-Station on the upper platform deck, and the guns. These included telephonic and telegraphic mechanisms. (M0953)

		H.K.	Hinterer-Kommandoturm.	Aft conning tower.
		K.K.P.	Kugelkompass-Podest.	Ball-compass pedestal.
		M.A.	Munitionsaufzug.	Ammunition hoist.
		R.B.L.	Ruderball leitung.	Rudder-ball mechanism.
		S.F.	Signalflaggenschacht.	Signal flag shaft.
		K.f.8.8cm A.K	Kasten für 8.8cm Abh. Kanone.	Locker for for 8.8cm sub-calibre insert
		K.W.	Kohlenwinde.	Coal hoist.
		Tr.	Trossenrolle.	Coiled hawsers.
		Kl.	Klampe.	Clamp.
		L.R.	Leitrolle.	Fairlead-roller.
		Sch.R.St.	Scheinwerferrichtsände.	Searchlight control.
		D.f.F.	Davit für Fleischtransport.	Meat handling davit.
		H.f.G.	Halter für Göschstock.	Holder for jackstaff.

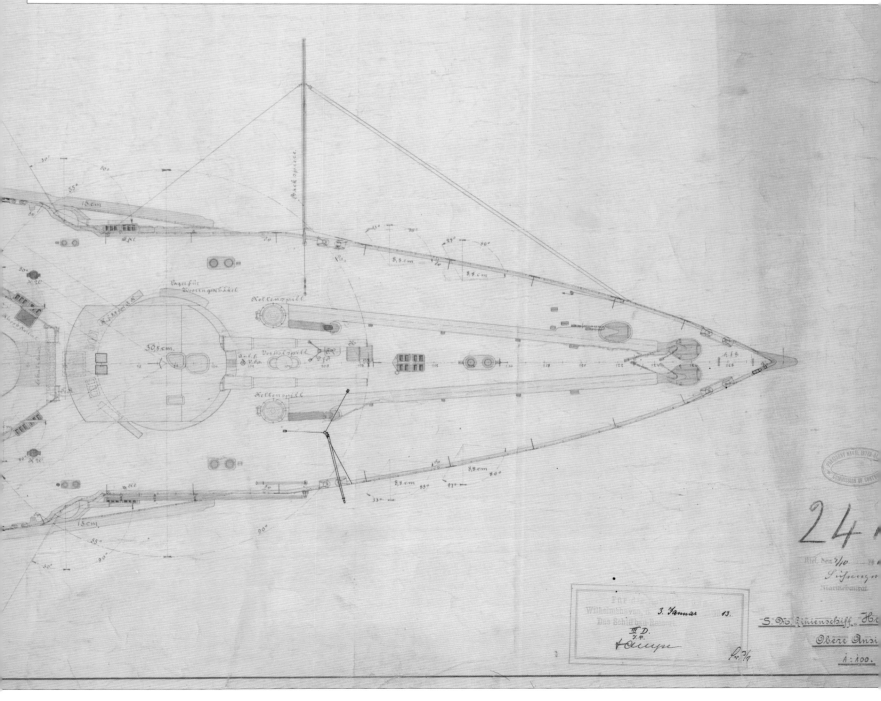

AFT SUPERSTRUCTURE DECK
For translation of key, see page 114

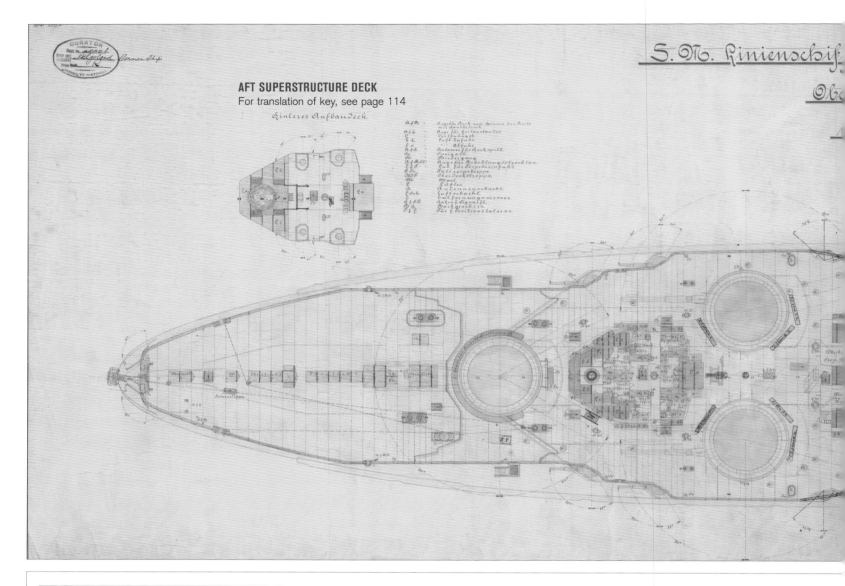

S. M. Linienschiff

Key to J8976 (overleaf, see also pages 120-123)

A A	Artillerie-Akkumulatorenspind.	Locker for gunnery batteries.
A S	Artillerie-Schraubenschlüsselspind.	Locker for gunnery spanners.
A T	Anrichtetisch.	Sideboard.
B L	Blechkasten für Galazeug.	Metal box for full dress uniform.
B M L	Bereitschaftsmunitions-Kasten für leichte Artillerie.	Ready-use ammunition box for tertiary battery.
B R	Backsregal.	Back shelf.
F	Fallreepsstauung.	Stowing-position for accommodation ladder.
F L	Flaggenleisten.	Flag-racks.
G Bu K S	Geheimbücher- u. Kassenschrank.	Confidential books and general safe.
G F	Gehänge für Fleischwaren.	Hooks for butchers' equipment.
G G	Gewehrgerüst.	Rack for firearms.
G R	Geschossracken für mittlere Artillerie.	Projectile-racks for secondary guns.
H	Heizkörper.	Radiator.
K	Kohlenschütte, feste.	Coal chute, permanent.
K l	Kohlenschütte, losnehmbare.	Coal chute, dismountable.
K B	Klappbank.	Folding bench.
K B M	Kartuschbüchsen für mittlere Artillerie.	Cartridge cases for secondary guns.
Kj	Koje.	Bunk.
Kl S	Kleiderschrank.	Wardrobe.
K P	Klappbare Platte als Nachttisch.	Folding bedside table.
K St	Konsol für Sterilisierapparat.	Console for steriliser.
K T	Klapptisch.	Folding table.

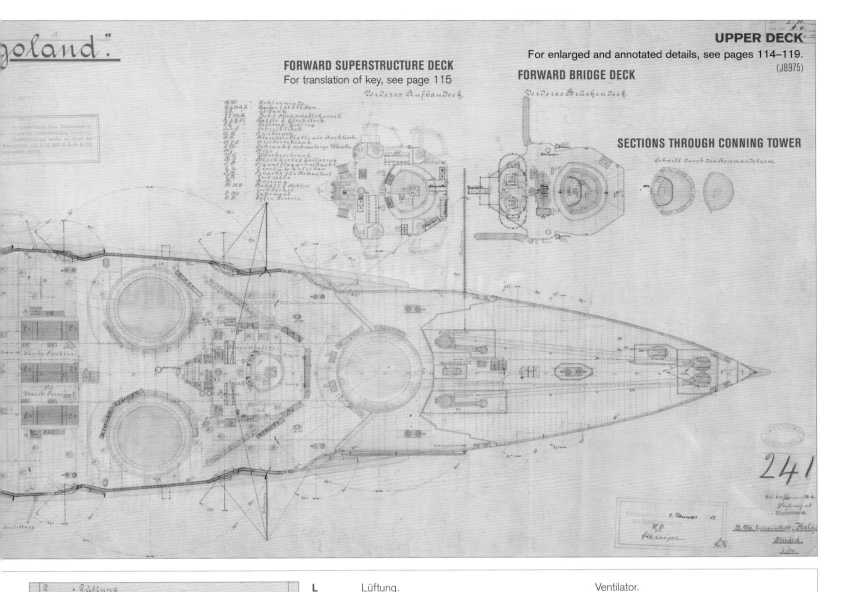

FORWARD SUPERSTRUCTURE DECK
For translation of key, see page 115

FORWARD BRIDGE DECK

UPPER DECK
For enlarged and annotated details, see pages 114–119.
(J8975)

SECTIONS THROUGH CONNING TOWER

		Ventilator.
L	Lüftung.	Ventilator.
M A	Munitionsaufzug.	Ammunition hoist.
M L	Munitionsluk.	Ammunition hatch.
M G	Maschinengewehr.	Machine gun.
N T	Nachttisch.	Nightstand.
R	Regal.	Shelf.
R A	Reserve-Aschaufzug.	Reserve ash-ejector.
R G	Reinigungsgeschirr.	Cleaning material.
R S	Öffnung zum Herausnehmen der Ruderspindel.	Hatch for extracting rudder-shaft.
S	Schrank.	Cupboard.
Sch	Scheinwerfer.	Searchlights.
Sch.MG	Scheinwerfer-Motorgeneratoren.	Generators for searchlights.
S D	Schrank für Dienstzeug.	Locker for work clothes.
S P	Schreibpult.	Upright writing desk.
Sp	Schrank for schmutziges Dienstzeug.	Locker for dirty work-clothes.
Sp B	Spülbecken.	Sink.
S T	Schreibtisch.	Writing desk.
St.Sp	Stiefelspind.	Boot locker.
S W	Schrank für schmutzige Wäsche.	Locker for dirty laundry.
W B	Waschbecken.	Sink.
W G	Waschgestell.	Washstand.
W S	Wäscheschrank.	Laundry locker.
W T	Waschtisch.	Washbasin.

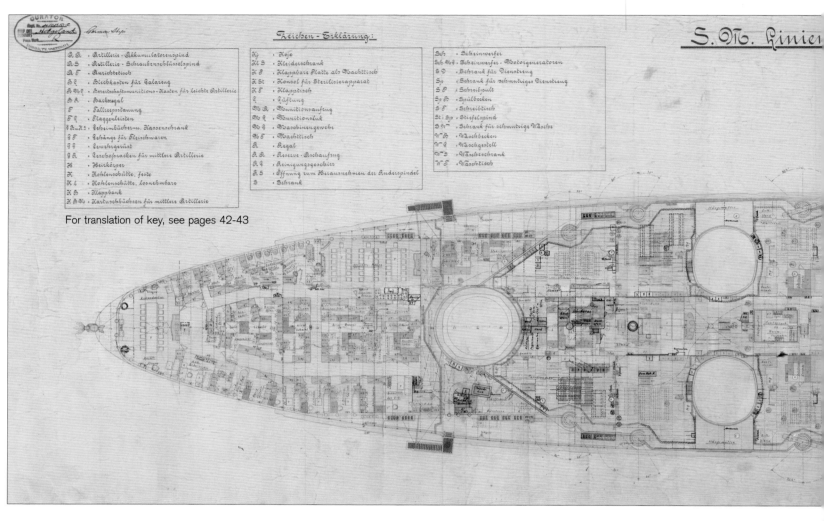

For translation of key, see pages 42-43

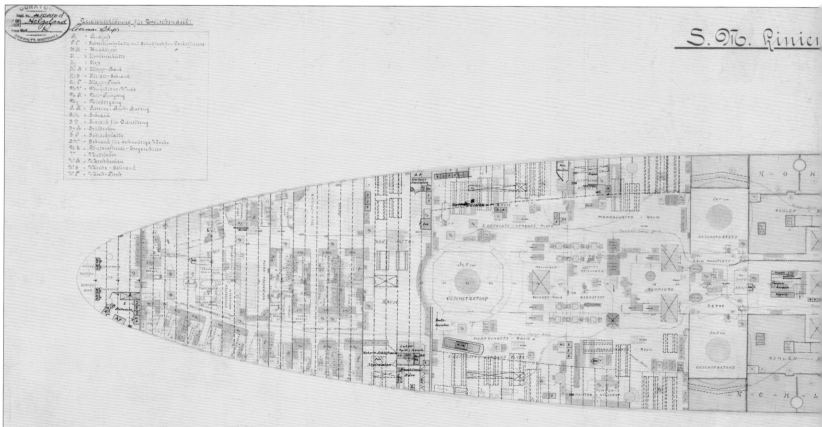

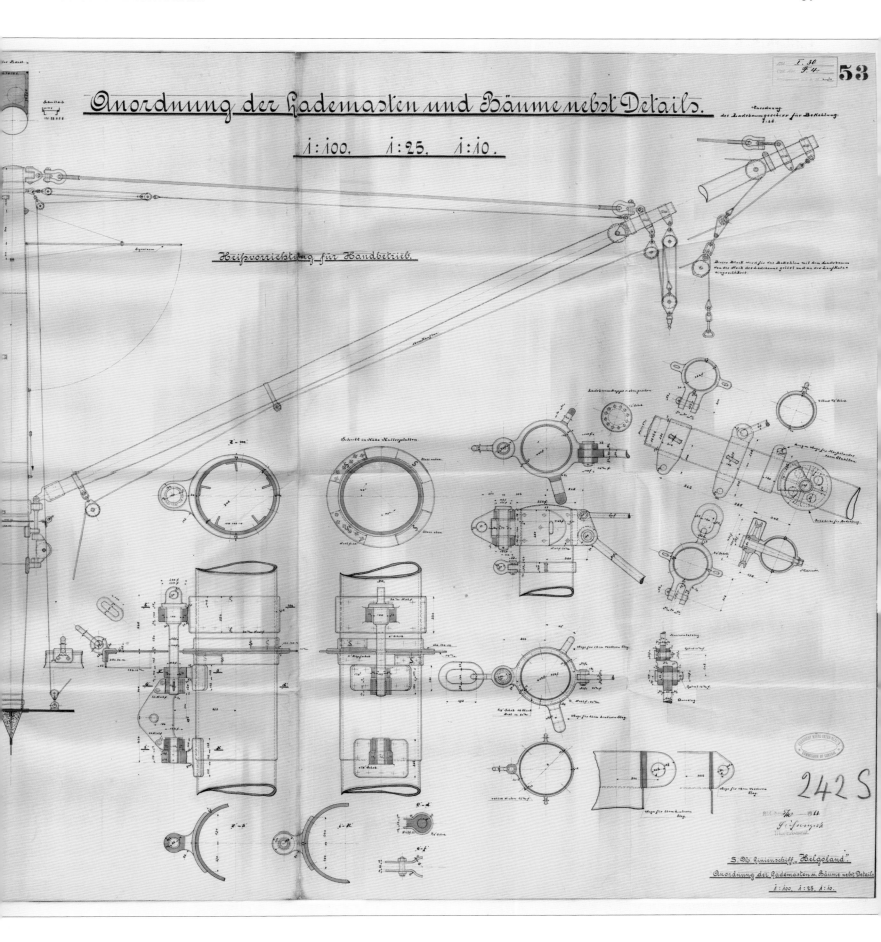

Anordnung der Rademasten und Bäume nebst Details.

1 : 100. 1 : 25. 1 : 10.

Heißvorrichtung für Handbetrieb.

KINGPOSTS AND DERRICK DETAILS (previous pages)
The left half of the diagram shows the equipment as rigged for motorised use, the right for manual employment. (M0952)

FORWARD CAPSTAN MECHANISM
The ship's capstans (there is also one aft) are employed both for raising and lowering the anchors, and for a range of other mooring and wider haulage tasks. (M0956)

TECHNICAL DETAILS

Machinery

Number of cylinders	2
Cylinder diameter	320mm
Cylinder stroke	280mm
Revolutions per minute	300
Boiler pressure	16atm

Capstan mechanism

Chain	72mm
Chain links	940mm
Hemp hawser 18cm size	
Steel hawser 13cm size	
Bolted drum for steel hawser	660mm
Speed of chain per minute, if n=300	12.0m
Speed of hawser per minute, if n=300	24.0m
Total efficiency	0.34

S. M. Linienschiff „Helgoland."

Bugspillanlage.

Bow Capstan

Maßstab 1:25.

Hauptabmessungen.

Maschine.

Cylinderzahl	2
Cylinderdurchm.	320 %
Kolbenhub	240 "
Umdrehungen pr. Minute	300 "
Kesselüberdruck	15 atm.

Spillanlage.

Kette	72 %
Kettennabe ø	940 "
Stahltrosse 14 cm Umfang	
Stahltrosse 13 cm Umfang	
Verholtrommel für Stahltrosse	550
Geschwindigkeit der Kette pr. Min. bei n=300	12,0 m
Geschwindigkeit der Trosse " n=300	24,0 "
Gesamtwirkungsgrad	0,34

Rädertabelle.

	ø	t	z	b
Ankerspillschnecke	290	4½"	eingängig	rechts
Ankerspillrad	2544	4½"	72	200
Verholspillschnecke	290	3"	dreigängig	links
Verholspillrad	1014	3"	62	140
Verholspillstirnräder	420	26π	16	200
Verholspillstirnräder	794	29π	24	200

FROM THE STERN TO THE AFT END OF THE CITADEL

The aft section of the ship, to Station 23, is dominated by the accommodation areas for the vessel's officers and NCOs, together with the three propellers, two rudders, and the latter's actuation mechanism. It also accommodates parts of the tertiary (anti-torpedo-boat) and torpedo armament, and is protected for its whole length by an armour deck, although the side armour terminates short of the stern.

STERN TO STATION -4

The extreme stern of the ship contains in particular the main cabin of the Captain's quarters, together with the aftermost pair of tertiary guns. It was the only part of the ship without side armour, protected only by the armour deck and a transverse armoured bulkhead.

The aftermost of a series of skylights along the centreline of the quarterdeck provides illumination for the largest compartment of the Captain's quarters, with a large table, capable of seating sixteen for conferences and formal dinners. While *Ostfriesland* was fitted as a squadron flagship, with admiral's quarters, *Helgoland* and her other sisters were built as private ships, with the result that their commanding officers enjoyed more commodious and better-situated accommodation.

The stern anchor, of Hall stockless type, and weighing 3750kg, is stowed at the extreme stern, its support also acting as the mount for the stern steaming light.

The aftermost 8.8cm/45 C/06 guns are mounted in the same compartment as the Captain's dining/conference table, which thus had to be secured when the ship was cleared for action. Intended for use against attacking torpedo craft, with a maximum elevation of 25°, and a maximum depression of -5°, and placed 4.19m above the waterline, they obtained clear arcs across the stern by the omission of the Upper Deck aft of them. This feature had been introduced in the *Deutschland* class, but the *Helgoland*s were the last to be so arranged, the succeeding *Kaiser* class having a conventional stern, with the 8.8cm guns in sided embrasures. All the original 8.8cm guns were removed during the First World War, many for reuse in smaller vessels.

–4 STATION

STATION -4

(After sections -4 to 30 J8981) It should be noted that from the stern to midships (Station 56), sections are drawn looking aft; from midships (Station 64) to the bow, they look forward.

The 8.8cm/45 guns formed part of the tertiary battery, intended for use against torpedo boats. Trials in 1897 had suggested that such guns should be as widely dispersed, and as low down in the hull as possible, to best spot and engage small and inconspicuous torpedo craft. While rarely possible amidships owing to the presence of secondary guns on the battery deck (except in the reconstructed battleships of the *Kaiser Friedrich III* class), it could easily be implemented at the fore and aft extremities. *Helgoland*'s aft pair of guns were capable of traverse through 90°, but stowed trained directly aft, closed off by sectional shutters that extended around the mountings' full training range.

The sloped, curved, aft portion of the armour deck comprises a 20mm lower layer of mild steel, topped by 35mm of nickel steel, protecting the aft torpedo tube.

St.B. -4 B.B.

STATION 17

Officers' Mess.

The armour deck from Station 16 to Station 23 comprises 35mm of nickel steel, on both flat and slopes.

Aft broadside torpedo room, showing spare torpedoes.

St. B.

17
Scholt

B.B.

STATION 17 TO STATION 21

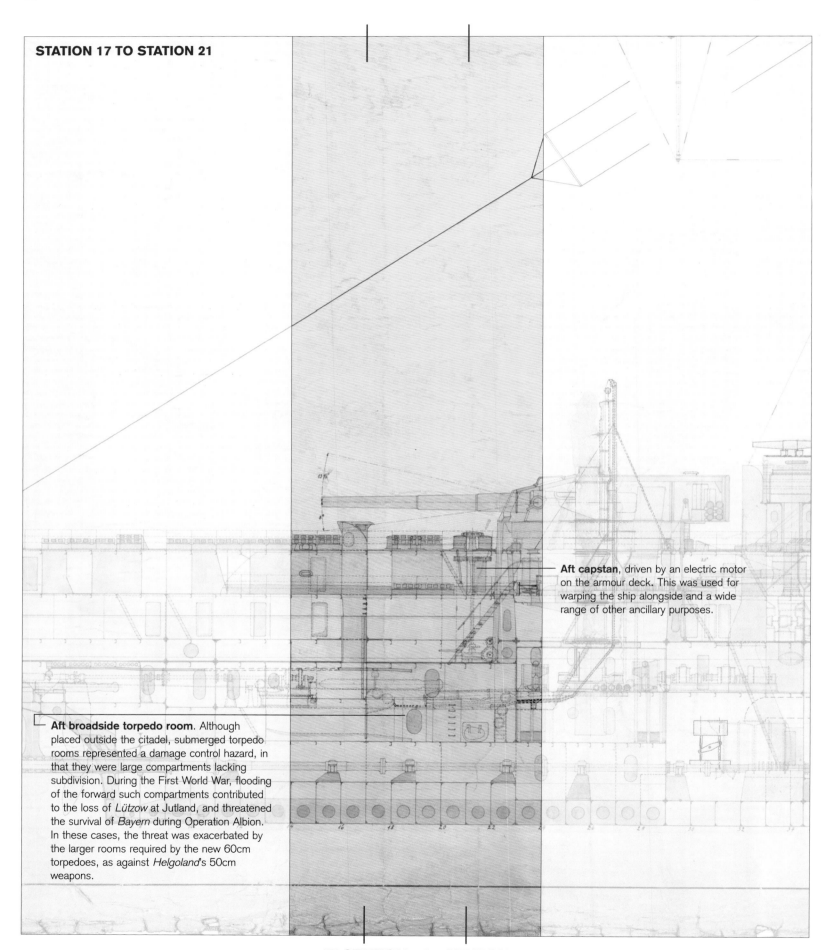

Aft capstan, driven by an electric motor on the armour deck. This was used for warping the ship alongside and a wide range of other ancillary purposes.

Aft broadside torpedo room. Although placed outside the citadel, submerged torpedo rooms represented a damage control hazard, in that they were large compartments lacking subdivision. During the First World War, flooding of the forward such compartments contributed to the loss of *Lützow* at Jutland, and threatened the survival of *Bayern* during Operation Albion. In these cases, the threat was exacerbated by the larger rooms required by the new 60cm torpedoes, as against *Helgoland*'s 50cm weapons.

17 STATION 21 STATION

STATION 21

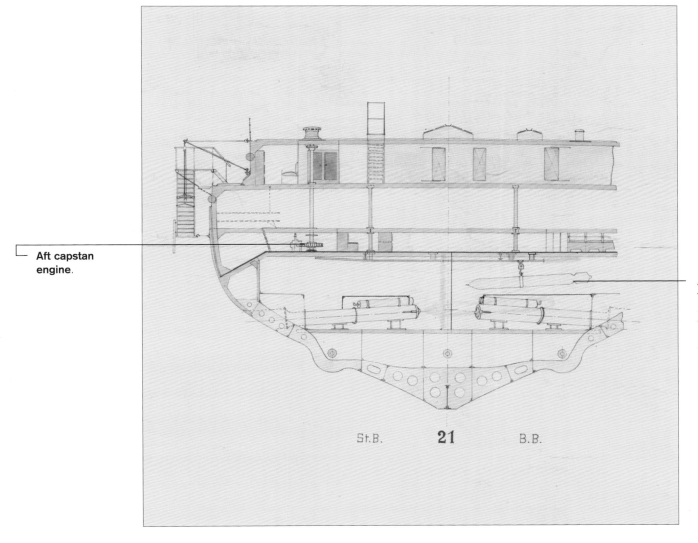

Aft capstan engine.

Aft broadside torpedo room, showing the torpedo tubes, angled down by 2° and 20° forward of the beam. A torpedo is shown being manoeuvred by the overhead hoist.

THE CITADEL

Between Station 23 and Station 100 is the core of the vessel as a fighting ship, containing the main and secondary armaments, propulsion machinery, and command and control facilities. As such, it is extensively protected by side, barbette and deck armour, together with an elaborate underwater protection system, the whole citadel being divided into three parallel sections by four continuous longitudinal bulkheads, the outer ones being the armoured torpedo bulkheads. Outside these on each beam are a layer of protective coal bunkers and a final void. Within the citadel, the flat portion of the armour deck is raised by half a deck to middle deck level.

STATION 21 TO STATION 26

This area is dominated by the aftermost of the ship's main battery turrets. In German practice, such mountings were lettered clockwise from the bow; thus, on a six-turret ship like *Helgoland*, the aft turret was 'D' ('Dora'). This was completely different from the British approach, where fore, midships and aft turrets were lettered in distinct groups, meaning that in a British ship *Helgoland*'s aft mounting would have been 'X'.

Also contrary to contemporary British practice, shell rooms are placed above the magazines, an arrangement reversed in the *Bayern* class. Curiously, from the *Nelson* class onwards, the British adopted the earlier German approach, on the safety grounds that in the event of underwater damage in the vicinity of the magazines they would flood naturally.

Loading rig for the aft broadside torpedo room. Torpedoes are lowered through a vertical shaft just starboard of 'D' turret, through the armour deck, and then obliquely aft in to the torpedo room.

Above the upper deck, the barbette armour of 'D' turret is 270mm thick across its frontal arc.

The working chamber is where the lower set of hoists from the magazines and shell room terminate, and shells and charges are transferred to the two upper hoists, which deliver them to each of the guns.

The frontal barbette armour is also 270mm thickness down to the armour deck, but behind the transverse bulkhead that intersects it at Station 23, the barbette reduces to 80mm. This hardened nickel-steel bulkhead is 170mm thick above the waterline, 210mm thick below.

The shell room is above the magazines, on the upper platform deck, and for 'D' turret contained ninety armour-piercing and ten base-fuzed high-explosive shells, the latter with a 26.8kg burster.

The two magazines of 'D' turret, containing the propellant for the aft turret, are on the lower platform deck. Charges were in two parts, the main charge (91kg) contained in a brass case with a thin metal closure at the front, and the fore-charge (35kg) entirely enclosed in thin metal. The latter case and main charge closure disintegrated on firing, but the main charge brass case was either returned direct to the magazine after firing or ejected through one of two ports in the rear wall of the turret. This metal-sheathing of the charges reduced the risk of the kind of propellant fires that proved fatal to a number of British vessels at Jutland.

STATION 26

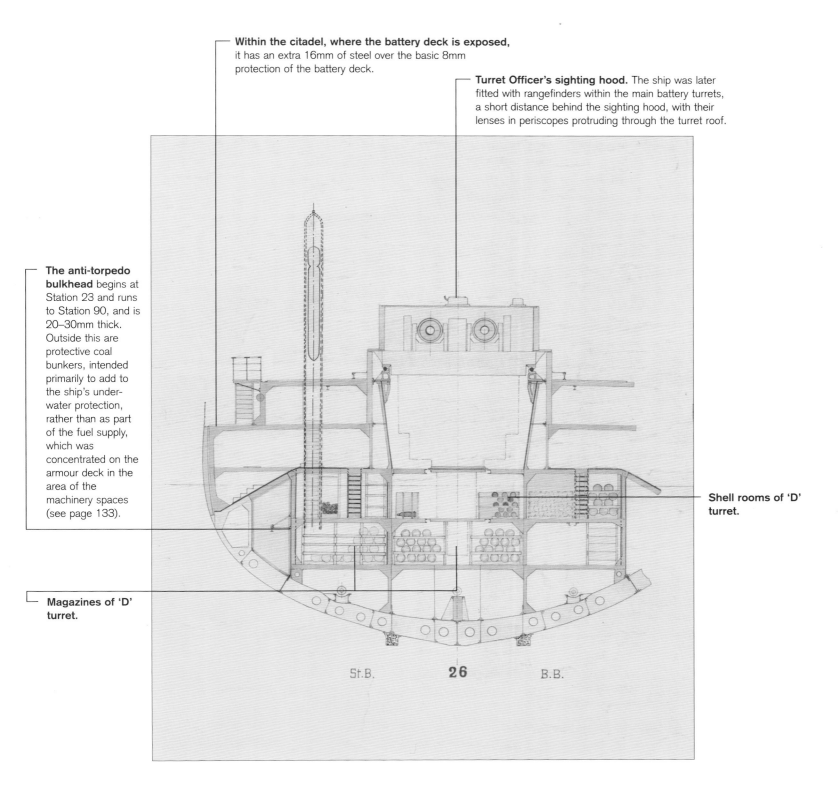

Within the citadel, where the battery deck is exposed, it has an extra 16mm of steel over the basic 8mm protection of the battery deck.

Turret Officer's sighting hood. The ship was later fitted with rangefinders within the main battery turrets, a short distance behind the sighting hood, with their lenses in periscopes protruding through the turret roof.

The anti-torpedo bulkhead begins at Station 23 and runs to Station 90, and is 20–30mm thick. Outside this are protective coal bunkers, intended primarily to add to the ship's under-water protection, rather than as part of the fuel supply, which was concentrated on the armour deck in the area of the machinery spaces (see page 133).

Shell rooms of 'D' turret.

Magazines of 'D' turret.

St.B. **26** B.B.

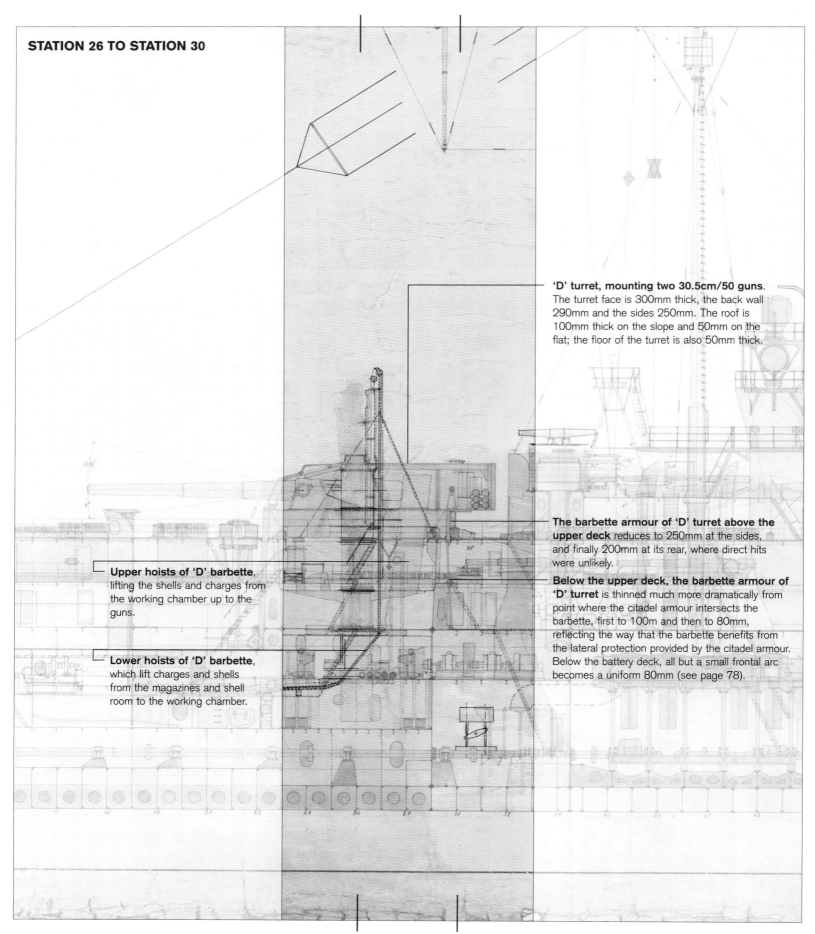

STATION 26 TO STATION 30

'D' turret, mounting two 30.5cm/50 guns. The turret face is 300mm thick, the back wall 290mm and the sides 250mm. The roof is 100mm thick on the slope and 50mm on the flat; the floor of the turret is also 50mm thick.

The barbette armour of 'D' turret above the upper deck reduces to 250mm at the sides, and finally 200mm at its rear, where direct hits were unlikely.

Below the upper deck, the barbette armour of 'D' turret is thinned much more dramatically from point where the citadel armour intersects the barbette, first to 100m and then to 80mm, reflecting the way that the barbette benefits from the lateral protection provided by the citadel armour. Below the battery deck, all but a small frontal arc becomes a uniform 80mm (see page 78).

Upper hoists of 'D' barbette, lifting the shells and charges from the working chamber up to the guns.

Lower hoists of 'D' barbette, which lift charges and shells from the magazines and shell room to the working chamber.

26 STATION 30 STATION

STATION 30

The belt armour thickens to 170mm (upper edge)/300mm (waterline)/170mm (lower edge) at Station 23 and continues as such to Station 45.

Seamen's mess.

NCO's mess.

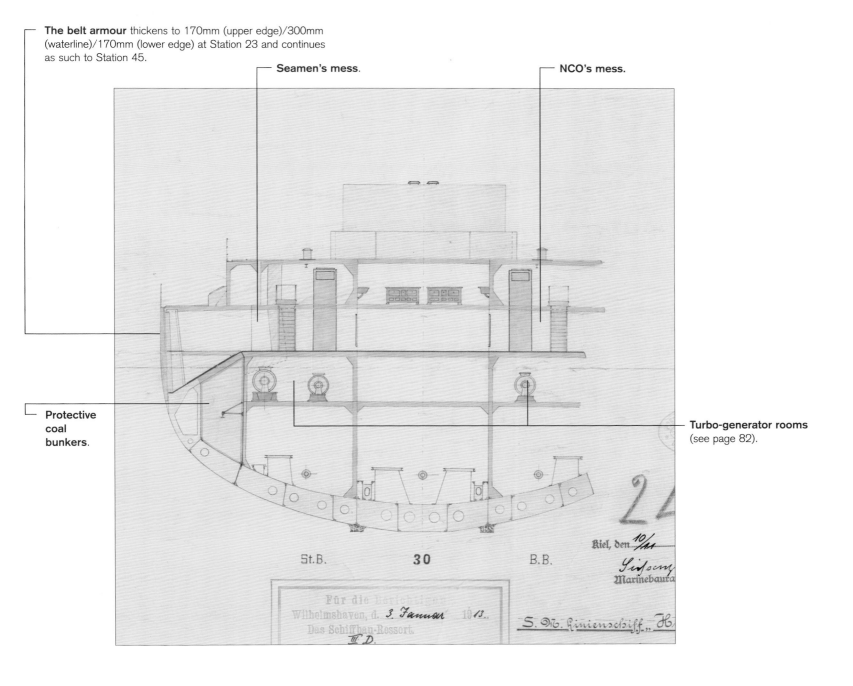

Protective coal bunkers.

Turbo-generator rooms (see page 82).

St.B. 30 B.B.

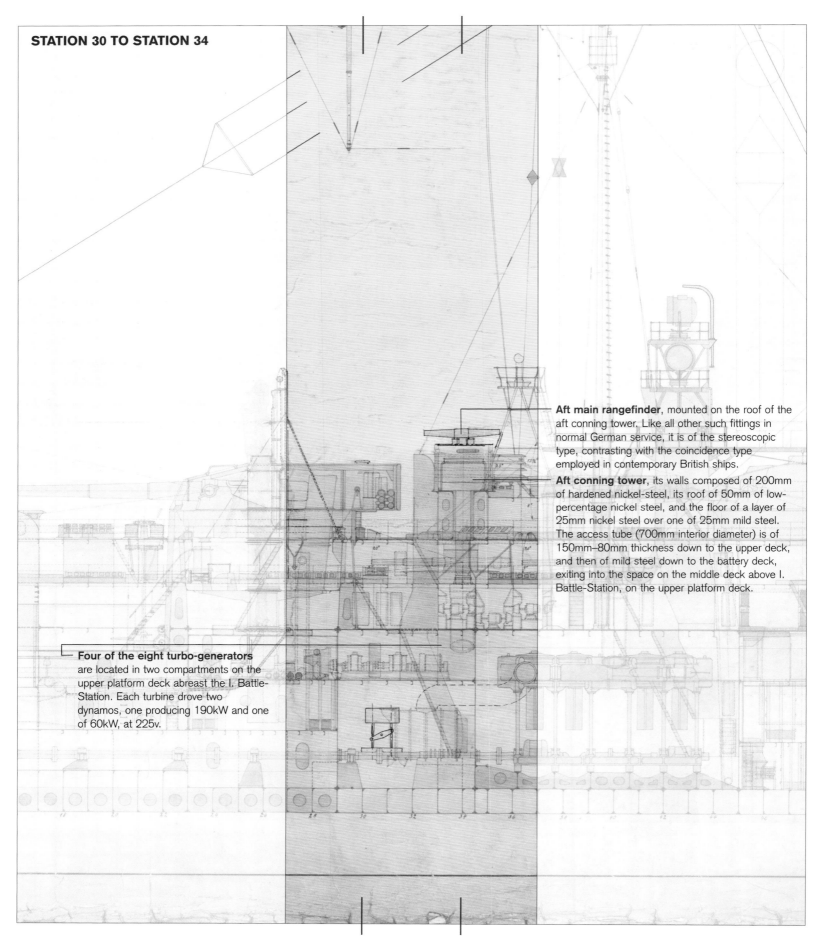

STATION 30 TO STATION 34

Aft main rangefinder, mounted on the roof of the aft conning tower. Like all other such fittings in normal German service, it is of the stereoscopic type, contrasting with the coincidence type employed in contemporary British ships.

Aft conning tower, its walls composed of 200mm of hardened nickel-steel, its roof of 50mm of low-percentage nickel steel, and the floor of a layer of 25mm nickel steel over one of 25mm mild steel. The access tube (700mm interior diameter) is of 150mm–80mm thickness down to the upper deck, and then of mild steel down to the battery deck, exiting into the space on the middle deck above I. Battle-Station, on the upper platform deck.

Four of the eight turbo-generators are located in two compartments on the upper platform deck abreast the I. Battle-Station. Each turbine drove two dynamos, one producing 190kW and one of 60kW, at 225v.

30 STATION 34 STATION

STATION 52

This area of the ship is particularly 'busy', containing not only the magazines and shell-rooms for the after pair of midships turrets ('C' [starboard] and 'E' ['Emil', port]) at upper and lower platform deck level, but also magazines for the secondary and tertiary guns.

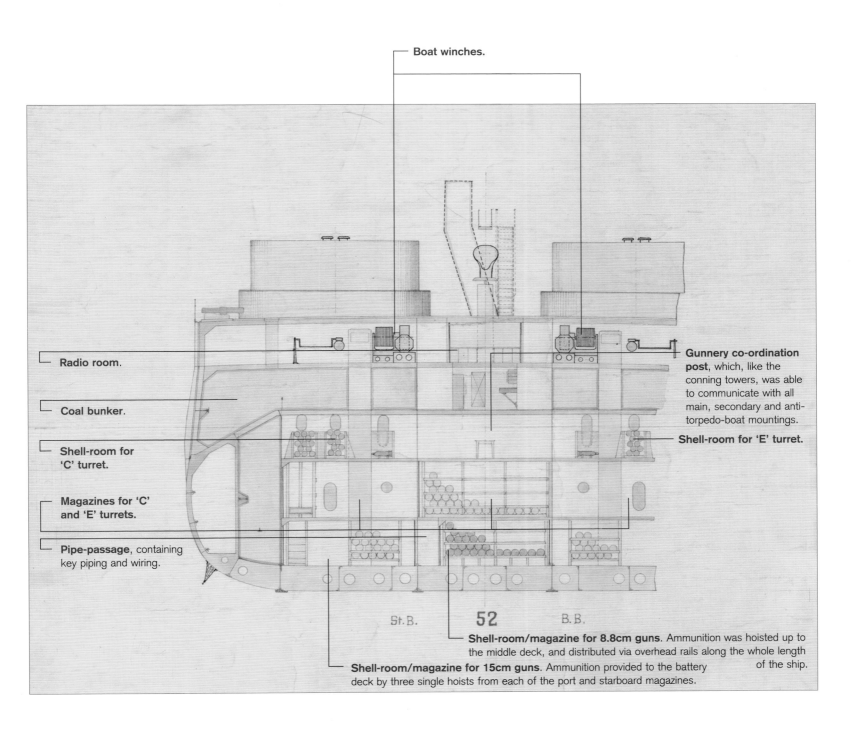

Boat winches.

Radio room.

Coal bunker.

Shell-room for 'C' turret.

Magazines for 'C' and 'E' turrets.

Pipe-passage, containing key piping and wiring.

Gunnery co-ordination post, which, like the conning towers, was able to communicate with all main, secondary and anti-torpedo-boat mountings.

Shell-room for 'E' turret.

St.B. 52 B.B.

Shell-room/magazine for 8.8cm guns. Ammunition was hoisted up to the middle deck, and distributed via overhead rails along the whole length of the ship.

Shell-room/magazine for 15cm guns. Ammunition provided to the battery deck by three single hoists from each of the port and starboard magazines.

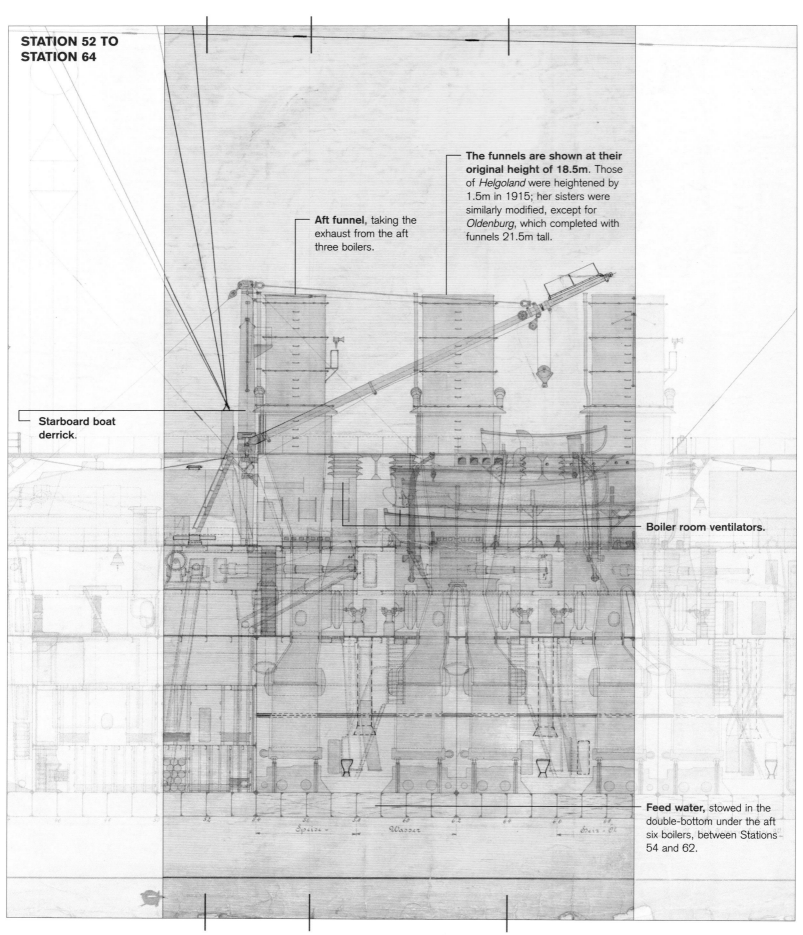

**STATION 52 TO
STATION 64**

**The funnels are shown at their
original height of 18.5m.** Those
of *Helgoland* were heightened by
1.5m in 1915; her sisters were
similarly modified, except for
Oldenburg, which completed with
funnels 21.5m tall.

Aft funnel, taking the
exhaust from the aft
three boilers.

**Starboard boat
derrick**.

Boiler room ventilators.

Feed water, stowed in the
double-bottom under the aft
six boilers, between Stations
54 and 62.

52 STATION 56 STATION 64 STATION

STATION 56

This is the last section which looks aft; after this, they look forward.

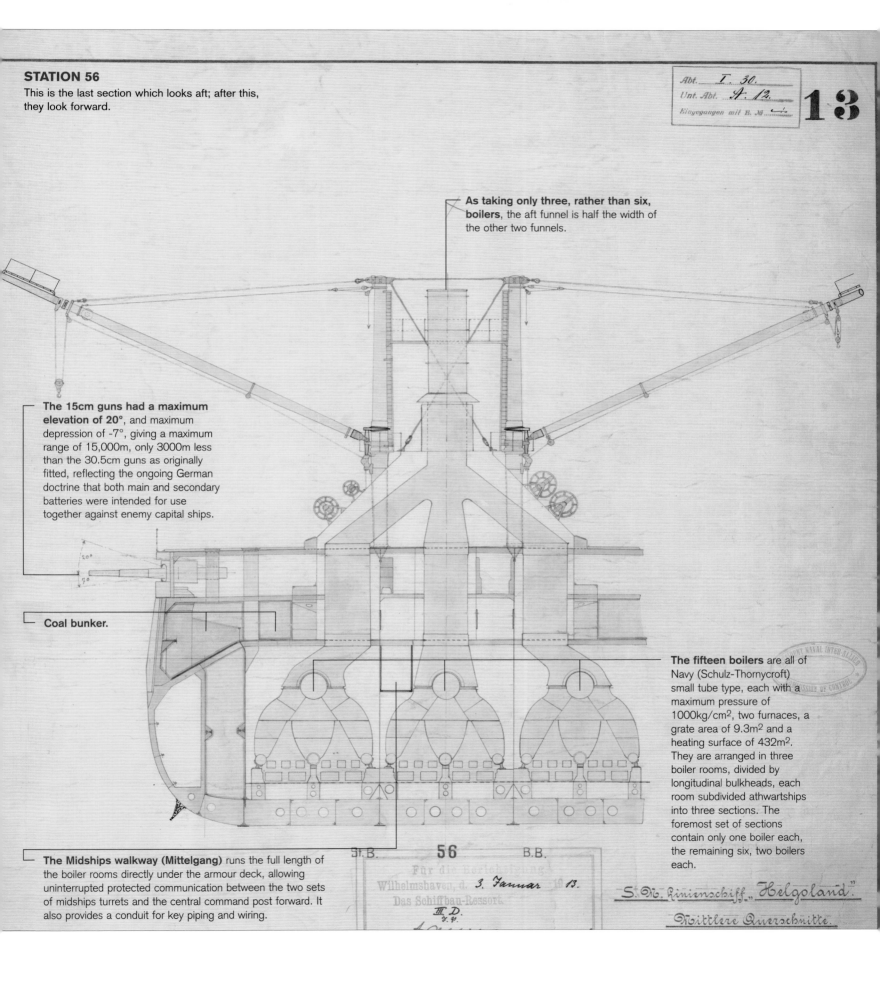

As taking only three, rather than six, boilers, the aft funnel is half the width of the other two funnels.

The 15cm guns had a maximum elevation of 20°, and maximum depression of -7°, giving a maximum range of 15,000m, only 3000m less than the 30.5cm guns as originally fitted, reflecting the ongoing German doctrine that both main and secondary batteries were intended for use together against enemy capital ships.

Coal bunker.

The fifteen boilers are all of Navy (Schulz-Thornycroft) small tube type, each with a maximum pressure of 1000kg/cm², two furnaces, a grate area of 9.3m² and a heating surface of 432m². They are arranged in three boiler rooms, divided by longitudinal bulkheads, each room subdivided athwartships into three sections. The foremost set of sections contain only one boiler each, the remaining six, two boilers each.

The Midships walkway (Mittelgang) runs the full length of the boiler rooms directly under the armour deck, allowing uninterrupted protected communication between the two sets of midships turrets and the central command post forward. It also provides a conduit for key piping and wiring.

St. B. **56** B.B.

Für die
Wilhelmshaven, d. *3. Januar* 19 13.
Das Schiffbau-Ressort.
III. D.

S. M. *Linienschiff* „*Helgoland*".

Mittlere Querschnitte.

STATION 64

(Sections 64 to 129, looking forward J8982)

The ship's boats are stowed amidships and handled by the derricks abreast the aft funnel, with the exception of two sea-boats carried on davits. The ship's standard complement was:

1 x steam launch
2 x motor boats, size A
1 x motor boat, size III
1 x launch with auxiliary motor, size 0
1 x launch, size 0
2 x cutters, size 0
2 x jolly-boats, size 0
1 x folding boat

Ash ejector, intended to evacuate the by-products of burning coal from the boiler room, by mixing them with water, which is then discharged outboard under pressure. In an emergency, the system could be used to pump floodwater out of the compartment.

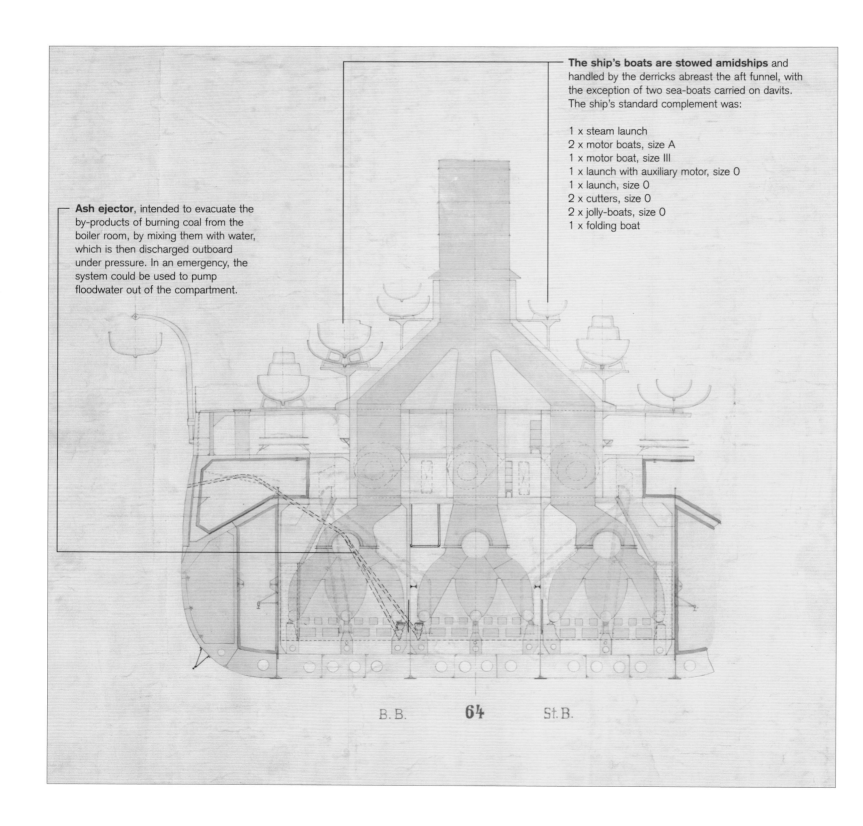

B.B. **64** St.B.

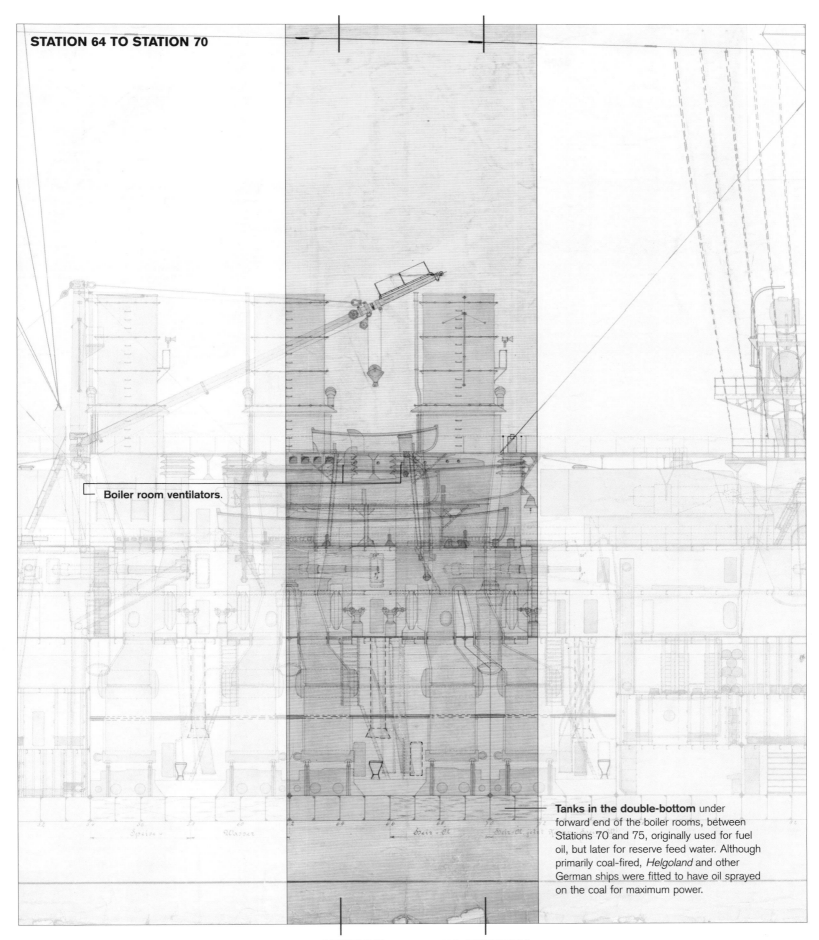

Boiler room ventilators.

Tanks in the double-bottom under forward end of the boiler rooms, between Stations 70 and 75, originally used for fuel oil, but later for reserve feed water. Although primarily coal-fired, *Helgoland* and other German ships were fitted to have oil sprayed on the coal for maximum power.

64 STATION **70 STATION**

STATION 70

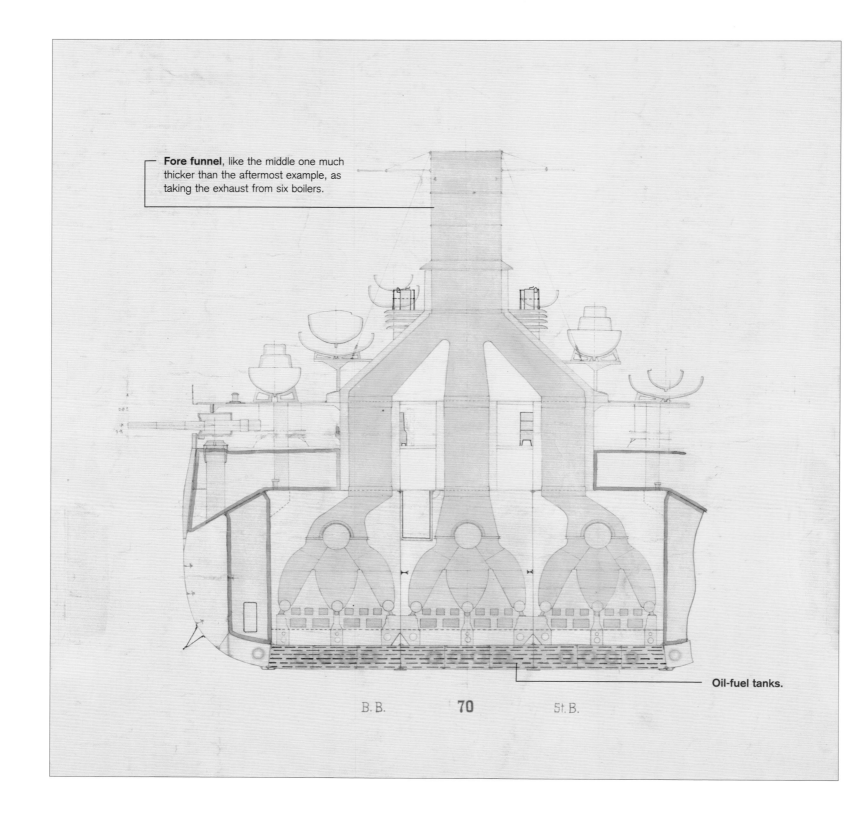

Fore funnel, like the middle one much thicker than the aftermost example, as taking the exhaust from six boilers.

Oil-fuel tanks.

B.B. **70** St.B.

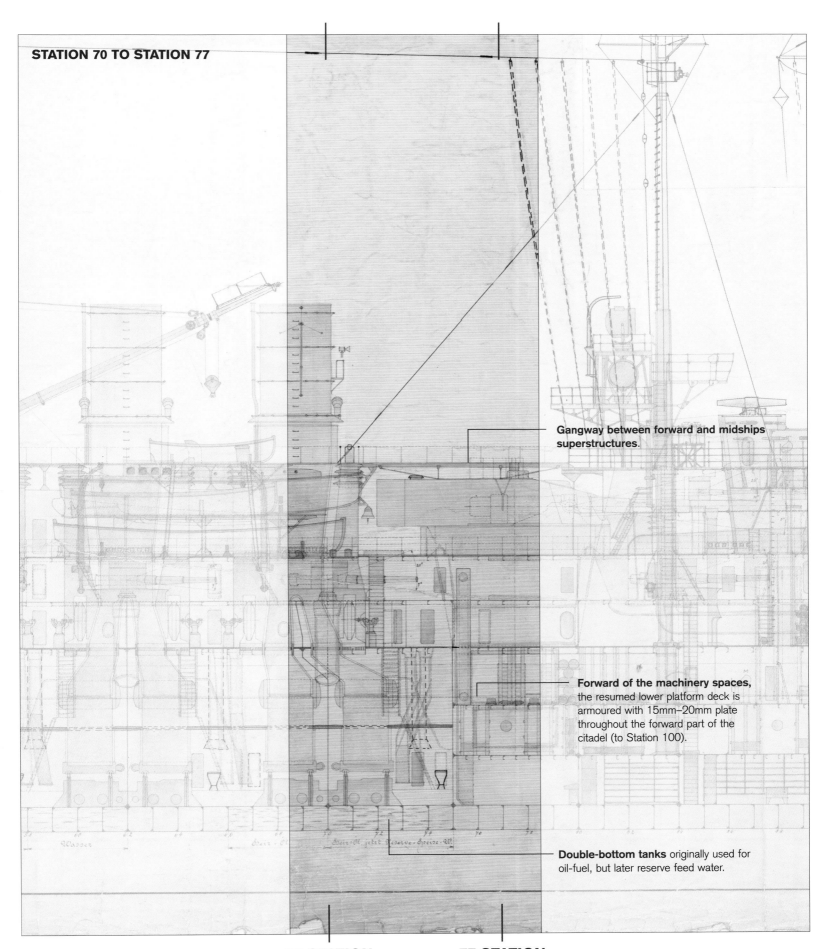

STATION 70 TO STATION 77

Gangway between forward and midships superstructures.

Forward of the machinery spaces, the resumed lower platform deck is armoured with 15mm–20mm plate throughout the forward part of the citadel (to Station 100).

Double-bottom tanks originally used for oil-fuel, but later reserve feed water.

70 STATION

77 STATION

STATION 77

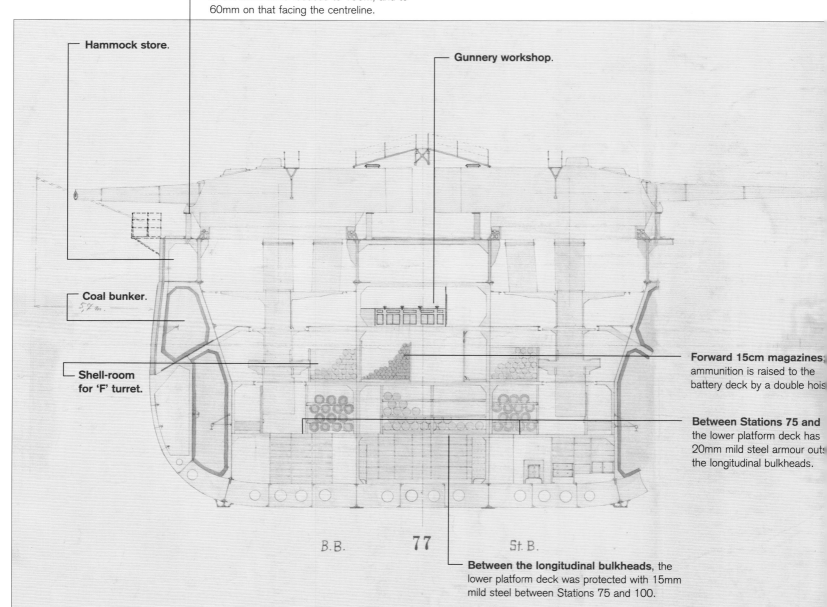

The armour of the midships barbettes is 270mm thick above the upper deck, except for the portion facing the centreline, which is 250mm thick. However, between the upper and battery decks, and now behind the thickened citadel armour (page 89), the beam-facing part of the barbette is reduced to 100m, and to 60mm on that facing the centreline.

Hammock store.

Gunnery workshop.

Coal bunker.
5.7 m.

Shell-room for 'F' turret.

Forward 15cm magazines; ammunition is raised to the battery deck by a double hois

Between Stations 75 and the lower platform deck has 20mm mild steel armour outs the longitudinal bulkheads.

B.B. 77 St. B.

Between the longitudinal bulkheads, the lower platform deck was protected with 15mm mild steel between Stations 75 and 100.

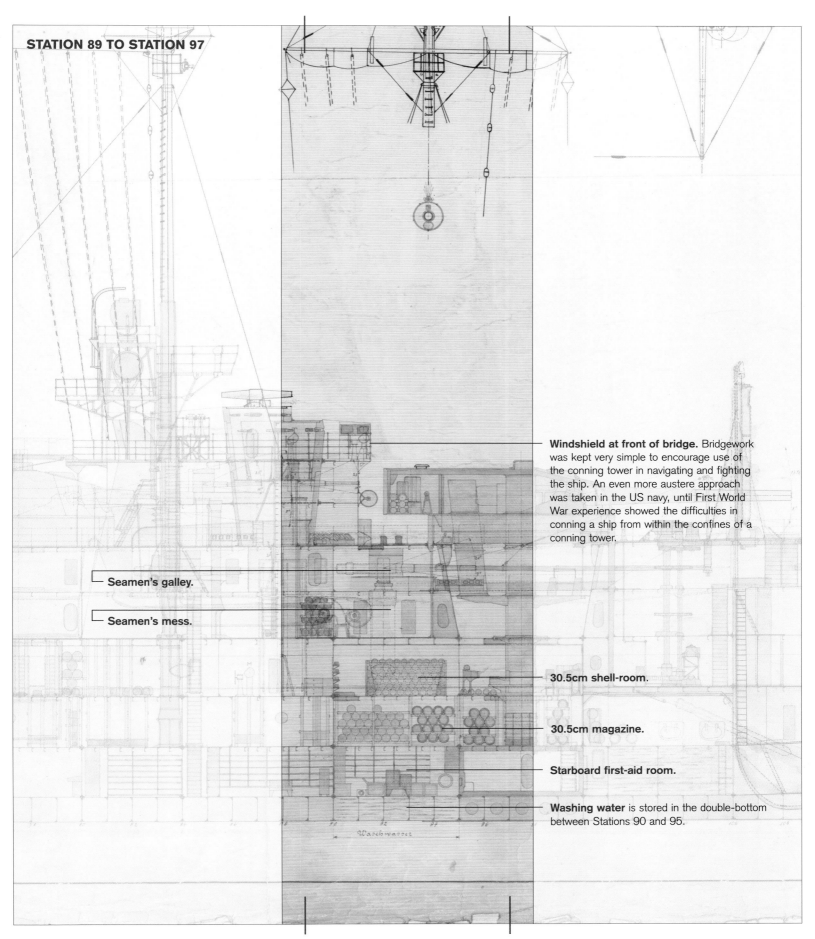

STATION 89 TO STATION 97

Windshield at front of bridge. Bridgework was kept very simple to encourage use of the conning tower in navigating and fighting the ship. An even more austere approach was taken in the US navy, until First World War experience showed the difficulties in conning a ship from within the confines of a conning tower.

Seamen's galley.

Seamen's mess.

30.5cm shell-room.

30.5cm magazine.

Starboard first-aid room.

Washing water is stored in the double-bottom between Stations 90 and 95.

89 STATION

97 STATION

STATION 97

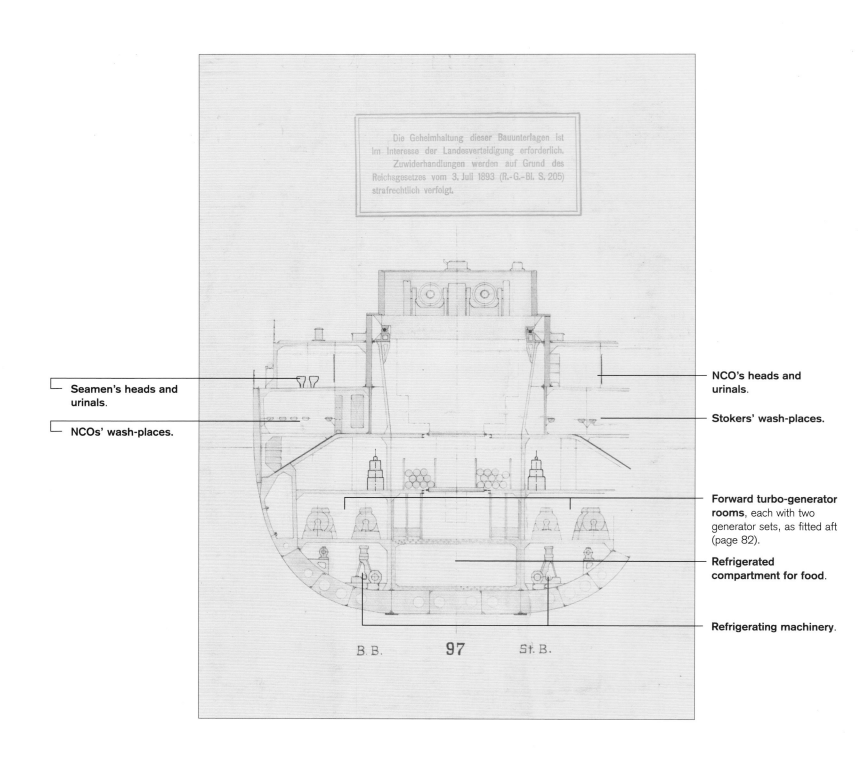

Seamen's heads and urinals.

NCOs' wash-places.

NCO's heads and urinals.

Stokers' wash-places.

Forward turbo-generator rooms, each with two generator sets, as fitted aft (page 82).

Refrigerated compartment for food.

Refrigerating machinery.

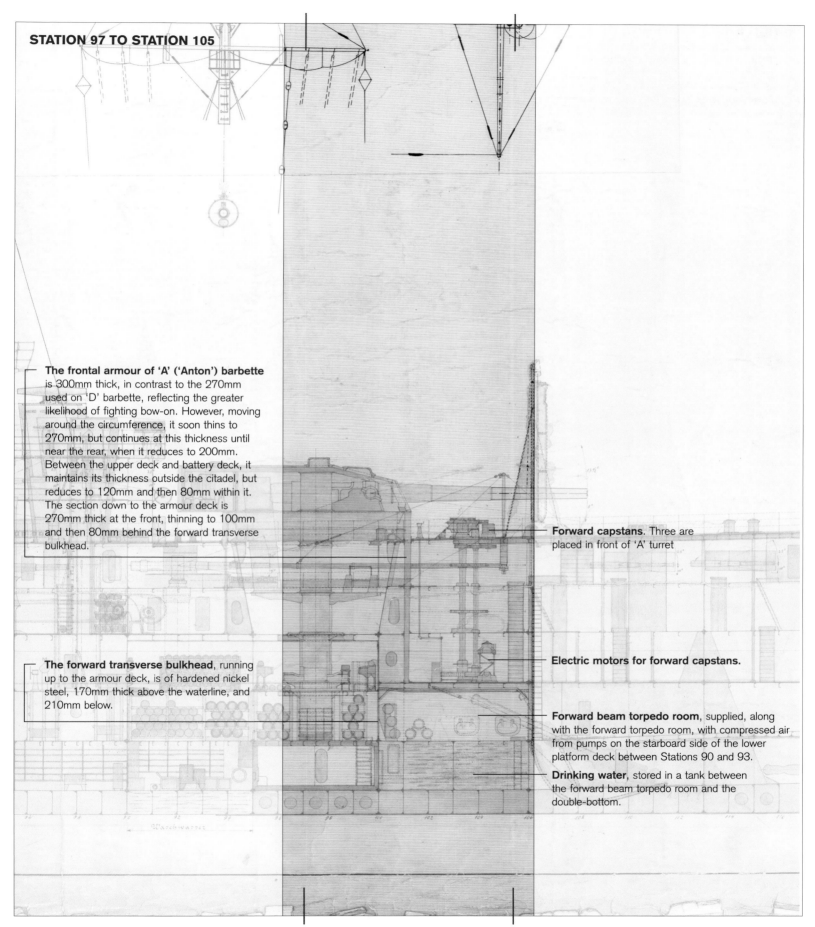

STATION 97 TO STATION 105

The frontal armour of 'A' ('Anton') barbette is 300mm thick, in contrast to the 270mm used on 'D' barbette, reflecting the greater likelihood of fighting bow-on. However, moving around the circumference, it soon thins to 270mm, but continues at this thickness until near the rear, when it reduces to 200mm. Between the upper deck and battery deck, it maintains its thickness outside the citadel, but reduces to 120mm and then 80mm within it. The section down to the armour deck is 270mm thick at the front, thinning to 100mm and then 80mm behind the forward transverse bulkhead.

Forward capstans. Three are placed in front of 'A' turret

The forward transverse bulkhead, running up to the armour deck, is of hardened nickel steel, 170mm thick above the waterline, and 210mm below.

Electric motors for forward capstans.

Forward beam torpedo room, supplied, along with the forward torpedo room, with compressed air from pumps on the starboard side of the lower platform deck between Stations 90 and 93.

Drinking water, stored in a tank between the forward beam torpedo room and the double-bottom.

97 STATION **105 STATION**

FROM THE CITADEL TO THE STEM

Forward of the citadel, the armour deck drops by a full deck and continues flat to the stem. The belt also continues to the bow, but at around half the thicknesses employed over the citadel. Most of the area above the waterline is taken up with messes for the seamen, and also by the sick bay and some NCO accommodation. Below the waterline are storerooms and the forward torpedo tube.

STATION 105

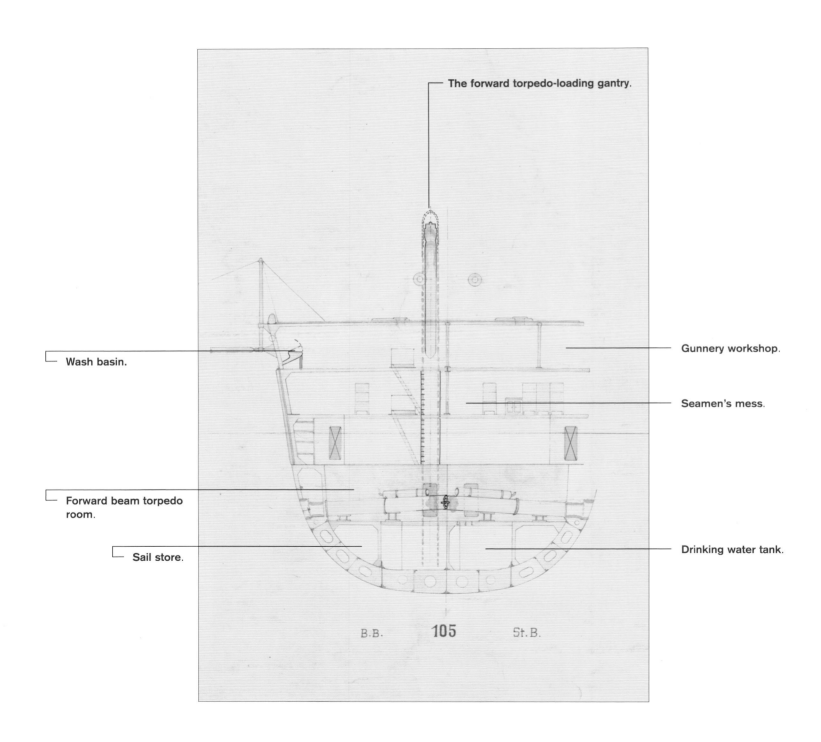

The forward torpedo-loading gantry.

Wash basin.

Gunnery workshop.

Seamen's mess.

Forward beam torpedo room.

Sail store.

Drinking water tank.

B.B. 105 St.B.

STATION 105 TO STATION 114

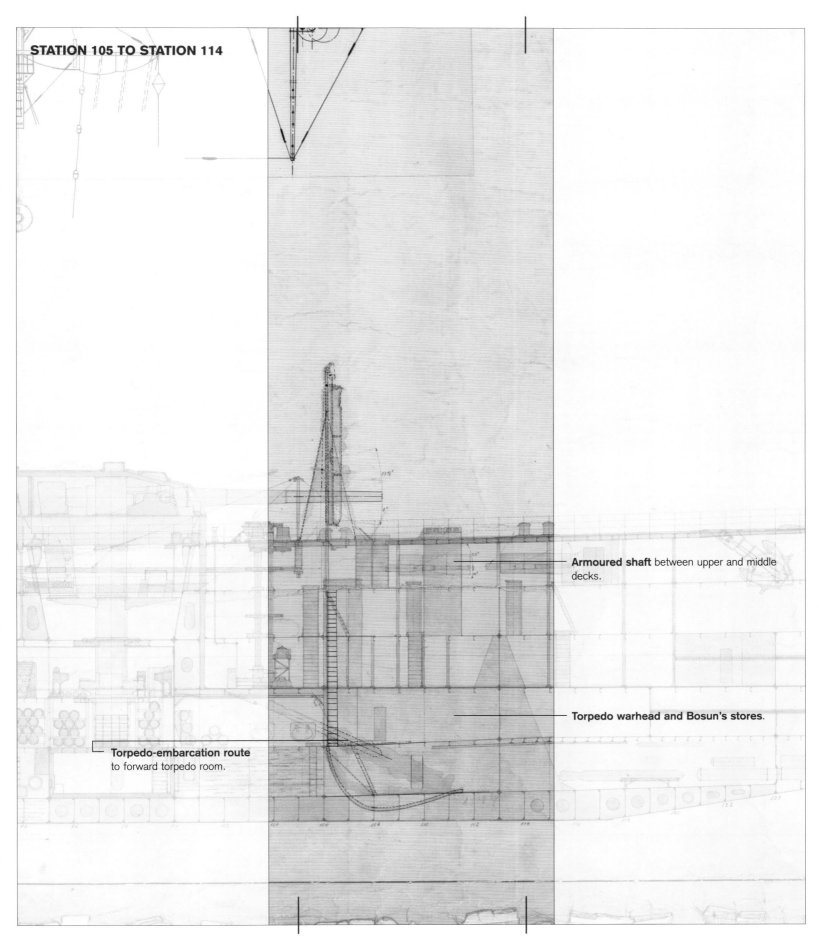

Armoured shaft between upper and middle decks.

Torpedo warhead and Bosun's stores.

Torpedo-embarcation route to forward torpedo room.

105 STATION

114 STATION

Ventilation trunks.

Armoured shaft from aft conning
tower to battery deck.

Ready-use ammunition for tertiary guns.

Ventilation
trunks.

Laundry-drying room for
mechanic NCOs.

Laundry-drying room for
seaman NCOs.

FORWARD HALF OF UPPER DECK

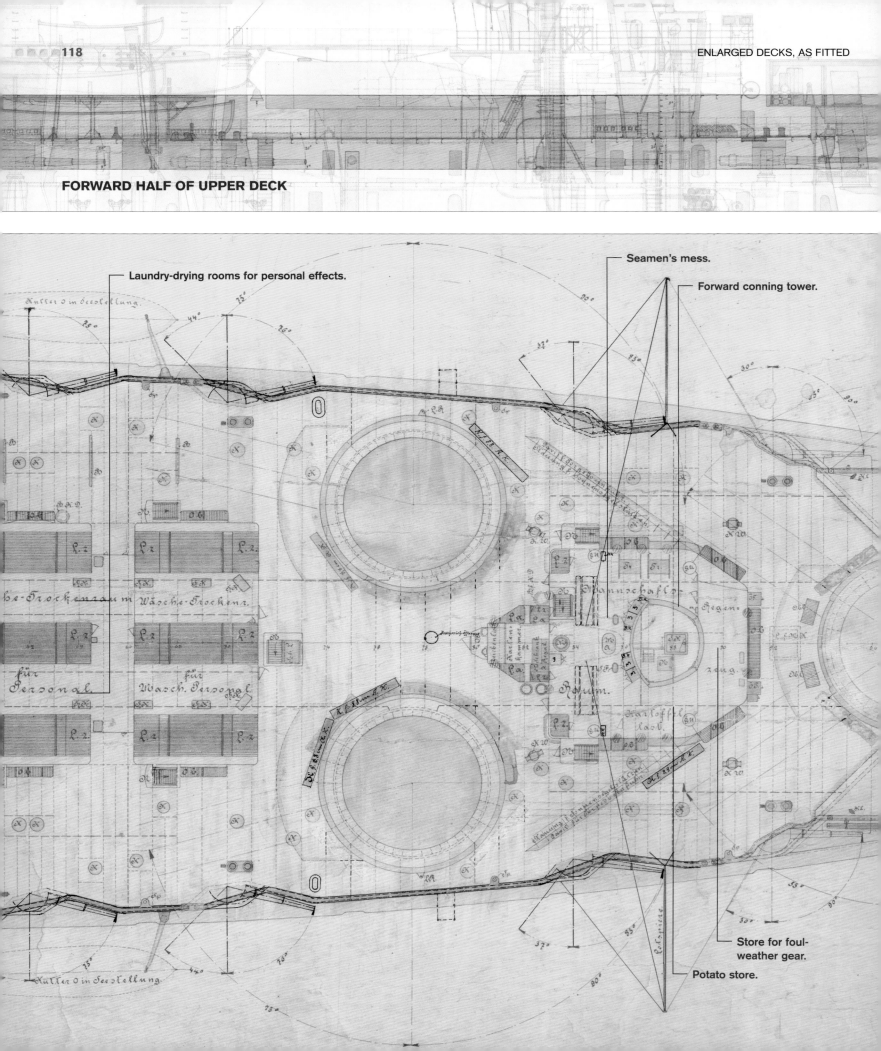

Laundry-drying rooms for personal effects.

Seamen's mess.

Forward conning tower.

Store for foul-weather gear.

Potato store.

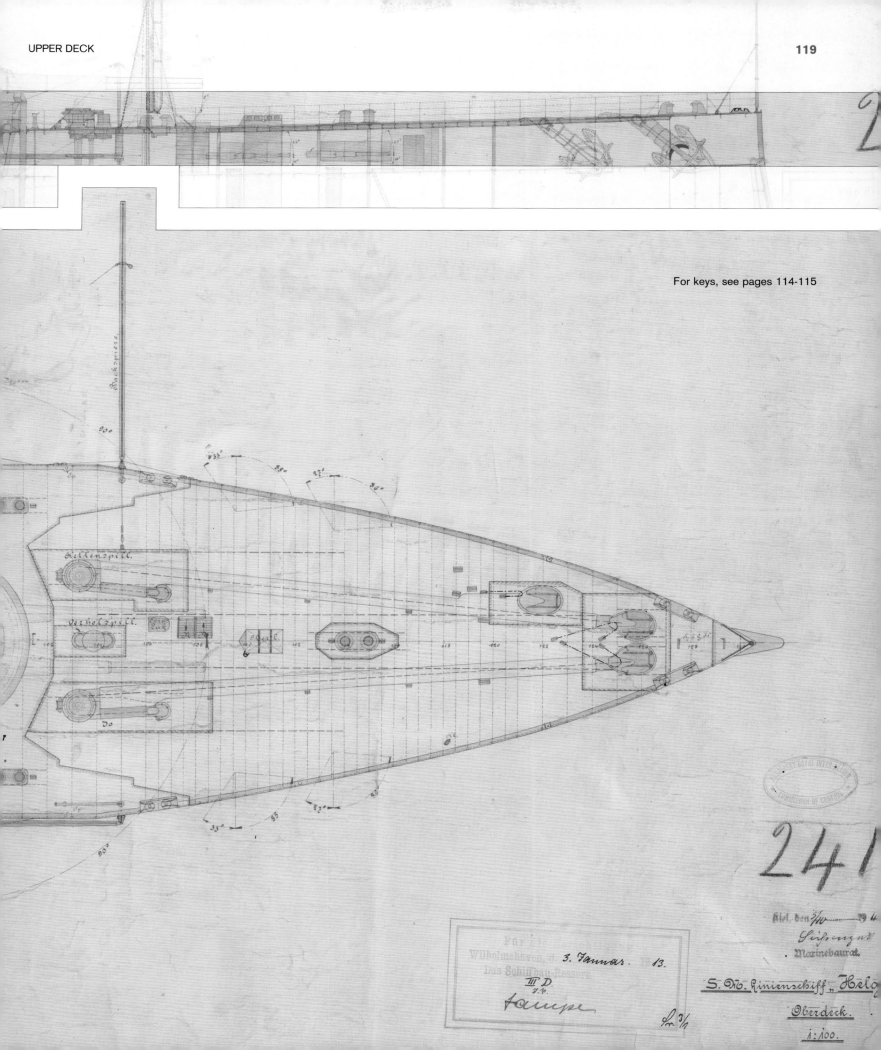

For keys, see pages 114-115

AFT HALF OF BATTERY DECK

As well as mounting the secondary battery, together with part of the tertiary, this deck houses the principal accommodation spaces. As in the case of many navies, the after part is in particular dedicated to the ship's officers and their activities. In the Imperial German Navy, some senior NCOs constituted a group known as 'deck-officers', who shared some of the privileges of commissioned officers.

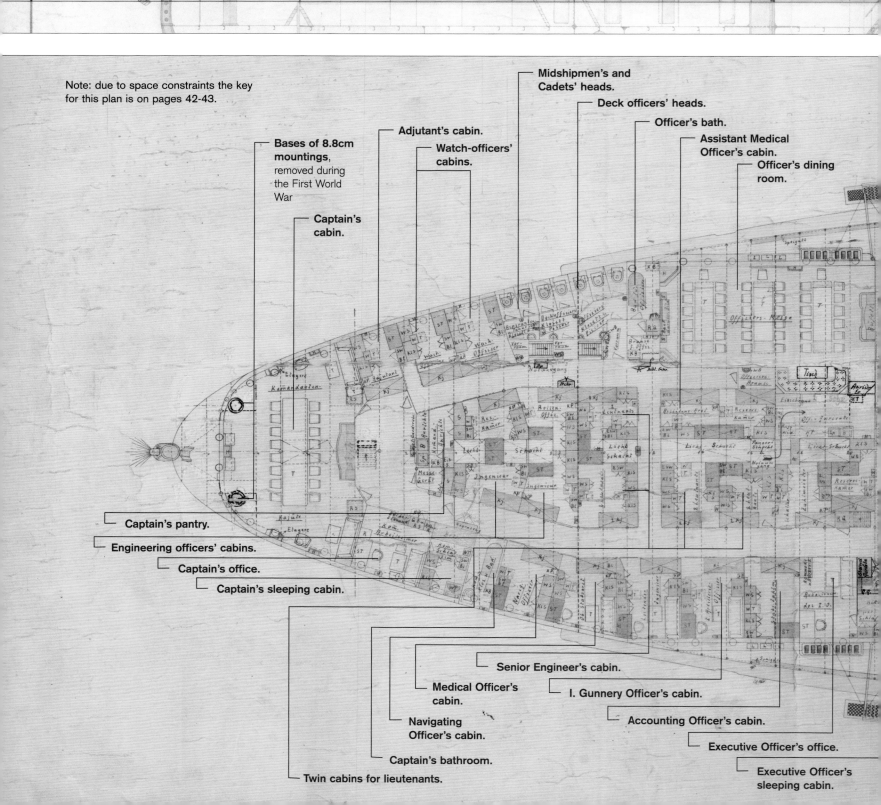

Note: due to space constraints the key for this plan is on pages 42-43.

Midshipmen's and Cadets' heads.

Deck officers' heads.

Officer's bath.

Assistant Medical Officer's cabin.

Officer's dining room.

Adjutant's cabin.

Watch-officers' cabins.

Bases of 8.8cm mountings, removed during the First World War

Captain's cabin.

Captain's pantry.

Engineering officers' cabins.

Captain's office.

Captain's sleeping cabin.

Senior Engineer's cabin.

Medical Officer's cabin.

I. Gunnery Officer's cabin.

Navigating Officer's cabin.

Accounting Officer's cabin.

Captain's bathroom.

Executive Officer's office.

Twin cabins for lieutenants.

Executive Officer's sleeping cabin.

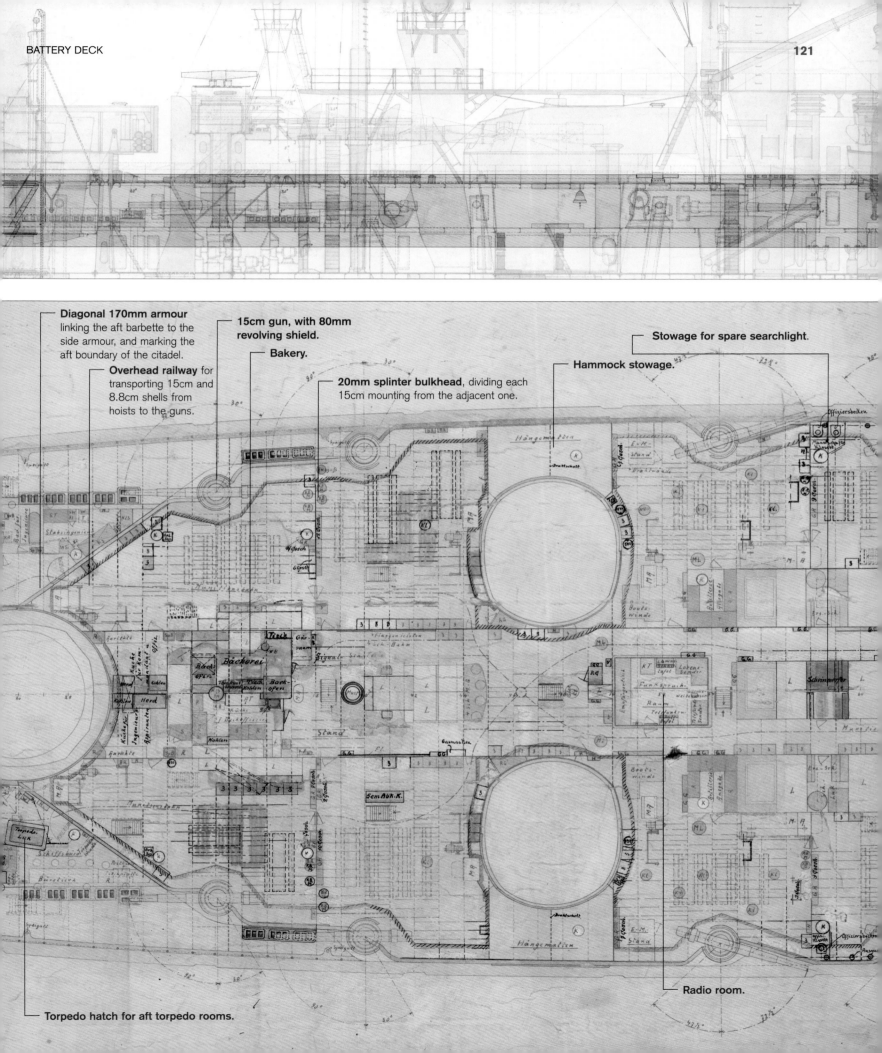

Diagonal 170mm armour linking the aft barbette to the side armour, and marking the aft boundary of the citadel.

Overhead railway for transporting 15cm and 8.8cm shells from hoists to the guns.

15cm gun, with 80mm revolving shield.

Bakery.

20mm splinter bulkhead, dividing each 15cm mounting from the adjacent one.

Stowage for spare searchlight.

Hammock stowage.

Radio room.

Torpedo hatch for aft torpedo rooms.

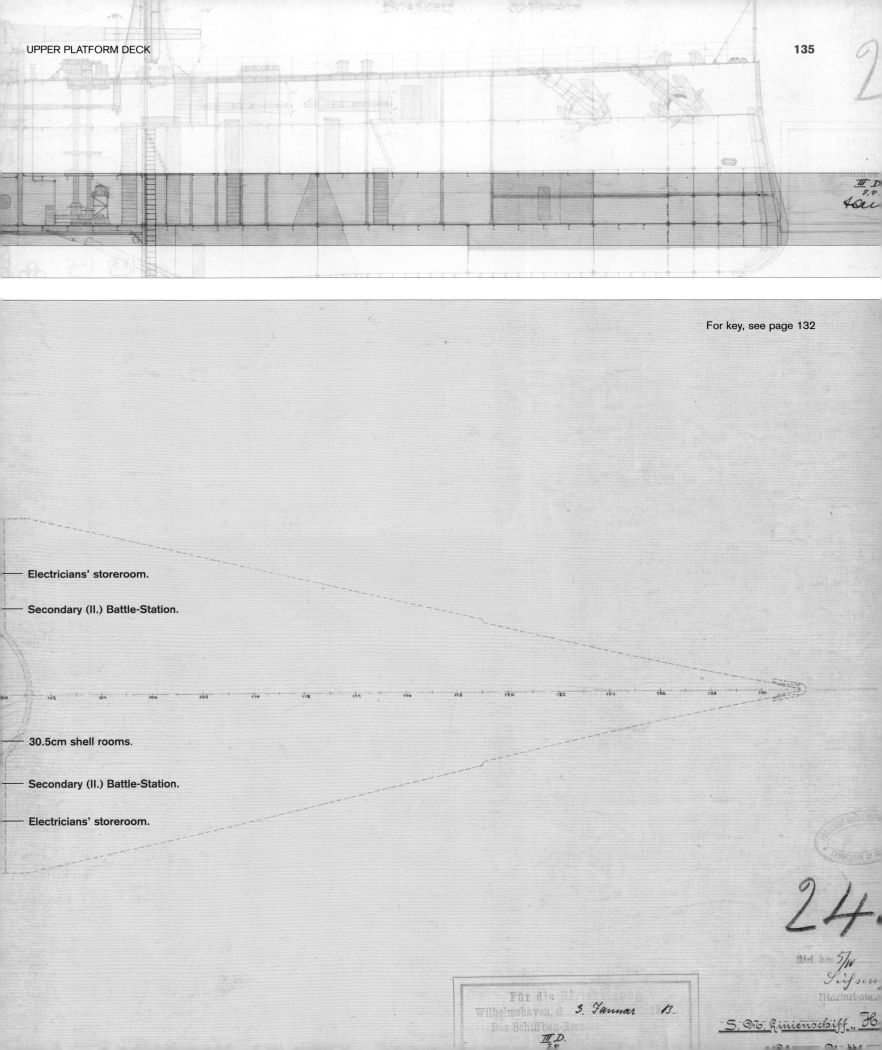

For key, see page 132

Electricians' storeroom.

Secondary (II.) Battle-Station.

30.5cm shell rooms.

Secondary (II.) Battle-Station.

Electricians' storeroom.

AFT PART OF LOWER PLATFORM DECK

This terminates short of the stern owing to the rise of the floor of the ship.
It forms the floor of the main machinery and beam torpedo compartment,
as well as accommodating the main battery magazines.

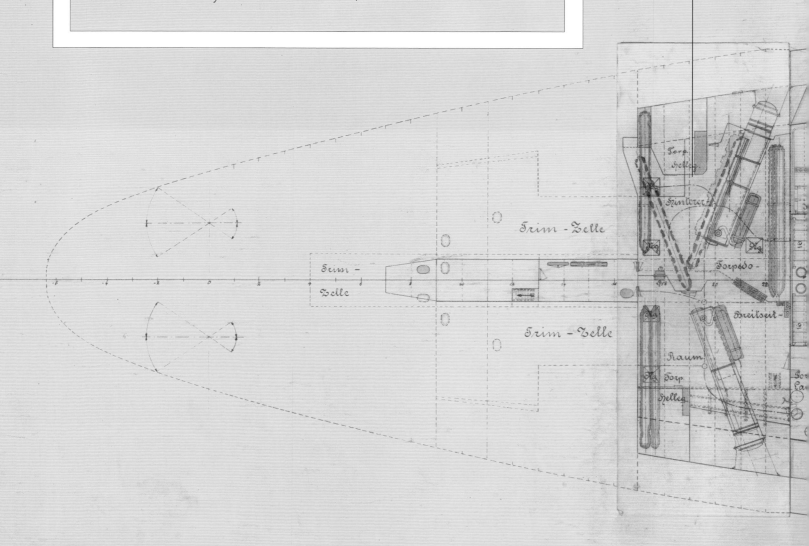

Zeichenerklärung.	Key		
Ng. = Niedergang.	Ng.	Niedergang	Companionway.
N. = Niedergang.	N.	Niedergang	Companionway.
Afz. = Aufzug.	Afz.	Aufzug.	Hoist.
K.S. = Kohlenb. Schiebetür.	K.S	Kohlenb. Schiebetür.	Sliding door of coal bunker.
H. = Heizkörper.	H.	Heizkörper	Radiator.

Aft broadside torpedo room.
A passage aft led up to the
stern torpedo room.

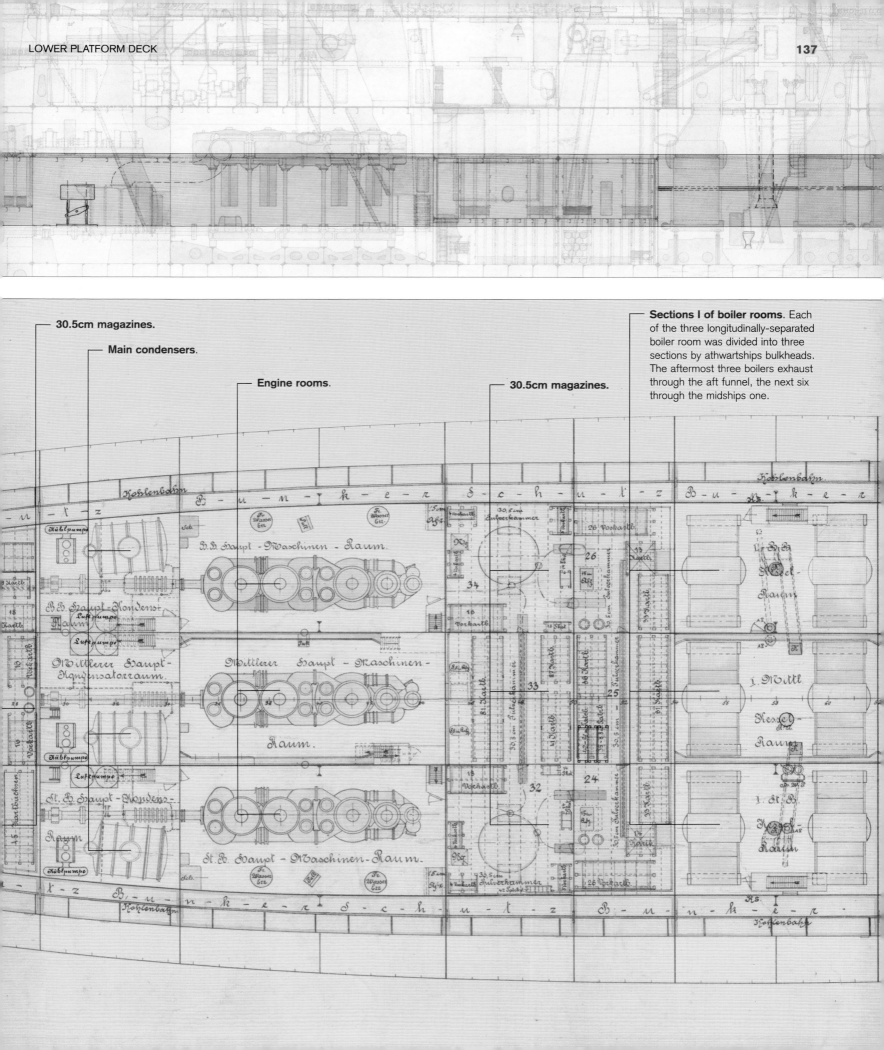

30.5cm magazines.

Main condensers.

Engine rooms.

30.5cm magazines.

Sections I of boiler rooms. Each of the three longitudinally-separated boiler room was divided into three sections by athwartships bulkheads. The aftermost three boilers exhaust through the aft funnel, the next six through the midships one.

FORWARD PART OF LOWER PLATFORM DECK

Like the aft part of the deck, this is dominated by machinery (including the forward generators) and magazines.

Sections II of boiler rooms. The three aft boilers exhaust through the midships funnel, together with the forward three from Sections I, the forward three with those in Sections III.

Sections III of boiler rooms.

30.5cm magazines.

Turbo-generators.

8.8cm cartridge magazine.

30.5cm magazines.

Air compressor for torpedoes.

For key, see page 136

Forward broadside torpedo room.

Hatch to bow torpedo room.

Torpedo fuze store.

Boatswain's store.

Trim tanks.

Coxswain's store.

Mine equipment store.

Torpedo warheads.

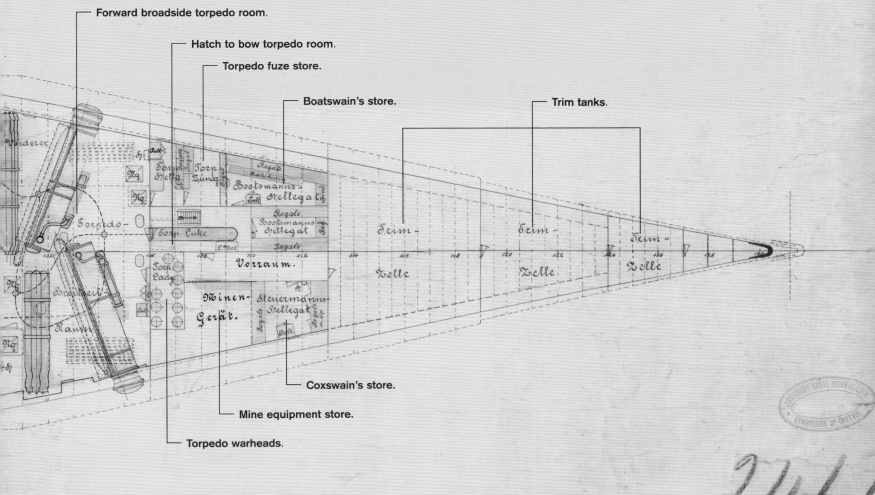